MIAO XIAOCHUN

DUMONT

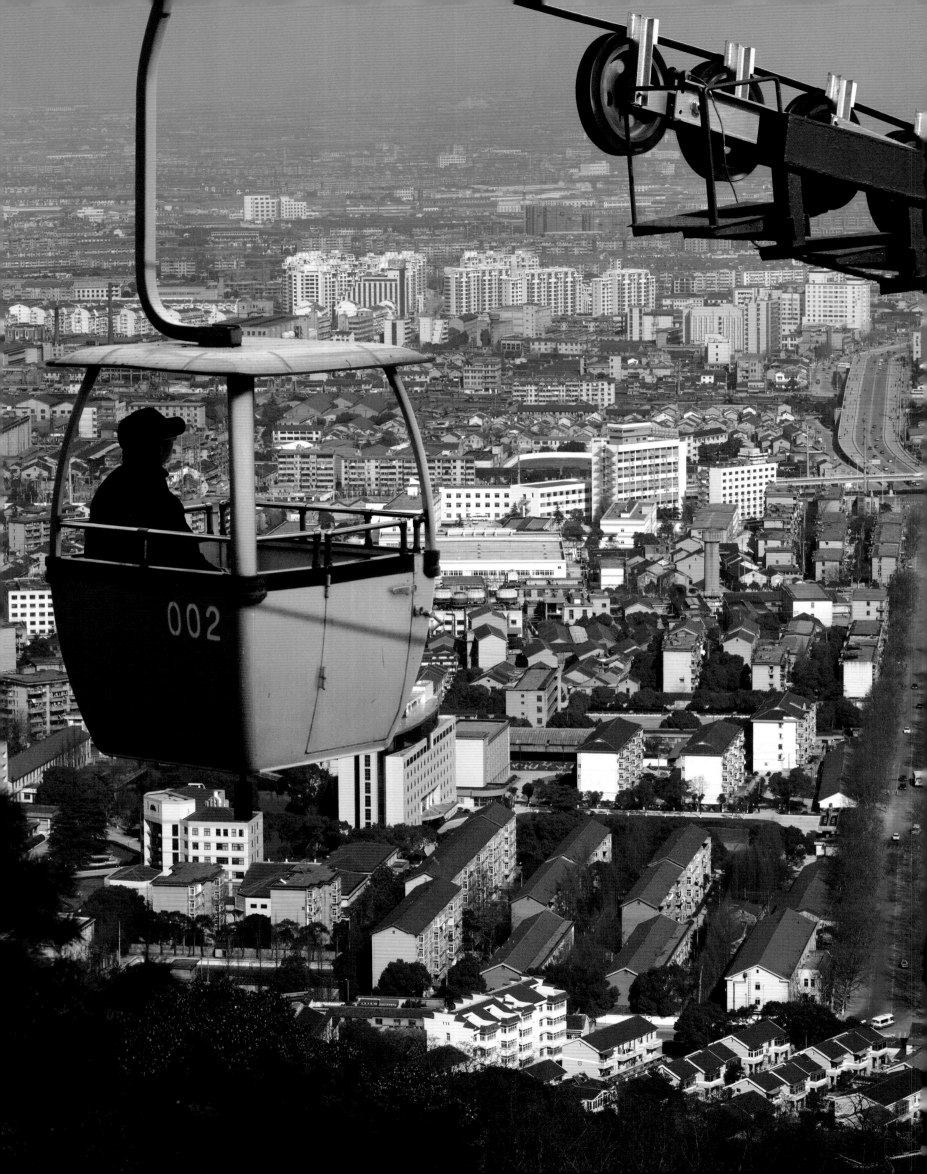

MIAO XIAOCHUN

Edited by | Herausgegeben von
UTA GROSENICK & ALEXANDER OCHS

With text contributions by | Mit Textbeiträgen von
GREGOR JANSEN
WU HUNG
SIEGFRIED ZIELINSKI

TABLE OF CONTENT
INHALTSVERZEICHNIS

8

UTA GROSENICK & ALEXANDER OCHS

Chinese, artist, yellow & white
Chinese, Künstler, gelb & weiß

12

Microcosm
Microcosm

54

SIEGFRIED ZIELINSKI

Discovering the New in the Old:
The Early Modern Period as a Possible Window to the Future?
Neues im Alten entdecken:
Die frühe Neuzeit als mögliches Fenster in die Zukunft?

70

H_2O
H_2O

86

The Last Judgment in Cyberspace
The Last Judgment in Cyberspace

94

Beijing Index
Beijing Index

108

New Urban Reality
New Urban Reality

124

GREGOR JANSEN

Post-History's Being Just So
Das So-Sein der Postmoderne

134

A Visitor from the Past
A Visitor from the Past

172

WU HUNG IN CONVERSATION WITH MIAO XIAOCHUN
WU HUNG UND MIAO XIOACHUN IM GESPRÄCH

'You might think I was Japanese or Korean'
On self-portrayal in Miao Xiaochun's work
‚Man könnte glauben, ich sei Japaner oder Koreaner'
Über das Selbstbild in Miao Xiaochuns Arbeit

186

Biography | Biografie

192

Bibliography | Bibliografie

194

About the authors | Über die Autoren

196

Thanks to | Danksagung
Imprint | Impressum

I don't believe that animals, after they are satiated, don't think about their fates or life journeys. Think about intelligent monkeys, mighty lions, and magnificent elephants, they all raise their heads to the sky with such abstruse looks in their eyes. Maybe they have more time to think than us busy humans.

Ich glaube schon, dass Tiere – wenn sie satt sind – über ihr Schicksal und ihren Lebensweg nachdenken. Man denke nur an all die intelligenten Affen, mächtigen Löwen und prächtigen Elefanten, die ihre Köpfe mit einem realitätsfernen Blick in ihren Augen gen Himmel erheben. Vielleicht haben sie sogar mehr Zeit nachzudenken als wir viel beschäftigten Menschen.

UTA GROSENICK & ALEXANDER OCHS

CHINESE, ARTIST, YELLOW & WHITE
CHINESE, KÜNSTLER, GELB & WEISS

Miao Xiaochun is Chinese and an artist, and was originally a Germanist. Upon being refused a place at the Nanjing Arts Institute in China because he was considered too romantic, went to study Art History in Beijing and subsequently went to Kassel. In the city of the Brothers Grimm and the documenta he did casual work at Volkswagen and studied at the art college, which is over two centuries old. He arrived in the middle of the 1990ies: his stay in Germany followed no plan. The Chinese call this fate—a fate that many *bananas* share.

A banana is white on the inside and yellow on the outside; in China, *banana* is a nationalistic derogatory term for Chinese nationals who involve themselves with the West. A *banana* is always generally suspected of committing cultural betrayal.

Miao Xiaochun is Chinese, and did not want to be a banana; during the Kassel years he created from himself a figure—his alter ego in the guise of a polymath from the Song Dynasty, which dates back to the first millennium after Christ. The polymath was always

an artist too, and Miao Xiaochun, Germanist and Chinese, brought a small case from China to Germany, in which alongside his cultural stock lay the costume of his alter ego.

Down in this cultural stock the artist found the *diang renwei*, tiny figures that are *applied* to the paintings of the Song Dynasty. Applied, because they follow no central perspective; the artist places his alter ego into his black and white photographs on an equal plane with the figures.

The *diang renwei* generally do not correspond with each other; they stand isolated in the image and around them arises distance, arises emptiness. In Kassel, which the artist left in 1999, his alter ego stands in a telephone booth or sits at the laid table of a family with whom he is friends. At the same time, the figure communicates only in one direction, and a field of tension arises across the table.

One of the most impressive photographs in this series was taken two years later in China; here, the *other self* is employed for the last time. It sits in front of a small TV set and watches the Twin Towers burning. Again, it communicates only in one direction, but the tension turns to emptiness, to nothing. Buddhism however explains the void to us as the idea that includes and unites everything.

In 2006, the artist came back to Germany for a visit. In Berlin's *Neue Gemäldegalerie*, he repeatedly visited Lucas Cranach the Elder's painting *The Fountain of Youth*. The early 16th century master showed Miao Xiaochun many different individuals: old men and women, humiliated by life, who emerge from the spring rejuvenated and refreshed.

In his own *Fountain of Youth,* Miao Xiaochun depicts Cranach's figures, after his original, with eternally firm bodies, faceless or—always the same—with his own face.

Is the Germanist Miao Xiaochun here constituting himself as a Chinese in *Buddhist multiplicity*, surrendering the demand for individuality? Or are we here experiencing the oft-uttered demand for *China's cultural hegemony*, fed by the new nationalism?

This book should make it clear that Miao Xiaochun's oeuvre is not yellow and not white. In him we discover an artist whose multilayered development and multifaceted work throws up more questions than we are in a position to answer—and therein lies his relevance.

Miao Xiaochun ist Chinese und Künstler, und war ursprünglich Germanist. Nachdem er, weil zu romantisch veranlagt, an der chinesischen Nanjinger Kunstakademie nicht zugelassen worden war, studierte er in Peking Kunstgeschichte und ging anschließend nach Kassel. In der Stadt der Gebrüder Grimm und der documenta jobbte er bei Volkswagen und studierte an der über zweihundert Jahre alten Kunsthochschule. Er kam Mitte der 1990er, der Aufenthalt in Deutschland folgte keinem Plan, ein Chinese nennt das Schicksal, ein Schicksal das viele *Bananen* teilen.

Eine Banane ist innen weiß und außen gelb, eine Banane in China ist ein böses, nationalistisches Etikett für Chinesen, die sich mit dem Westen einlassen. Eine Banane steht immer unter dem Generalverdacht des kulturellen Verrats.

Miao Xiaochun ist Chinese und wollte keine Banane sein; in den Kasseler Jahren schuf er eine Figur von sich selbst, sein Alter Ego im Habitus eines Universalgelehrten aus der ins erste Jahrtausend nach Christus zurückreichenden Song Dynastie. Der Universalgelehrte war immer auch Künstler und Miao Xiaochun, Germanist und Chinese, trug eine kleine Kiste von China nach Deutschland, in dieser lag neben seinem kulturellen Fundus das Kostüm des Alter Egos.

Unten im kulturellen Fundus fand der Künstler die *diang renwei*, winzige Figuren, die in die Malerei der Song Dynastie *eingesetzt* werden. Eingesetzt, weil sie keiner zentralen Perspektive folgen; ihnen gleich stellte der Künstler sein Alter Ego in seine schwarzweißen Fotografien.

Die *diang renwei* korrespondieren gemeinhin nicht miteinander, sie stehen isoliert im Bild und um sie herum entsteht Distanz, entsteht Leere. In Kassel, das der Künstler 1999 verlässt, steht sein Alter Ego in einer Telefonzelle oder sitzt am gedeckten Tisch einer befreundeten Familie. Dabei kommuniziert die Figur nur in eine Richtung und über dem Tisch entsteht ein Spannungsfeld.

Eine der eindrucksvollsten Fotografien aus dieser Serie wird zwei Jahre später in China aufgenommen, hier funktioniert das *Andere Selbst* ein letztes Mal. Es sitzt vor einem kleinen TV-Gerät und schaut auf die brennenden *Twin Towers*. Wieder kommuniziert es nur in eine Richtung, aber die Spannung wird zur Leere, zum Nichts. Der Buddhismus allerdings erklärt uns die Leere als die Idee, die alles umfasst und vereinigt.

2006 kehrt der Künstler für einen Besuch nach Deutschland zurück. In der Berliner *Neuen Gemäldegalerie* besucht er wiederholt das Bild *Jungbrunnen* von Lucas Cranach dem Älteren. Der Meister aus dem frühen 16. Jahrhundert zeigt Miao Xiaochun viele verschiedene Individuen. Vom Leben gedemütigte alte Frauen und Männer, die das Bad verjüngt und erfrischt verlassen.

Danach zeigt Miao Xiaochun Cranachs Figuren in seiner *Fountain of Youth* mit ewig straffem Körper, gesichtslos oder – immer gleich – mit seinem eigenen Gesicht.

Formuliert sich der Germanist Miao Xiaochun hier als Chinese in *buddhistischer Vielheit*, der die Forderung nach Individualität aufgibt? Oder erleben wir hier den vielfach geforderten Anspruch nach *kultureller Hegemonie Chinas*, gespeist aus neuem Nationalismus?

Dieses Buch soll verstehbar machen, dass Miao Xiaochuns Werk nicht gelb und nicht weiß ist. Wir entdecken in ihm einen Künstler, dessen vielschichtige Entwicklung und facettenreiche Arbeit mehr Fragen aufwirft als wir zu beantworten in der Lage sind – und darin offenbart sich seine Relevanz.

MICROCOSM
2008

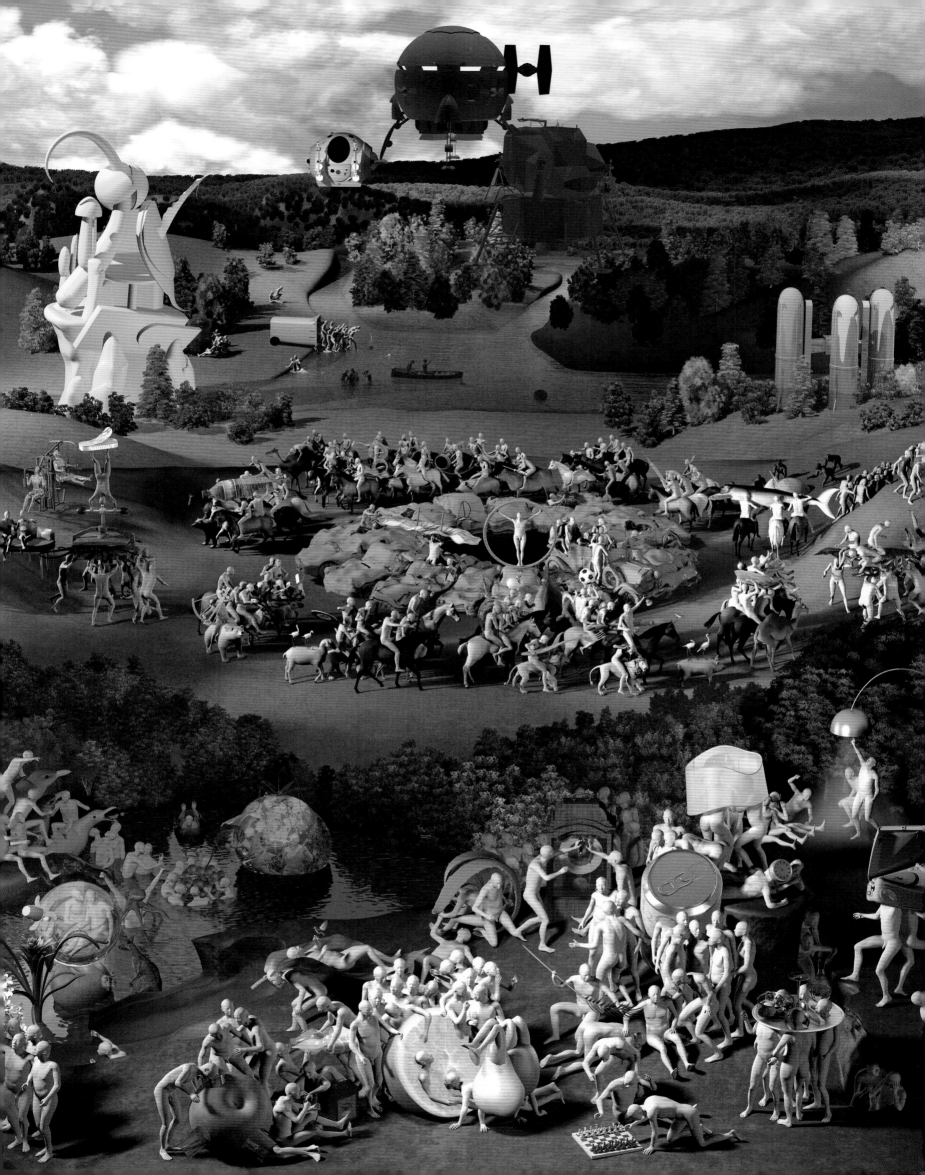

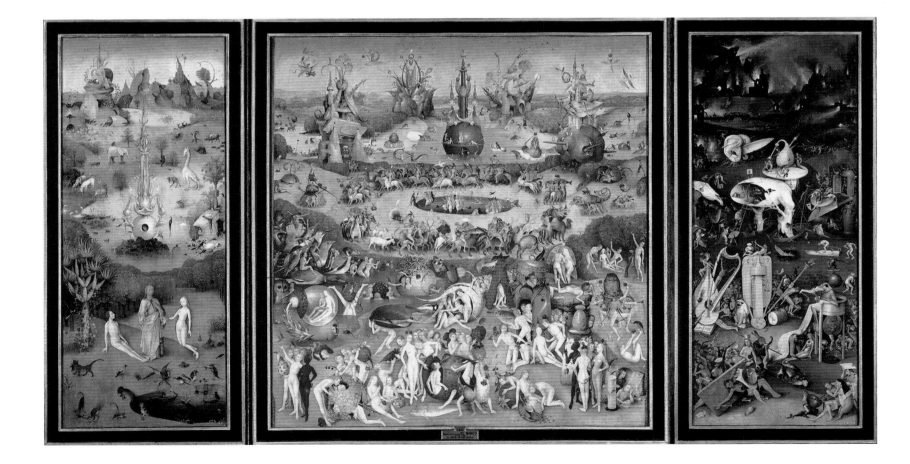

Hieronymus Bosch, **The Garden of Earthly Delights**, 1503–1504

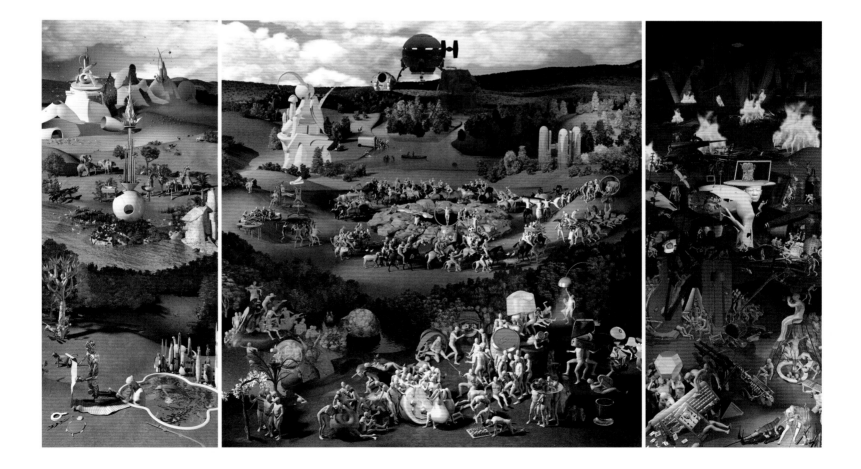

Microcosm, 2008
C-Print, central panel, wing 2 and wing 8

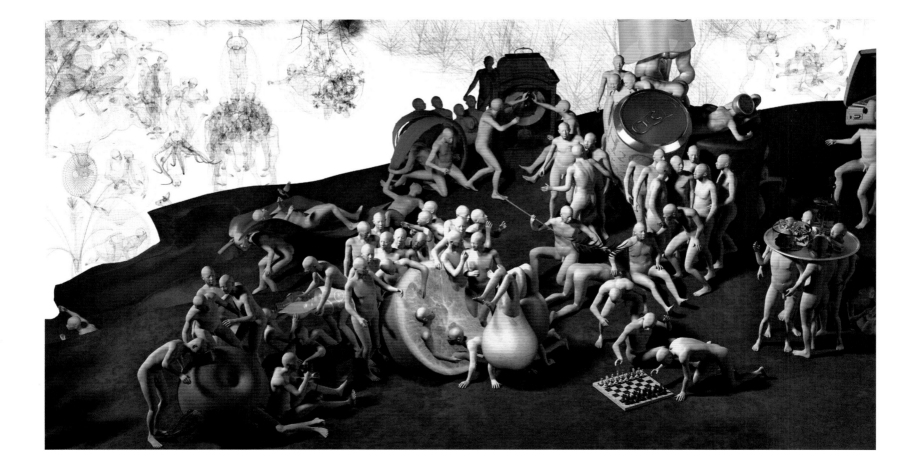

Fullness, 2008
C-Print, 257 x 480 cm

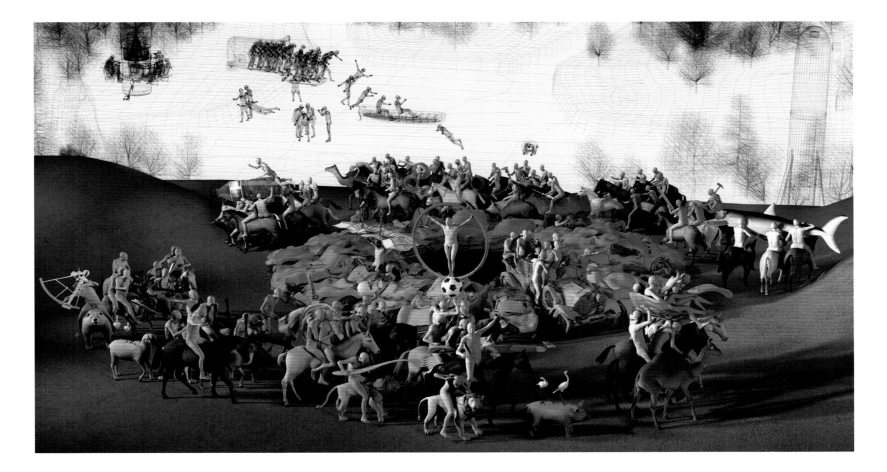

Transport, 2008
C-print, 260 x 480 cm

Next page: **Samsara**, 2008
C-Print, 57 x 200 cm

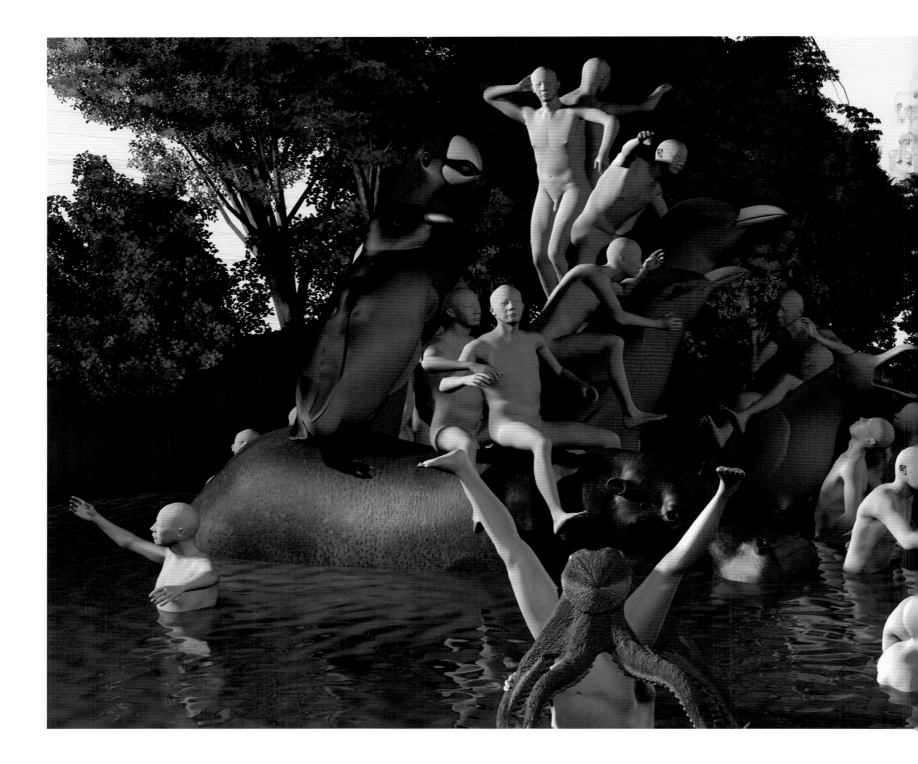

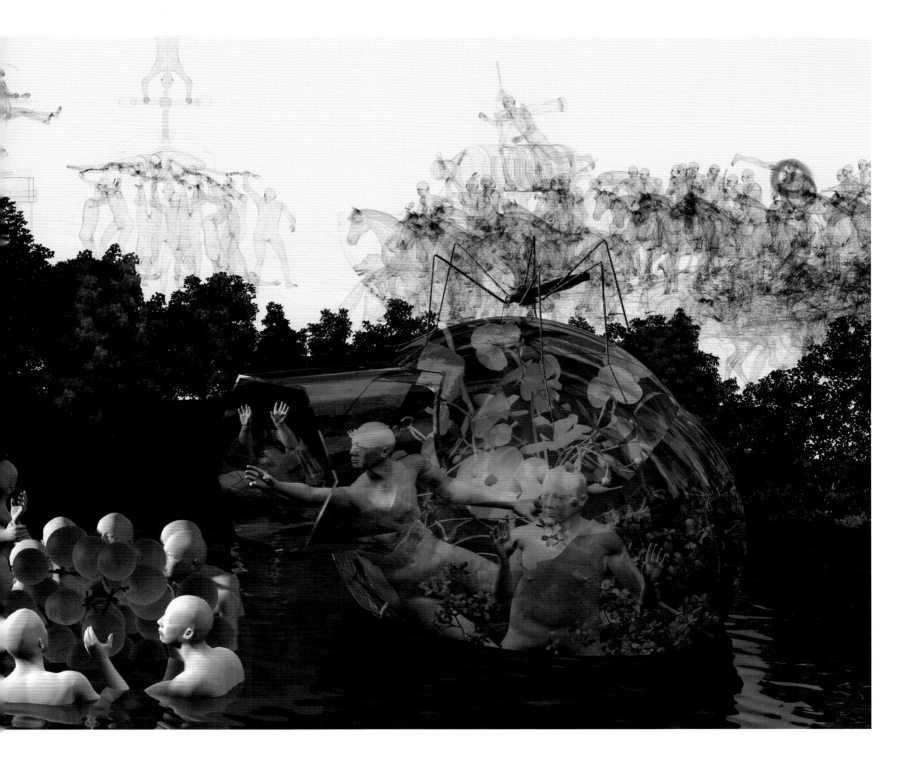

Desire, 2008
C-Print, 194 x 480 cm

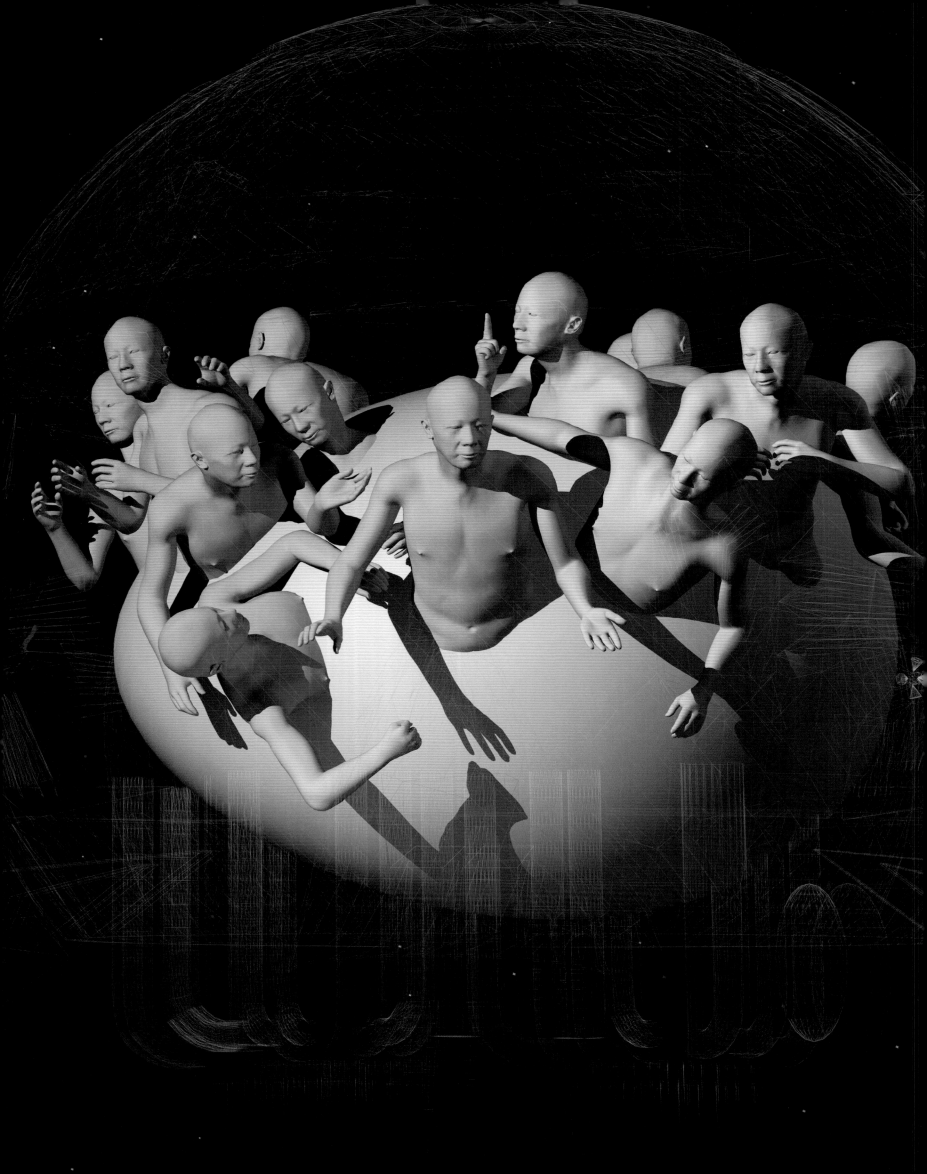

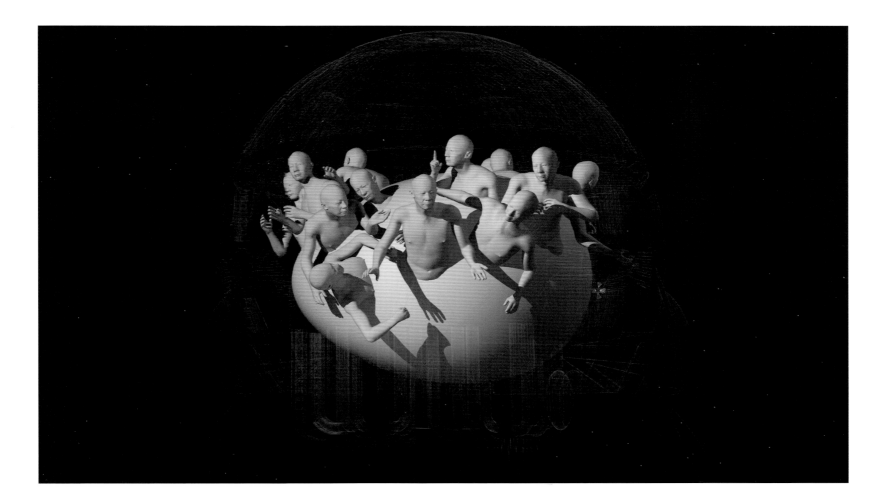

Fatalism, 2008
C-Print, 150 x 257 cm

MICROCOSM
DRAWINGS

Carry (Detail), 2008
Pencil on paper, 100 x 182 cm

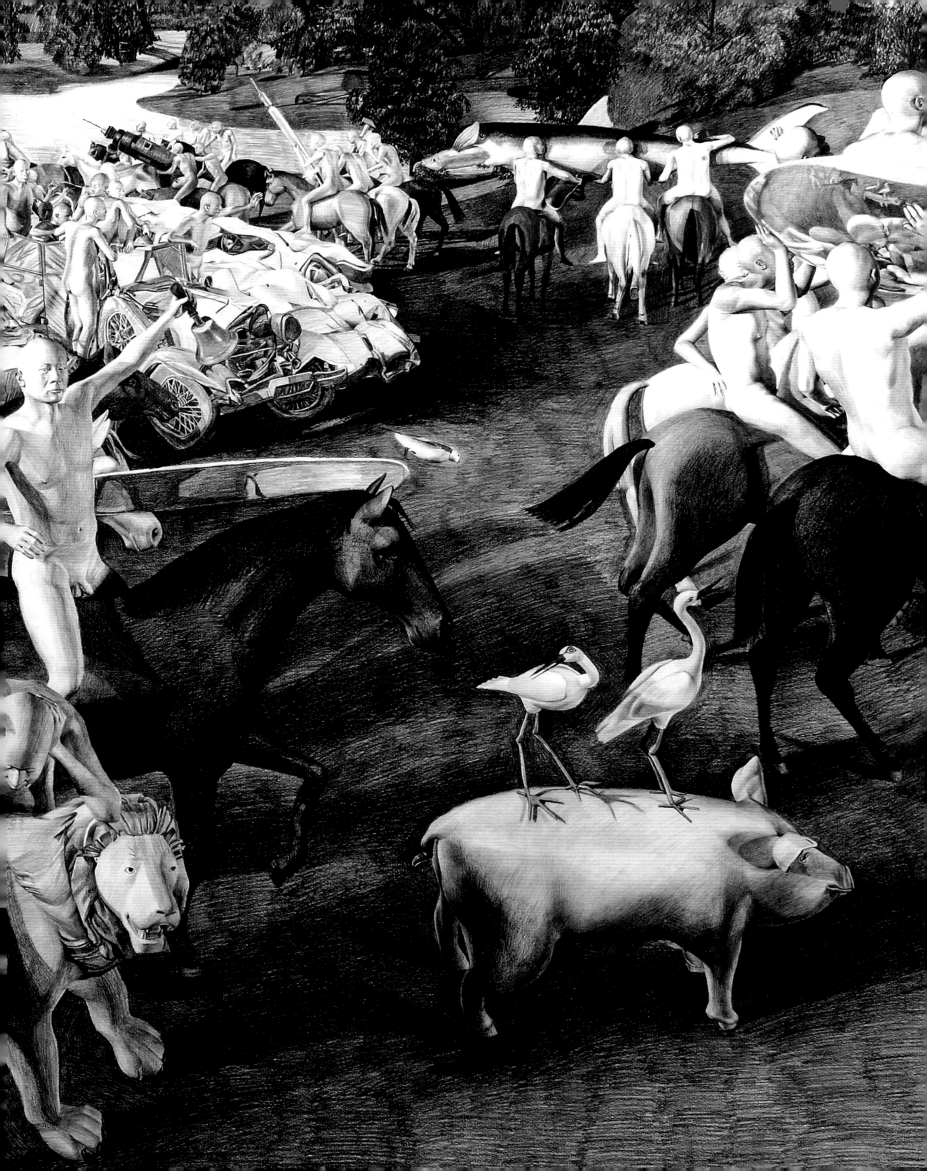

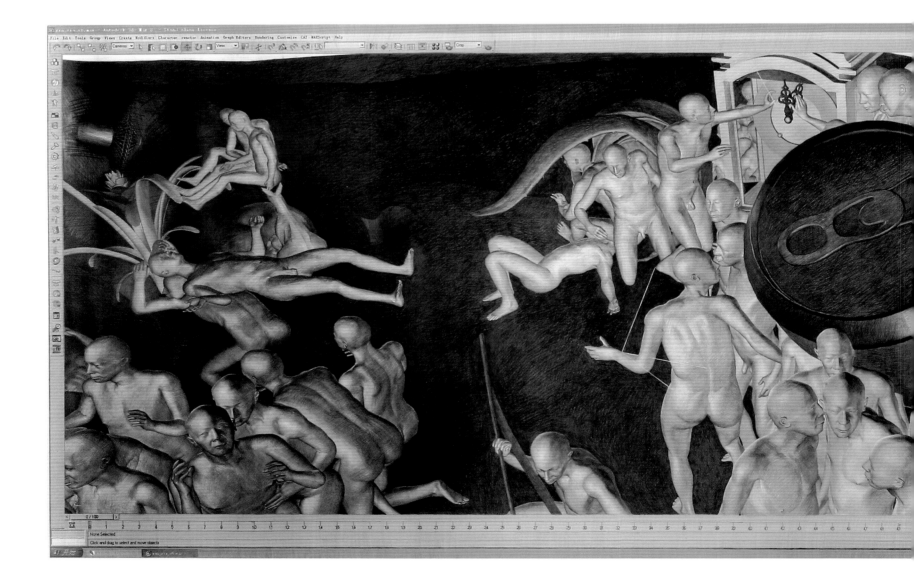

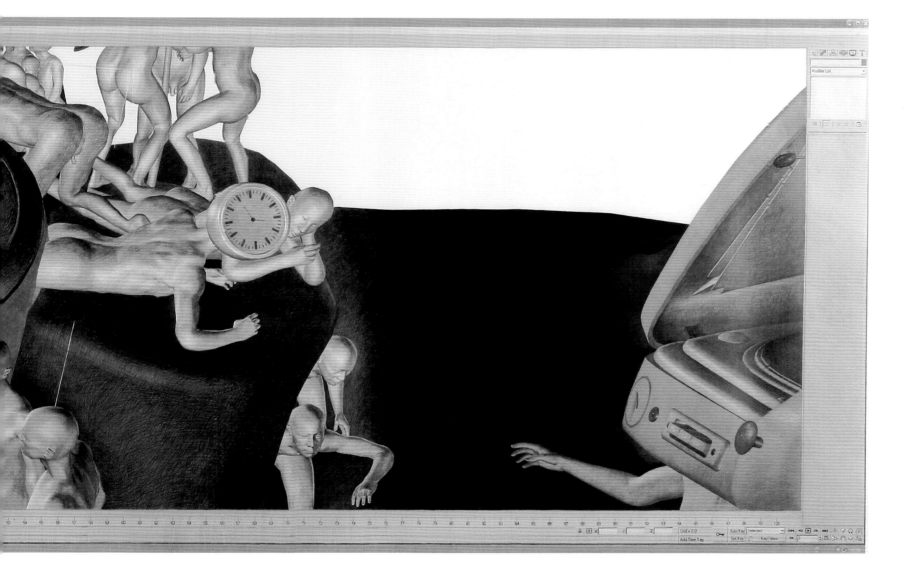

Sundial, 2008
Pencil on paper, 87 x 281 cm

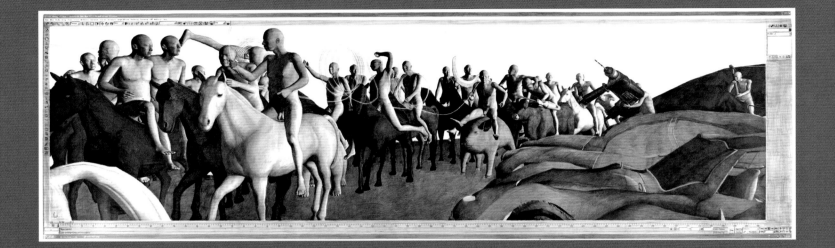

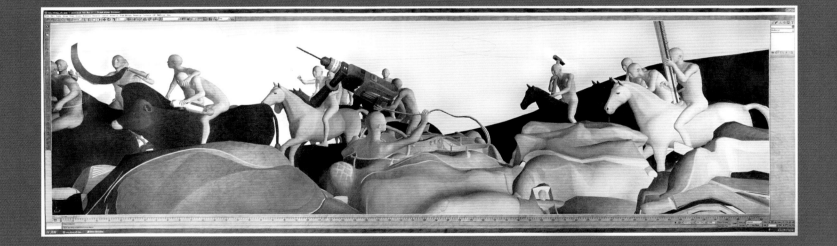

Exotica, 2008
Pencil on paper, 87.5 x 281 cm

Force, 2008
Pencil on paper, 87.5 x 281 cm

28

Abyss, 2008
Pencil on paper, 100 x 170 cm

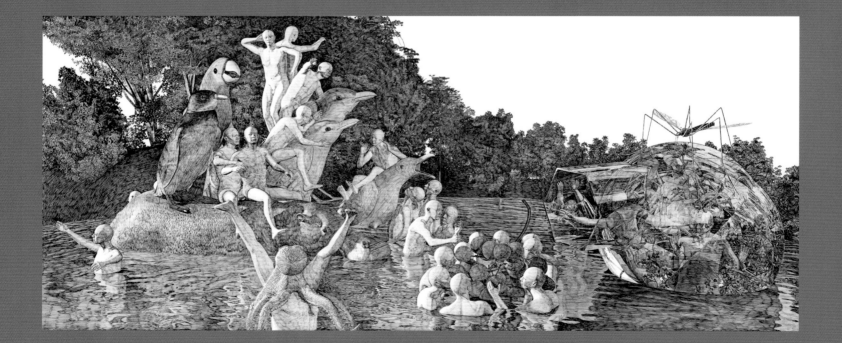

Yearn, 2008
Pen on paper, 89.8 x 210 cm

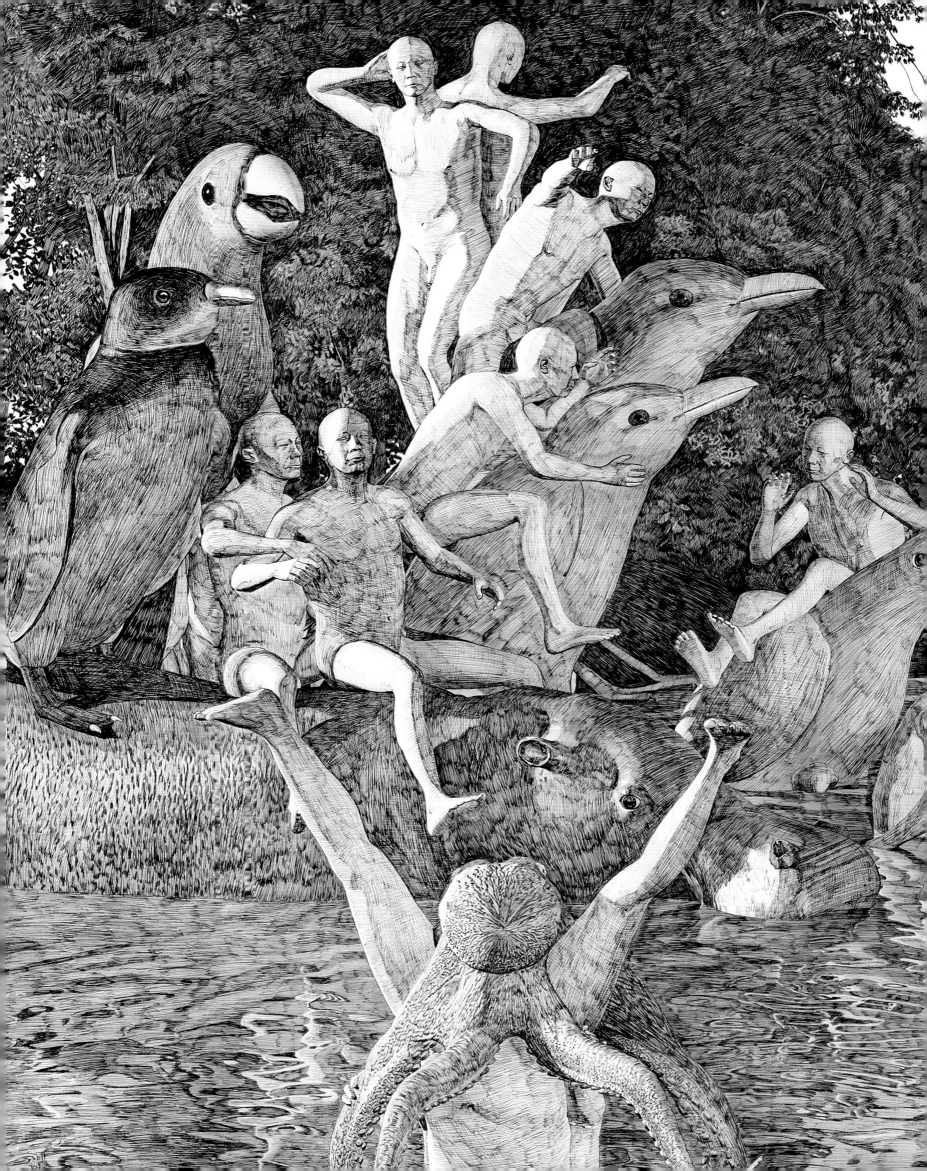

History, 2008
Pen on paper, 99.5 x 160 cm

Shoulder, 2008
Pen on paper, 100 x 145.5 cm

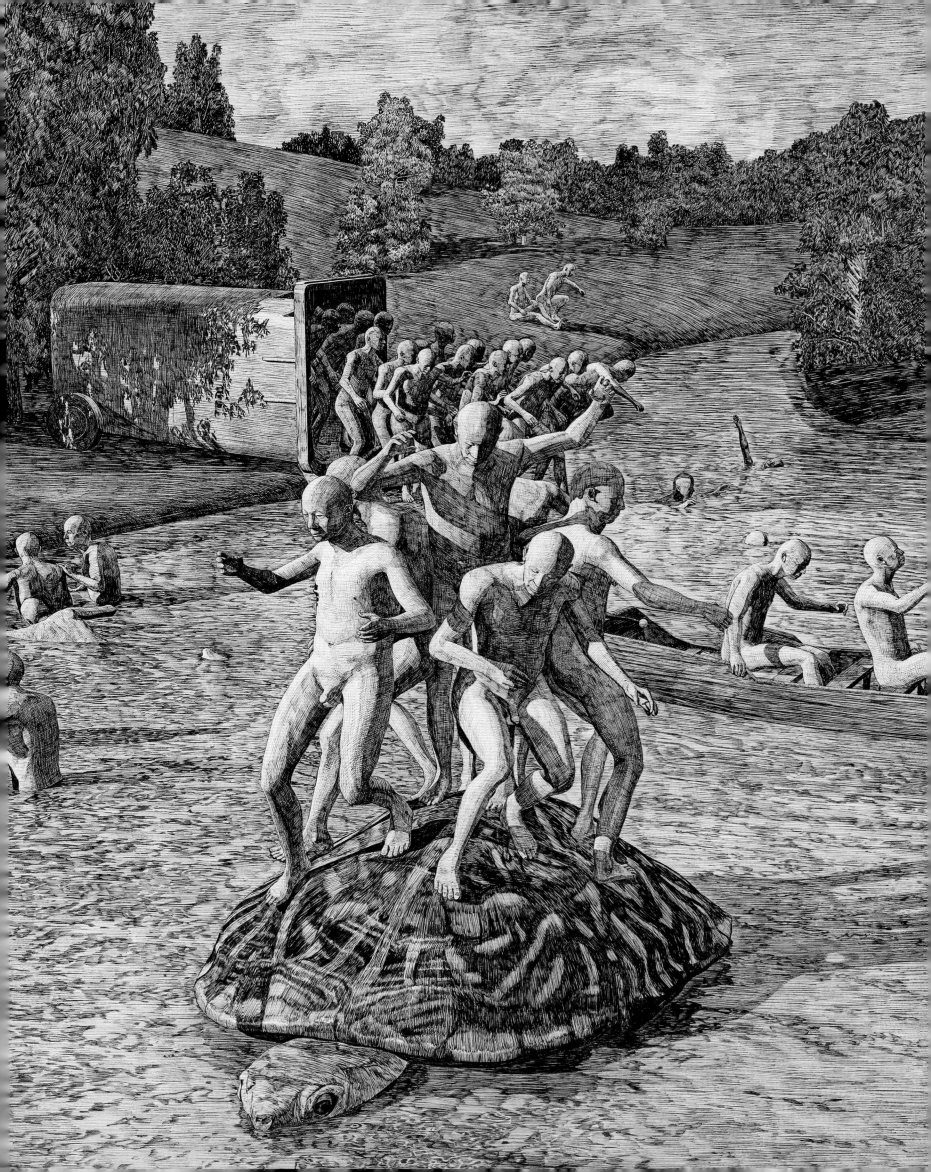

MICROCOSM
DIGITAL INK PAINTINGS

Extremity (Details), 2008
Digital ink painting, 240 x 95 cm

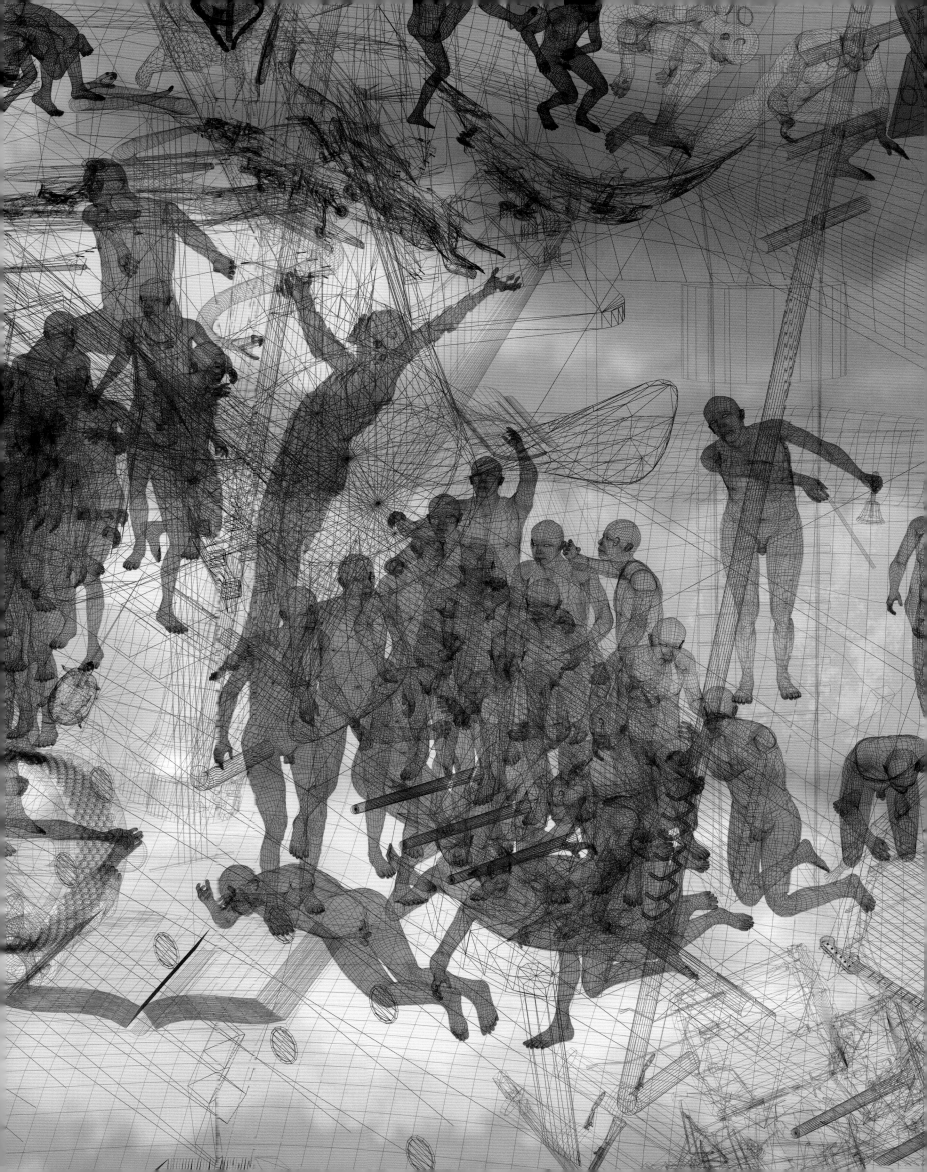

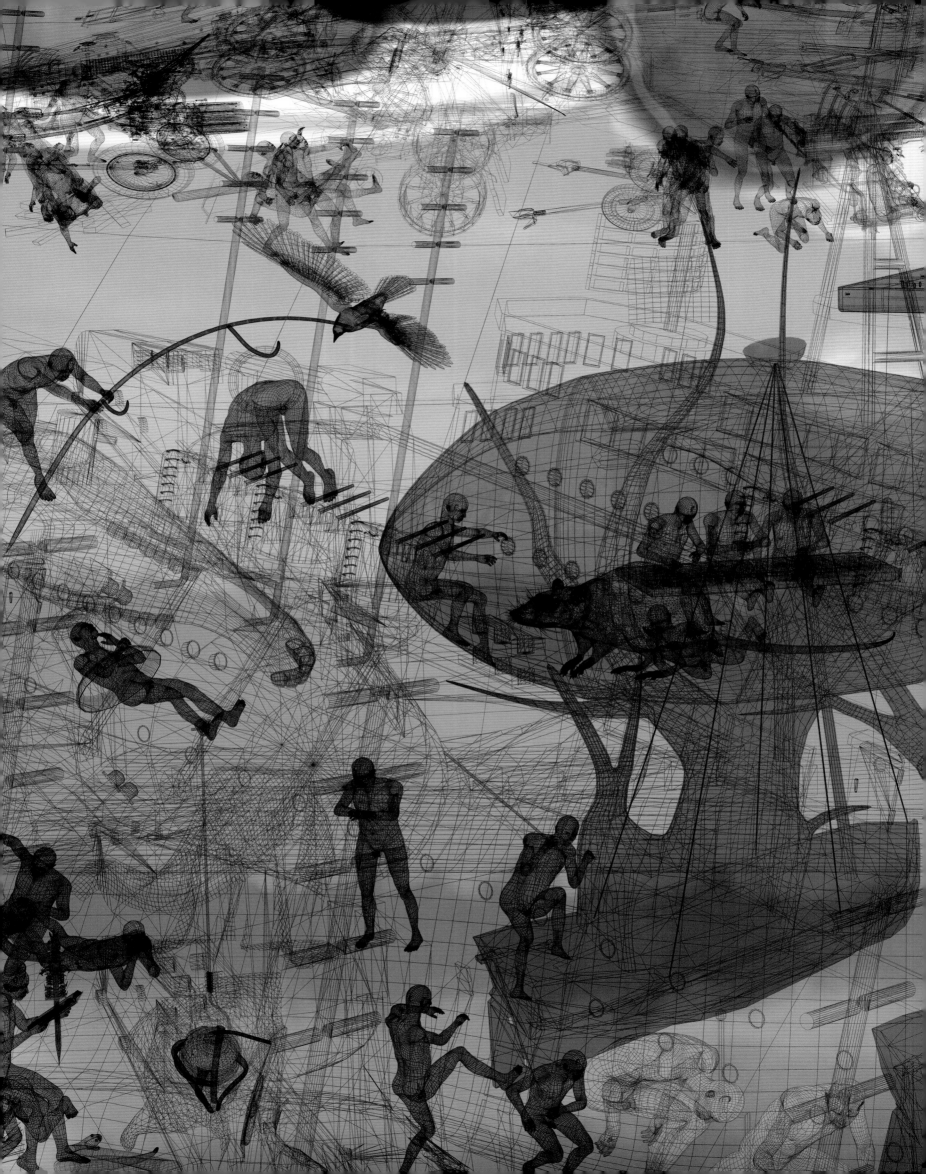

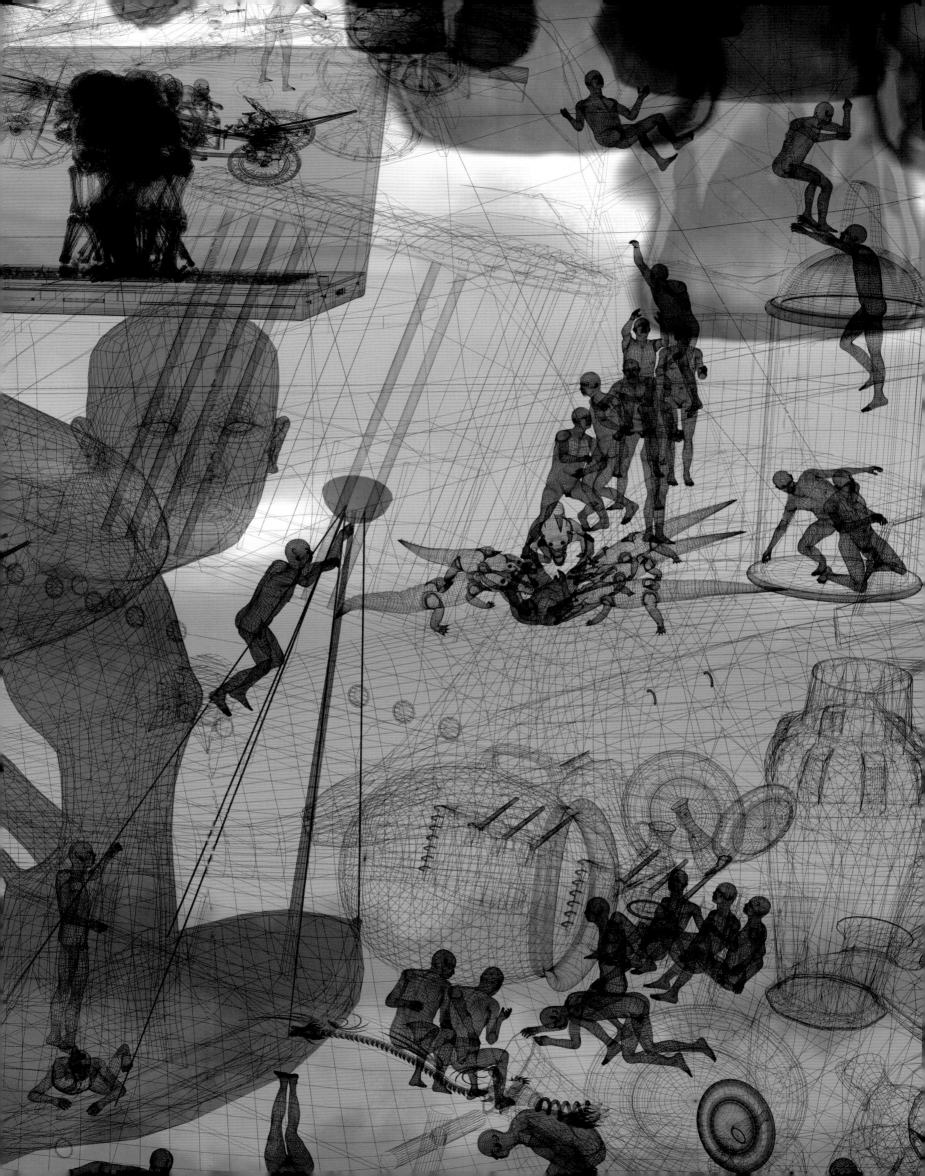

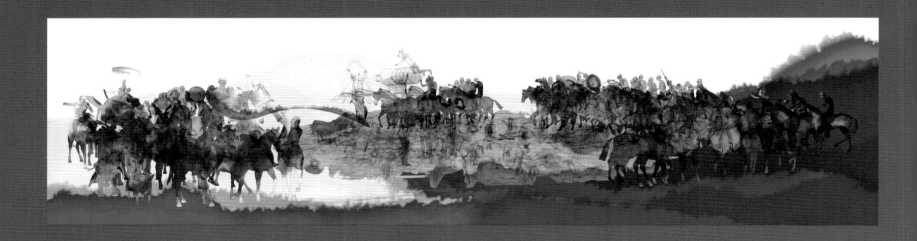

Rest, 2008
Digital ink painting, 63 x 240 cm

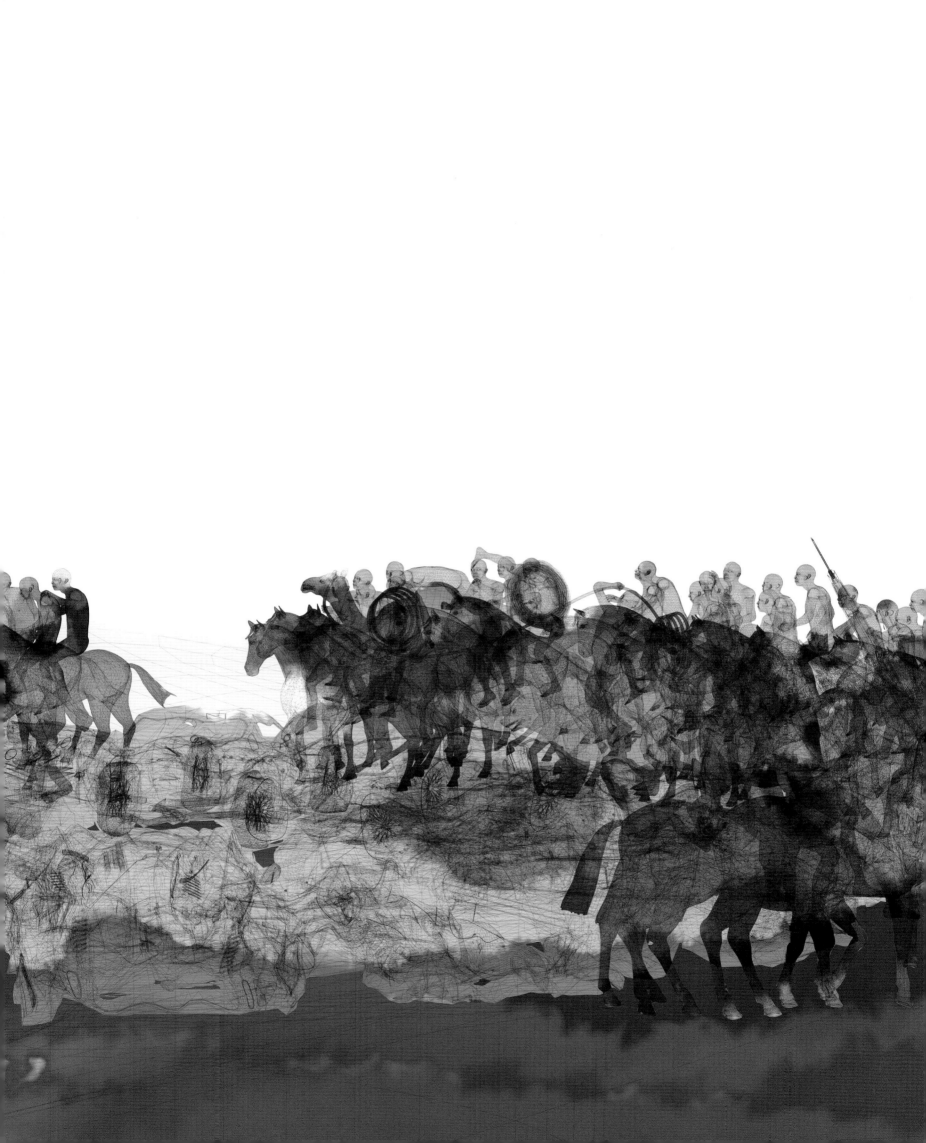

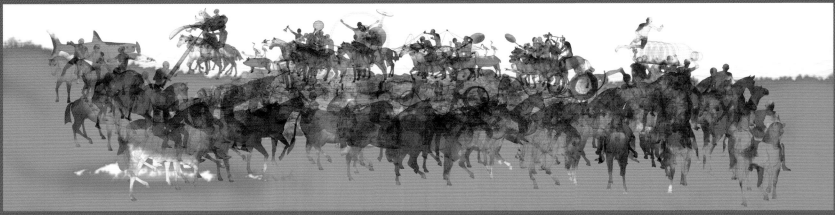

Hesitation, 2008
Digital ink painting, 63 x 240 cm

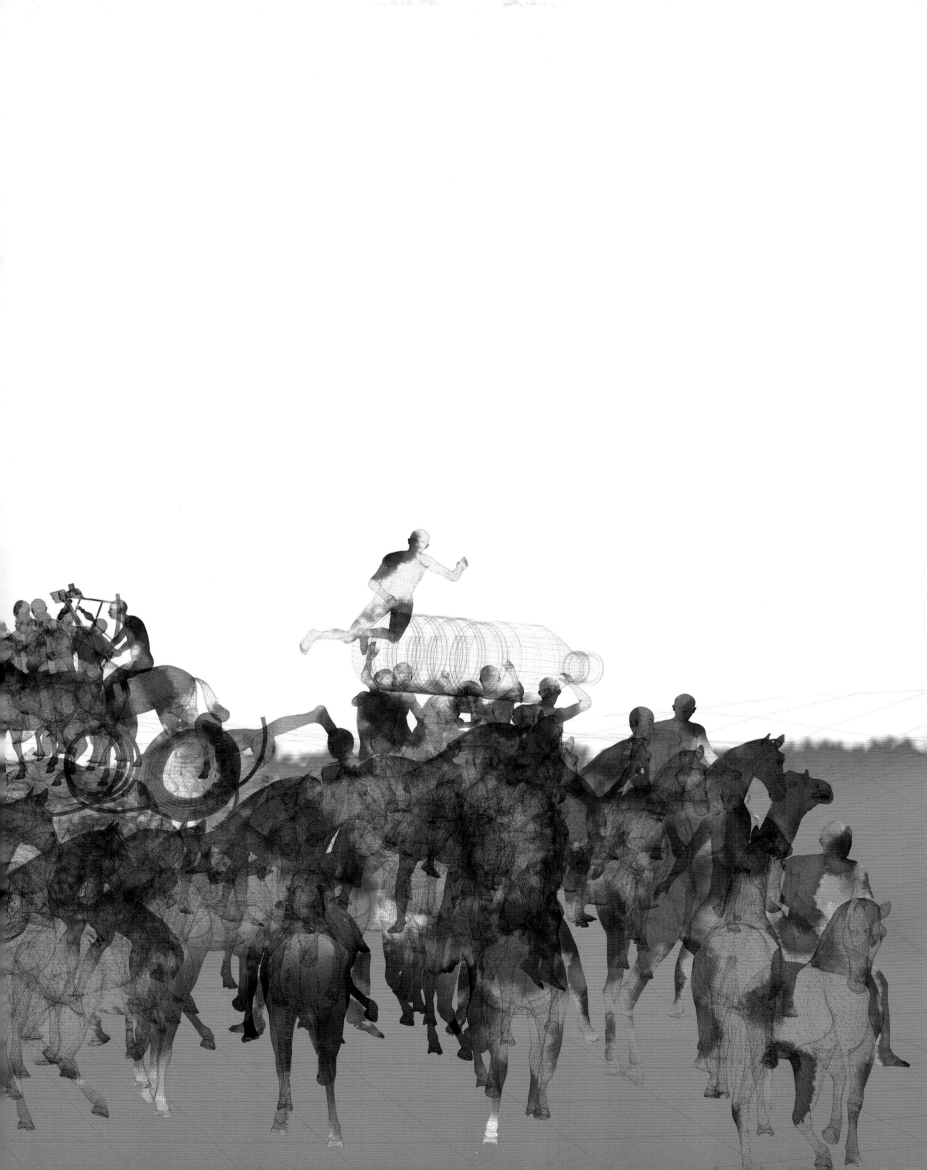

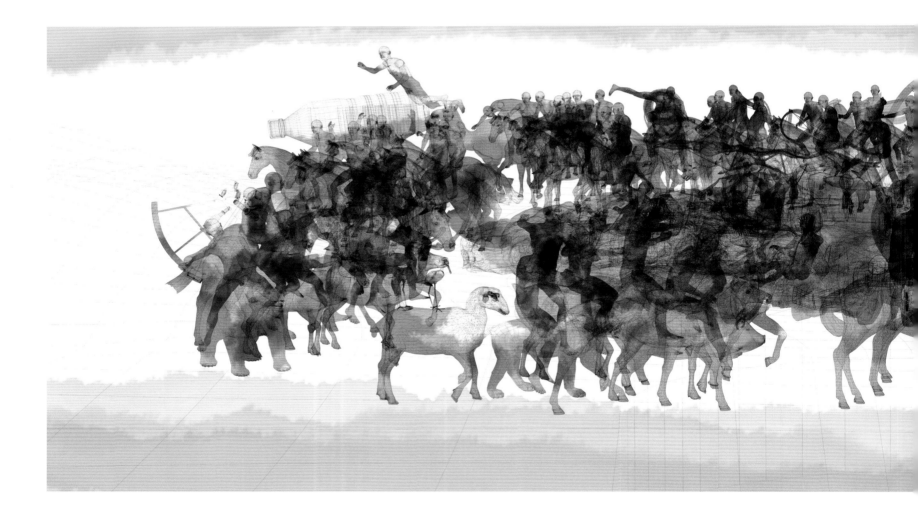

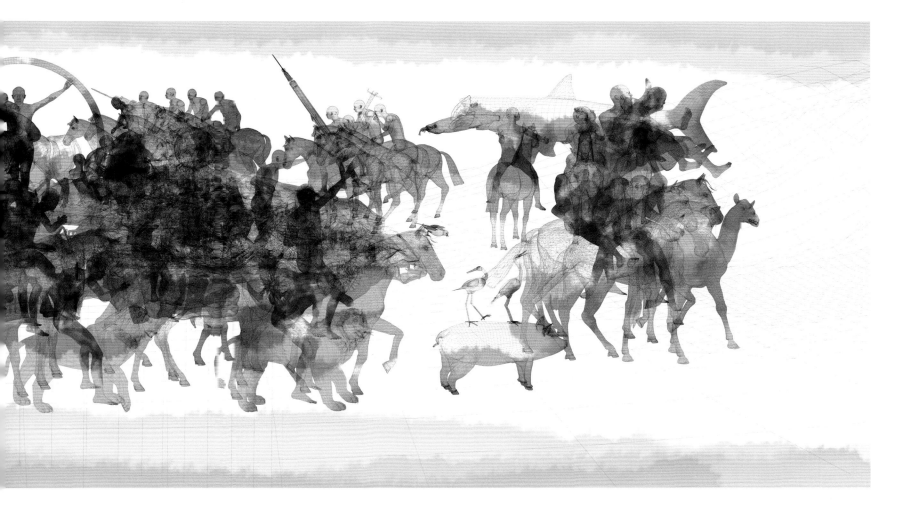

Outing, 2008
Digital ink painting, 63 x 240 cm

43

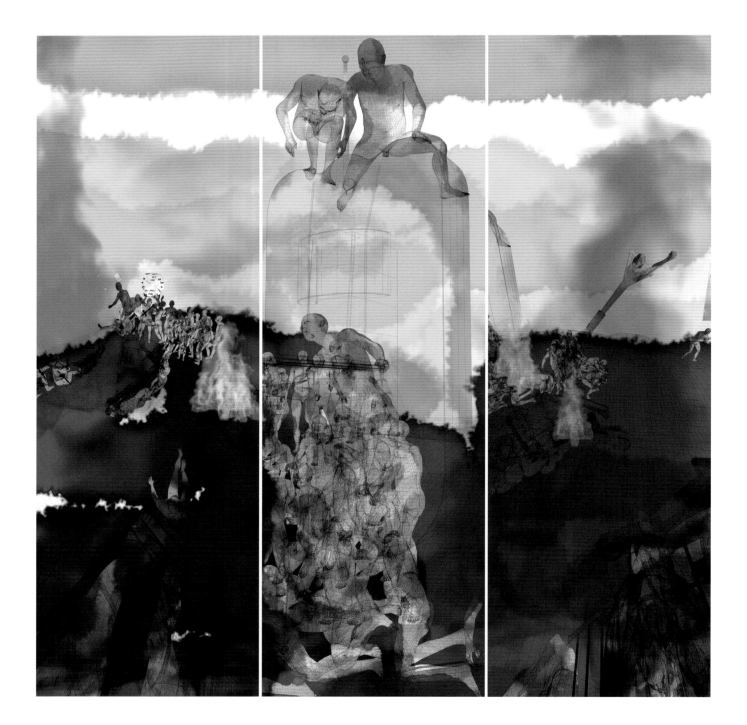

Fire, 2008
Digital ink painting
160 x 157 cm, 3 panels, each 160 x 52.3cm

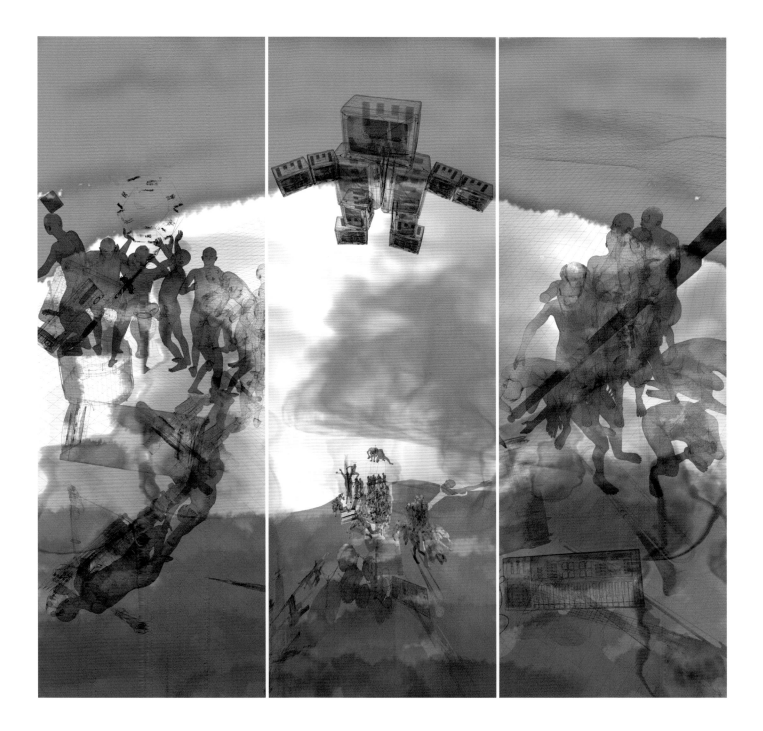

Flame, 2008
Digital ink painting
160 x 160 cm, 3 panels, each 160 x 53.3 cm

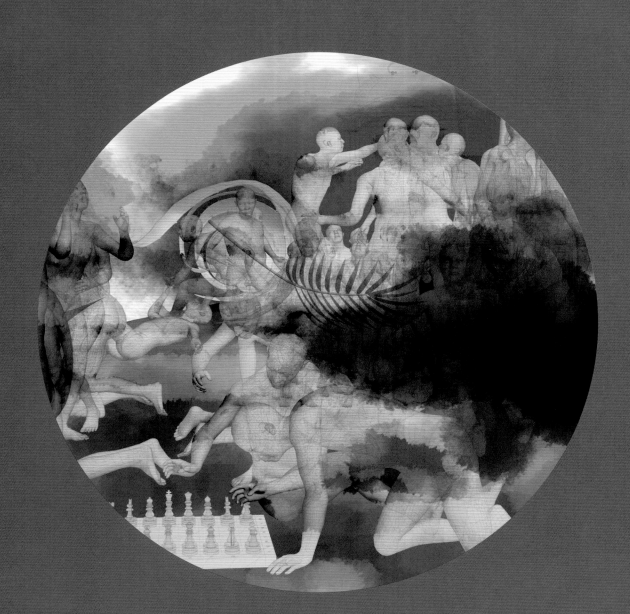

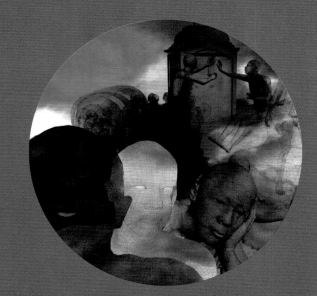

Chess, 2008;
Digital ink painting, ø 70 cm

Nostalgia, 2008
Digital ink painting, ø 70 cm

Right: **Blossom**, 2008
Digital ink painting, 240 x 77 cm

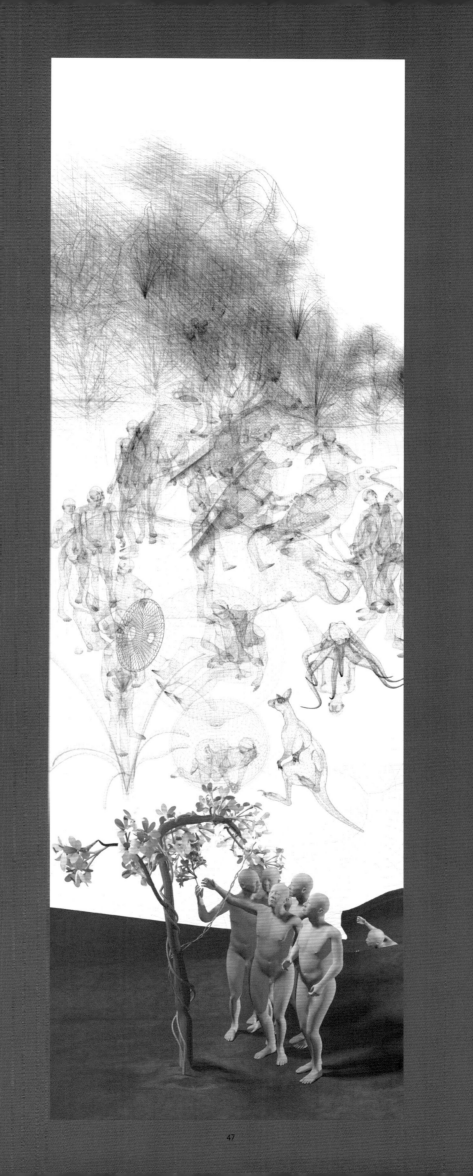

MICROCOSM
EMBROIDERED WORKS

Fall (Detail), 2008
Embroidery on silk, 114 x 304 cm

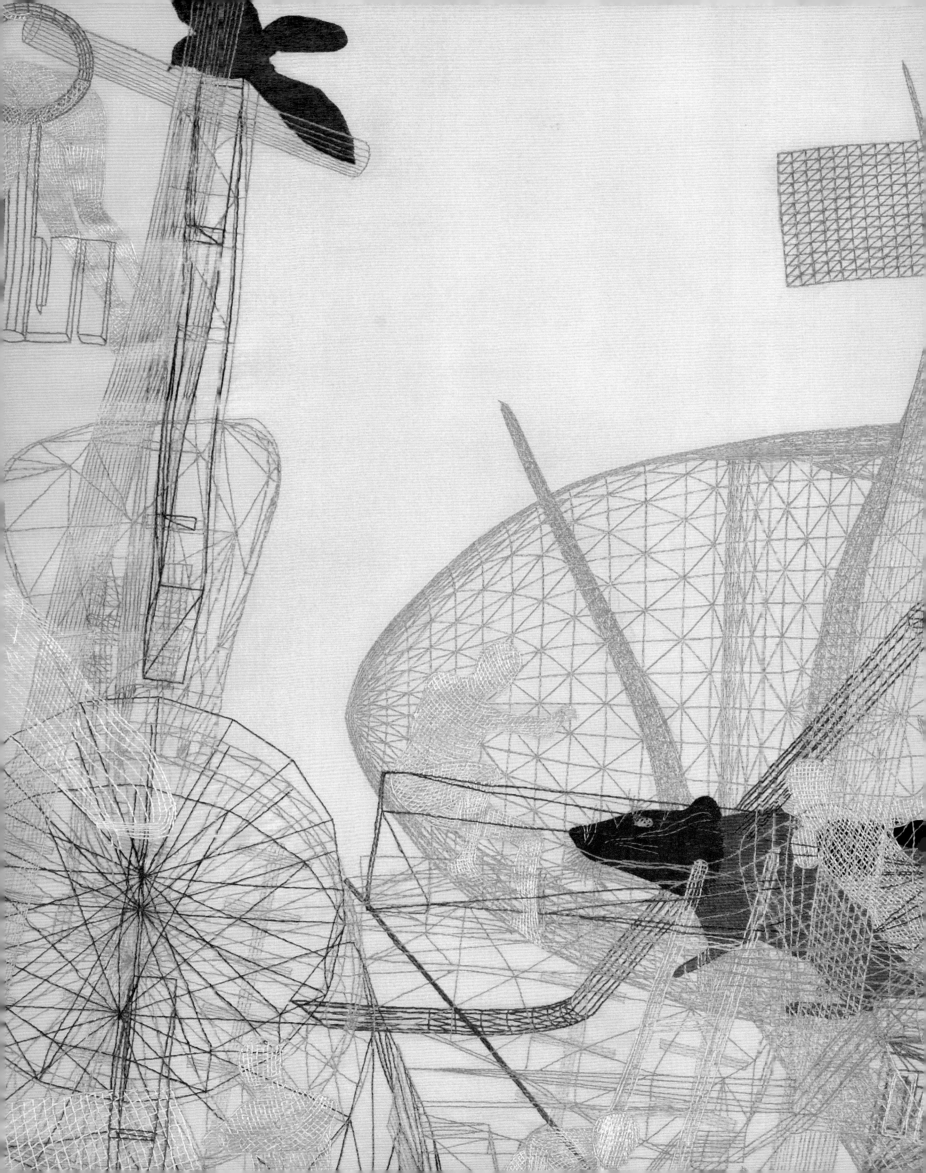

Fall, 2008
Embroidery on silk, 114 x 304 cm

Abandon, 2008
Embroidery on silk, 114 x 304 cm

SIEGFRIED ZIELINSKI

DISCOVERING THE NEW IN THE OLD:
THE EARLY MODERN PERIOD AS A POSSIBLE WINDOW TO THE FUTURE?
NEUES IM ALTEN ENTDECKEN:
DIE FRÜHE NEUZEIT ALS MÖGLICHES FENSTER IN DIE ZUKUNFT?

ON MIAO XIAOCHUN'S RENAISSANCE TRILOGY
THE LAST JUDGMENT IN CYBERSPACE / H2O / MICROCOSM

I.

Concepts that dramatically announce paradigmatic changes in thought and artistic creation are short-lived as a rule. At the start of the third millennium, hardly anybody still speaks of postmodernism, which as a concept had so shaped the 1970s and 1980s of the Western world. A half-life of fifteen to twenty years is very little in the energy balance of the theory market.

When postmodernism was all the rage, critics and cultural philosophers were using this concept to react to the deep insecurity that they felt in face of the saturation of life conditions with new electronic and digital technologies. Whatever was classified as a later deposit as an identification with the material seemed impossible to rescue. It necessarily culminated in the dead-end of the zero dimension of algorithmic world construction. The consequence propagated was the complete dissolution of everything corporeal in abstraction, from which there was no escape. "The scourges of the present are not cancer, not AIDS," as Berlin philosopher and anthropologist Dietmar Kamper summed up in an interview in 1989. "We are dying an audiovisual death, drowning in a flood of images without any longer having experienced lives ourselves, understanding sensuality with our own bodies."[I] At this point in time, a video recorder in the People's Republic of China was a valuable commodity. It cost 25 times the average monthly income in the PRC, around 2,500 Yuan. Four years later, the price went up to 6,000 Yuan, or 1,800 USD, for a single video recorder.[II]

Miao Xiaochun is an artist who is not left awestruck in the face of new technologies for the creation of images and sounds and in confrontation with cultural pessimism. For at least a decade, he has been taking up the challenge of understanding the zero dimension of number as a necessary passage to a possibly other quality of experience. From the abstraction of mathematical rows, in combination with machines new concretizations can be gained, even if they are not identical to those familiar from sensual perception. Vilém Flusser, a Jewish philosopher from Prague, the city of alchemists, responded in an extreme formulation to the apocalyptic horsemen of theory with the harsh formulation that the digital image could be understood as an answer to Auschwitz. After the final death of God in the Nazi murder camps, it was possible for a new inventive power to grow from abstraction with the help of algorithmic machines, a power we still need to master. This goes beyond the concept of a *post-histoire* and contains at least in part the idea of the present as a prior period. It tries to react to what might still come, and not just to what has already been.

I

Das Auge: Zur Geschichte der audiovisuellen Technologie. Narziss, Echo, Anthropodizee, Theodizee. Dietmar Kamper im Gespräch mit Bion Steinborn, Christine v. Eichel-Streiber, in: *Filmfaust* 74 (1989), 31.

II

According to a study by Ling Chen, which I commissioned in 1988 a Technische Universität Berlin. The author based his estimate on information from Xinhua, the Chinese news agency.

But this in turn is only possible by moving through the experience of history. A fundamental premise of an-archeology is that the avant-garde is nothing but the inventive (re) appropriation of the past. With the discovery, research, and transformation of whatever can be found in the deposits of historical processes, for centuries we have written the future from our respective standpoint. With the paintings that Miao Xiaochun has chosen for his trilogy to engage with European art of the early modern period, the Chinese artist makes clear that the transformations in Europe of the sixteenth century were from a time that was preparing for what was to come. Michelangelo, Hieronymus Bosch, and Lucas Cranach (the Elder) were in their day courageous visionaries, not speculators turned toward the past. In visual terms, they were among the pioneers of a European modernity that were shaped by the hegemony of the natural sciences and a physics of the visible. A passage through their work allowed Miao Xiaochun to open the present for the future.

II.

The idea of the microcosm is necessarily bound to the idea of the macrocosm. In its origin and in their development, the two ideas are like two sides of the same coin. They are inseparably linked to one another, for at issue here is a mutual interrelationship. The microcosm is the projection of the very large, that which surpasses human existence, onto the Lilliputian world in the sublunary realm. Conversely, the macrocosm is the projection of the inner relationships that constitute people bio-logically and psycho-logically onto the endless expanse of the universe.

Aristotle developed the term microcosm in his thoughts on physics. He took the idea from his teacher Plato, who formulated it in the dialog Philebus. Both Greek masters were implicitly referring back to the worldview of the school of Pythagoras. He is the secret father figure of all those in Europe who generate art with algorithms, regardless of whether we are dealing with sounds or images. The composer Xenakis once said that all computer artists are basically Pythagoreans.

For Pythagoras, number was the medium through which the relationship between the small and the large was mediated. For him, both the individual on earth and totality in space were shaped by relationships of divine harmony. Well-proportioned relations are measurable between their single components; here as well as there they can be expressed in definable distances, that is, in mathematics and geometry. The core of the Pythagorean worldview is lovely simplicity, the triviality of consonance, which in music theory based on the basic intervals octave, fifth, and fourth, from which the more complicated relations of consonance and dissonance are derived.

By working with the *Garden of Delights* by Hieronymus Bosch from the early sixteenth century, Miao Xiaochun reaches back into the depths of European culture, the Christian Middle Ages. The abbess Herrad von Landsberg created an impressive picture for the moral instruction of her fellow sisters around 1170/80. It bears the title *Hortus Delicarum* (The Garden of Delights). Those hoping for eternal life, the Christian adepts, move uneasily up a ladder between the evil below and the good above. In their dangerous and

difficult ascent, they are on the one hand attacked by the deadly arrows of dark demons and on the other hand protected by guardian angels and kept from falling. Seductive evil in Herrad von Landsberg's image simply appears in the guise of the everyday: property, comfort, and desire are illustrated with gold coins, a castle, a restful bed, and a beautiful woman. What dramatically takes place between heaven and earth, between the hellish maws of the dragon on the one hand and the stretched out hand of God as a mediator to the world beyond on the other, is nothing other than life itself.

This also defines the large centerpiece in Hieronymus Bosch's triptych. Miao Xiaochun staged the endless facets of earthly existence not in strict verticals like Herrad von Landsberg, but, like Bosch, predominantly in the horizontal, as an exuberant dance on different earthly plateaus, or better: deceptively idyllic volcanoes that form at the same time individual dynamic thematic fields: transportation that developed from fast horsemen and with the help of technical devices mutated to a roaring, no longer controllable traffic: the natural sciences, architecture, desire, and always in this special work, war, the presence of technology as dangerous destruction.

The splendid orgy of simulated images seems initially to be formed from the firmament, out of the endless macrocosm. The *Fiat lux!* (Let there be light!) of the Christian myth of creation is impudently animated—here meaning so much as "given a soul"—the stars on the nightly sky transform into letters spelling out the name of the artist. With these digital letters, first the title *Microcosm* is formulated, and then the apple of the tree of knowledge. Adam has already bitten into the forbidden fruit: paradise is lost forever and cannot be recreated, at least not outside our imagination. This is clear from the very beginning.

God cannot be represented and cannot be written, only as JHWH (Yahweh), the name of God. Clearly, the artist Miao Xiaochun is playing God in the sense of the European myth of creation. With the help of his inventive power, computer science, and a Mac that uses the bitten apple as an omnipresent icon and trademark, he creates the world anew, at least in the image on the computer screen. The apple multiples immediately in mass production, is cloned in endless seeming duplications, like all the other figures in Miao Xioachun's work trilogy. There are no longer any originals. From the fruit of the tree of knowledge, we have arrived at a game with the commands written in binary code. An anthropomorphic machine can read endless series of zeroes and ones, tossing them out one after the other as commands into the sky. The apparatus generates what we call civilization to the wild applause of an anonymous audience. Powerful Wagnerian sounds announce greatness, the superman, *Gesamtkunstwerk*. Miao Xiaochun immediately gives this an ironic turn. Increasingly, the rhythm of taps on a keyboard comes through acoustically. Creation here means programming and typing.

The creative drive of the computer and its sorcerer's apprentice at the keyboard is increasingly running amok. What were once paradisiacal idylls are becoming nightmares, traffic collapses, bows and arrows mutate into helicopters, bombs, and rockets, desire is locked in fatal lethargy; in brief, an earthly hell develops. Referring to the Human Genome Project of US doctors, the human body is cut slice for slice like a salad

cucumber so that it can be decoded entirely into its genetic code. Music, dance, play: the media of entertainment are invented and formatted to compensate for the constant experience of lack. At the end of the audiovisual marathon, everything that technological intelligence has created is tossed onto the struggling individual, including the framed painting of Hieronymus Bosch and a kinetic structure of monitors that seems like an early robot by Nam June Paik. Media art too has long become part of the cosmic trash flying through space.

But the video does not end with this apocalyptic vision of a failed technical rationality. Everything that exists in extension is ultimately transformed back into the cosmic egg, the original material of the Hermetics, before it was analytically segmented and mixed. This is a powerful image from the world of alchemy. The *prima materia* symbolized by the egg in Europe is called *tai chi* in the Chinese tradition. The digital has become the analog pendant to the alchemistic formula of gold. Paradise as an invention of the mind disappears, dissolves with its implosion. This is the actual conclusion of the video work. Material returned to the origin can undertake new divisions and mixtures: separation seems possible at anytime.

With his *Microcosm*, Miao Xiaochun has created a huge sound-image in time. Over 15 minutes long, this exemplary story of civilization develops from the machine and spits carefully out hundreds of millions of organized pixels. *Microcosm* exists in visual elements, as frozen moments in the form of analog and digital drawings.
But the rapid movement can only finally develop as a large projection in an endless loop and in generous space. I saw the work in this format in 2009 in the huge belly of the Oriental Pearl Tower, the 468-meter high radio and television tower in Pudong, Shanghai's new busy center. On the skyscrapers outside, electronic messages for new commodity worlds, services, and artificial paradises of all kinds flicker in the nocturnal sky over the powerfully heat up metropolis in the far east of China.

"The everyday video fever is spreading unnoticeably in Shanghai": these words appeared in *Xinmin Wanboa*, a Shanghai evening newspaper, at the start of 1988, twenty years before Miao Xiaochun's *Microcosm* emerged. "It was a dream to see yourself in the future in a picture from today."[III]

III.

Art critics and art historians have a hard time in light of simulated worlds like the one Miao Xiaochun creates and which he has been teaching for ten years at Beijing's Central Academy of Fine Arts. Although they have learned to think about the mutual relationship between mathematics and painting or sculpture, the shameless surfaces generated from algorithms are highly suspect to them. Established art history tried to appropriate these new phenomena in international art by way of a ruse. It simply claims that artists who work with advanced technological means of production are not creating anything really new, but something already notoriously familiar is only being given new clothes. Images in which the beholder can immerse him or herself from various perspectives, so-called virtual realities, what a laughable concept! This echoed from Florence, Rome,

III
Quoted from Ling Chen's study, March 1988, 3.

Paris, and Madrid, where the treasures of Europe's cultural identity are carefully guarded. Michelangelo Buonarroti realized just that in the ceiling fresco of the Sistine Chapel of the Vatican five hundred years ago, and much more perfectly, and most importantly, more beautifully! Total immersion has always been the declared goal of an aesthetics based in Aristotle.

But these are primarily despairing gestures of self-assertion made by a special intellectual caste. By the early 1990s, at the latest, art history and art criticism found themselves quite behind when it came to an experimental artistic practice that they slept through entirely and that raced past them like a speeding train. They already had significant difficulties when they were confronted with the time-based art practices of Fluxus and performance, because these phenomena could not be slipped into a slide and analyzed as a two-dimensional surface. They were just barely able to recognize film and photography as artistic media. Now images emerged that needed no reference in the world outside the frame, that do not even need a standard material to be able to express itself to others. Monitors, a fleeting projection, loudspeakers would suffice. With antiquated thought prostheses like the propagation of an iconic turn or visual studies as a new master discipline that would be responsible for all that has become pictorially visible in two, three, or four dimensions, they tried to rescue themselves into the future.

Art that works with progressive media necessarily has a discursive character. It also deals with the understanding of the arts and their various perceptions. Just as every good artistic film is always also a treatment on the cinema and tries to add something to its history. With his trilogy on the resplendence of European images from the early modern period, the Chinese artist, who in the second half of the 1990s studied art in the Documenta city of Kassel, walks right into this discourse and comments upon it with the confidence of a young intellectual who comes from a culture whose deposits of civilization reach much further back in history than those of Europe. A camera obscura, for example, with the help of which objects illuminated with light can be projected from the outside world into a dark chamber, and whose invention the European Renaissance still claims as its own, was described quite precisely in the text canon of the Mohists in the fourth century before Christ.

The Last Judgment in Cyberspace opens Miao Xiaochun's trilogy in the middle of the first decade of the third millennium of the Common Era. Already in the title, the artist reveals that his artificial world is at least threefold in historical terms. It has the obvious reference to the high art of the late Renaissance, one of the most outstanding frescoes of art history, *The Last Judgment*, which Michelangelo worked on for eight years until utter exhaustion (1533–1541). At the same time, it operates quite within the worldview and technology of the present; and it points with a clear gesture towards a time still to come, when computers are as self-evidently part of our environment as electricity is today.

Miao Xiaochun's attitude to art history stands for the radical reversal of the boring premise of the old always already contained in the new. He turns this perspective around, discovering the new in the old. He undertakes a form of prospective archaeology. In moving through the past, he shows us how the world someday might look.

The consummation of Renaissance painting and architecture that Michelangelo's late addition to the staging of the dome of the Sistine Chapel represents becomes in the interpretation of the Chinese artist at the same time the starting point for a notion of the subject as it began to develop in the seventeenth century with the beginning of modernity and the hegemony of the natural sciences. The many figures that populate the scene are already in Michelangelo well-proportioned phenomena of the manifold only on first glance. The master interprets the day of the Last Judgment as one of vengeance and fury: *Dies irae, dies illa*. The figures that populate the scene are despairing and rejected. The merciless wheel of divine power (and its representatives on earth) did not allow these figures to become new sovereigns, but subjects in the direct sense of the word: subjected, subordinated. René Descartes formulated his concept of man as divine automaton around one hundred years later: they function and suffer monstrously in their functioning, an endless cycle of violation/sin and punishment. At the foot of the painting, behind the altar of the Vatican chapel, each new pope has been elected for the past 130 years.

By taking his own exact measurements and inserting a calculated image of his physiognomy in place of Michelangelo's painting—a kind of geometrical physiogram—Miao Xiaochun has taken the dissolution of the Renaissance ideal to its radical extreme. In the world of clones, there are no longer any originals. Behind the masks of sameness there remains only a suspicion of something consistent that, however, can no longer be identical with itself. *Always the same, but never myself*, to reverse an advertising slogan from the past *fin des siècle* that the advertising experts of Calvin Klein had invented for the brand's existentialism from the bottle—in a campaign featuring of all people Kate Moss, the princess of artificial paradises, as Charles Baudelaire called the world of drugs. The time after the subject has recognized that it was never was complete and assumes that it never will be whole. The only originary aspect of Miao Xiaochun's *Last Judgment* is the possible relationship of the individual cloned characters to one another, a relation that the artist can randomly alter. The particular, the sensational has slipped to the relational, become flexible, black and white, an abstraction. From here, after the *Last Judgment* the artist will push forward to the equally colorful *Garden of Delights*, and finally rejuvenate himself in the *Fountain of Youth*.

The classical subject begins to dissolve entirely in this process: Miao Xiaochun stages this in a dimension that he refers to as that of the future. "Where will I go?" is the essential video component of his *Last Judgment in Cyberspace* that sums up the silent work. The large format computer prints (C-prints) freeze time, like photography. They are momentary shots, gained from a complex movement. This is paradoxical for the computer, because it is a time machine par excellence. Everything that is seen on the monitor takes place in the moment of beholding, oscillates: it is frequency, a processed image in time. When the computer is turned off, the phenomenon disappears. In electronic and even more so in digital video, an art that sees itself as a temporal art is at one with itself. The figures become temporary existences in perception as well. The space expanded into the endless between them becomes a mechanically generated eternity AION, as the Greeks said, or GOD as the fastest way from zero to infinity, as the paraphysician and eccentric dramatist Alfred Jarry put it.

Cyberspace is not a reality that can be called objective. Created by algorithms, after its transformation into the sensually perceptible it is an experience in the first person, that is, of an entirely subjective nature. To be able to move within it using our dull senses, we need crutches, technical aids. Just as for example Christian religion needed the heavenly ladder as prosthesis to provide an image of the ascent of the human soul to the heavenly and the descent of the angels as messengers of God. The floating figures of Miao Xiaochun have long since lost the floor beneath their feet. They too used prostheses in continuous space, the ladder, the cog as a master artifact of mechanics, the boat, the bundled arrows that in European mythology stand both for the power of destruction as well as the capacity for insemination and can be found in countless allegoric representations of electricity, especially in the founding age of the newest media, the late nineteenth century.

IV.

The reference in art history for the 2007 series of computer-simulated visual sequences on water—H2O—is Lucas Cranach (the Elder)'s painting *The Fountain of Youth* from the mid-16th century. Forever young: the scene represented here tells of the longing to dispose of the cumbersome physical shell of one's own existence and to be able to immerse oneself in eternal life.

The image of Cranach's painting is divided into three parts, without taking on the form of a triptych. In the left part of the image, decidedly old women are being carted to a bathing pool. The basin is occupied by Amor and Venus, who lend the water the transmuting power of rejuvenation. On the right hand side, the figures emerge from the bath as young women. They enter a time in which they are newly clothed and adorned for the pleasurable sensations that they now can experience once again.

The pool or fountain with the water in the middle fulfills the function of a medium par excellence. Transformation is only possible by passing through the fluid element as prepared by the gods of love. Water takes on a function similar to that held by electricity in the media discourse of the Enlightenment. At the limit of materiality and its dissolution of the same, it embodies the power of transformation. It is the central phenomenon and original life elixir. Once electrified, bodies can become immortal, quite in the sense that Juliette emerged at the zenith of the Enlightenment in de Sade's famous double novel from 1792 (*Justine et Juliette*)—constantly electrified by immersing herself in evil and moral depravity.

In cybernetic space, there can be constant youth, because this space knows no physicality. It can constantly be created anew in image and time and animated with figures, so long as the current flows. Here, paradise can reemerge as painted by Hieronymus Bosch. In cybernetic space, the Last Judgment has already taken place.

But in the artistic fiction, H2O represents the logical conclusion of Miao Xiaochun's trilogy. It envisions a time after the media. The electrical no longer provides any sensations

for the living. Water is the most valuable raw material of all that is Bios [βιοσ]. The earthly Lilliputians have disregarded it across the centuries, allowing it to become an extreme scarcity. The People's Republic of China today is already starting to suffer from this.

Miao Xiaochun's idiosyncratic adaptations and interpretations of masterworks of European art from the early modern period are shameless in a direct sense. With no shame, he parades our own art history before us and at the same time opens our own present in a playful manner for a possible future of (art) history that might have already been its past. Only an artistic personality that comes from a culture rooted so deep in time like that of China and—despite all the references to the European—one that also works with this awareness can achieve something of this kind.

ZU MIAO XIAOCHUNS RENAISSANCE-TRILOGIE:
THE LAST JUDGMENT IN CYBERSPACE / H2O / MICROCOSM

I.

Begriffe, die marktschreierisch paradigmatische Wenden im Denken und im künstlerischen Schaffen ausrufen, sind in der Regel kurzlebig. Zu Beginn des dritten Millenniums spricht kaum mehr jemand von der Post-Moderne, die als Konzept die späten 1970er und 1980er Jahre der westlichen Welt so sehr geprägt hat. 15 bis 20 Jahre Halbwertszeit sind extrem wenig im Energiehaushalt des Theoriemarktes.

Als die Post-Moderne Konjunktur hatte, reagierten Kritiker und Kulturphilosophen mit diesem Begriff auf die tiefe Verunsicherung, der sie sich mit der Durchdringung der Lebensverhältnisse durch neue elektronische und digitale Technologien ausgesetzt fühlten. Was als der Identifikation mit dem Materiellen nachgelagert eingestuft wurde, schien nicht mehr zu retten. Es endete zwangsläufig in der Sackgasse der Nulldimension algorithmischer Weltkonstruktion. Eine komplette Auflösung alles Körperhaften in der Abstraktion, aus der es kein Entrinnen gab, war die propagierte Folge. „Nicht Krebs, nicht Aids sind die Geißeln der Gegenwart", brachte der Berliner Philosoph und Anthropologe Dietmar Kamper diese Weltanschauung in einem Interview 1989 radikal auf den Punkt. „Wir sterben den audiovisuellen Tod, ertrinken in einer Flut von Bildern, ohne mehr Leben selbst erfahren, Sinnlichkeit am eigenen Körper begriffen zu haben."[IV] Zu diesem Zeitpunkt war ein Videorekorder in der Volksrepublik China äußerst wertvolles Handelsgut. Er kostete das 25-fache des durchschnittlichen Monatseinkommens in der VR China, etwa 2.500 Yuan. Vier Jahre zuvor waren es sogar noch 6.000 Yuan, damals ca. 1.800 US-Dollar, die man für einen Videorekorder benötigte.[V]

Miao Xiaochun gehört zu denjenigen Künstlern, die im Angesicht der neuen Technologien für die Herstellung von Bildern und Tönen und in der Konfrontation mit kulturpessimistischen Weltanschauungen nicht erstarren. Mindestens seit einer Dekade nimmt er die Herausforderung an, die Nulldimension der Zahl als einen notwendigen Durchgang zu einer möglichen anderen Qualität von Erfahrung zu begreifen. Aus der Abstraktion mathematischer Reihungen können in der Verbindung mit Maschinen neue Konkretisierungen

IV
Das Auge – Zur Geschichte der audiovisuellen Technologie. Narziss, Echo, Anthropodizee, Theodizee. Dietmar Kamper im Gespräch mit Bion Steinborn, Christine v. Eichel-Streiber, in: FILMFAUST, Heft 74, 1989, S. 31.

V
Nach einer Untersuchung Ling Chens, die ich 1988 an der Technischen Universität Berlin in Auftrag gab. Der Autor bezog sich in den Daten auf die Agentur Neues China.

gewonnen werden, auch, wenn diese nicht identisch sind mit denen, die unserer sinnlichen Wahrnehmung vertraut sind. Der aus Prag, der Stadt der Alchimisten, stammende jüdische Philosoph Vilém Flusser konterte in extremer Zuspitzung die apokalyptischen Reiter der Theorie mit der harschen Bemerkung, das digitale Bild wäre als eine Antwort auf Auschwitz zu begreifen. Nach dem endgültigen Tod Gottes in den Mordlagern der Nazis könnte mit Hilfe algorithmischer Maschinen aus der Abstraktion heraus eine neue Einbildungskraft erwachsen, in die wir uns noch einzuüben hätten. Das geht über das Konzept einer Post-Histoire hinaus und enthält zumindest im Ansatz die Idee der Gegenwart als einer *Vor*-Zeit. Es versucht darauf zu reagieren, was kommen mag, und nicht nur darauf, was bereits gewesen ist.

Das geht aber wiederum nur durch die Erfahrung von Geschichte hindurch. Eine anarchäologische Grunderkenntnis ist, dass Avantgarde nichts anderes als eine erfindungsreiche (Wieder)Aneignung von Vergangenem bedeutet. Mit der Entdeckung, Erforschung und Transformation dessen, was man in den Ablagerungen der historischen Prozesse finden kann, wird seit Jahrhunderten vom jeweiligen Standpunkt aus Zukunft geschrieben. Mit den Gemälden, die Miao Xiaochun für seine Trilogie zur Auseinandersetzung mit der europäischen Kunst der frühen Neuzeit ausgesucht hat, macht der chinesische Künstler deutlich, dass die Aufbrüche des Europas im 16. Jahrhundert zu einer Zeit gehörten, die auf Kommendes vorbereitete. Michelangelo, Hieronymus Bosch und Lucas Cranach (der Ältere) waren in ihrer Zeit mutige Visionäre und keine rückwärts gewandten Spekulanten. In bildlicher Hinsicht gehörten sie zu den Wegbereitern der europäischen Moderne, die durch die Hegemonie der Naturwissenschaften und eine Physik des Sichtbaren geprägt wurde. Der Durchgang durch ihr Werk ermöglichte Miao Xiaochun, die Gegenwart für die Zukunft zu öffnen.

II.

Die Idee des Mikrokosmos ist notwendig an die Idee des Makrokosmos gebunden. In ihrer Herkunft und in ihrer Entwicklung funktionieren beide Ideen wie die zwei Seiten einer Medaille. Sie sind unauflösbar miteinander verknüpft, denn bei der Idee geht es um ein Wechselverhältnis. Der Mikrokosmos ist die Projektion des ganz Großen, desjenigen, was die menschliche Existenz überschreitet, auf die Welt der Däumlinge im sublunearen Bereich. Umgekehrt ist der Makrokosmos die Projektion der inneren Beziehungen, die den Menschen bio-logisch und psycho-logisch ausmachen, in die unendliche Weite des Universums hinein.

Aristoteles hat das Wort Mikrokosmos in seinen Betrachtungen zur Physik geprägt. Die Idee hat er von seinem Lehrer Platon entnommen, der sie im Dialog *Philebus* formulierte. Beide griechischen Meisterdenker rekurrierten implizit auf die Weltanschauung der Schule des Pythagoras. Er ist die heimliche Vaterfigur aller derjenigen, die in Europa Kunst mit Algorithmen generieren, ganz gleich, ob es sich um Klänge oder Bilder handelt. Der Komponist Xenakis sagte einmal, im Grunde wären alle Computerkünstler Pythagoräer.

Für Pythagoras war die Zahl das Medium, durch das sich die Beziehung zwischen dem Kleinen und dem Großen vermittelt. Das Einzelne auf der Erde und die Gesamtheit im All

waren für ihn durch Verhältnisse göttlicher Harmonie geprägt. Die wohlproportionierten Relationen zwischen ihren einzelnen Bestandteilen sind messbar, hier wie dort, sie lassen sich in definierbaren Entfernungen ausdrücken, also durch Mathematik und Geometrie. Der Kern des pythagoräischen Weltbildes ist die schöne Einfachheit, die Trivialität der Konsonanz, in der Musiktheorie basierend auf den Grundintervallen Oktave, Quinte und Quarte, aus denen die komplizierteren Verhältnisse der Konsonanz und Dissonanz abgeleitet sind.

Indem er den *Garten der Lüste* des Hieronymus Bosch aus dem frühen 16. Jahrhundert als *Microcosm* bearbeitet, spannt Miao Xiaochun thematisch den Bogen weit in die Tiefenzeit europäischer Kultur, hin zum christlichen Spät-Mittelalter. Die Äbtissin Herrad von Landsberg, fertigte zur moralischen Unterweisung ihrer Mitschwestern um 1170/1180 ein eindrucksvolles Bild an. Es trägt den Titel *Hortus Deliciarum [Der Garten der Lüste]*. Die Anwärterinnen auf das Ewige Leben, die christlichen Adepten, bewegen sich in diesem Bild auf einer Leiter strauchelnd zwischen dem bösen Unten und dem erstrebten guten Oben. Bei ihrem gefährlichen und mühsamen Aufstieg werden sie einerseits von dunklen Dämonen mit tödlichen Pfeilen beschossen und andererseits von lichten Schutzengeln hilfreich gestützt und vor dem Fall bewahrt. Das verführerische Böse erscheint bei Herrad von Landsberg schlicht im Gewand des Alltäglichen: Besitz, Bequemlichkeit, Begierde werden illustriert durch Goldmünzen und eine Burg, ein Ruhebett und eine schöne Frau. Was sich demnach zwischen dem höllischen Drachenschlund einerseits und der ausgestreckten Hand Gottes als Mittler zum Jenseits andererseits – also zwischen Himmel und Hölle – dramatisch ereignet, ist das Leben und nichts als das Leben.

Das bestimmt auch den großen Mittelteil im Triptychon des Hieronymus Bosch. Miao Xiaochun inszeniert die unendlichen Facetten irdischer Existenz nicht in der strengen Vertikalen wie Herrad von Landsberg, sondern, wie Bosch, vorwiegend in der Horizontalen, als ausufernden Tanz auf verschiedenen irdischen Plateaus oder besser: trügerisch idyllischen Vulkanen, die bei ihm zugleich einzelne dynamische thematische Felder bilden: der Transport, der sich aus den schnellen Reitern heraus entwickelte und mit Hilfe technischer Apparate zum tosenden, nicht mehr beherrschbaren Verkehr mutiert; die Naturwissenschaft, die Architektur, das Begehren und, immer wieder in dieser besonderen Arbeit: der Krieg, die Anwesenheit von Technik als gewaltsame Zerstörung.

Die prächtige Orgie aus simulierten Bildern scheint zu Beginn aus dem Firmament, aus dem unendlichen Makrokosmos heraus geformt zu werden. Das „fiat lux!" [„Es werde Licht!"] des christlichen Schöpfungsmythos wird in einer frechen Anmutung animiert (was soviel heißt wie beseelt): die am nächtlichen Himmel funkelnden Sterne verwandeln sich in einen Text, aus dem der Name des Künstlers buchstabiert wird. Aus den digitalen Lettern wird zunächst der *Microcosm* als Titel formuliert und sodann der Apfel des Baums der Erkenntnis geschleudert. Adam hat bereits in die verbotene Frucht hinein gebissen; das Paradies ist unwiederbringlich verloren und nicht noch einmal herstellbar, zumindest nicht außerhalb der Imagination. Das ist von Anfang an klar.

Gott kann man nicht darstellen und nicht schreiben, nur als JHWH (JAHVE), den Namen Gottes. Ganz offensichtlich spielt der Künstler Miao Xiaochun hier Gott im Sinn des euro-

päischen Schöpfungsmythos. Mit Hilfe seiner Einbildungskraft, der Informatik und einem Macintosh, der den angebissenen Apfel als allgegenwärtiges Icon und Markenzeichen benutzt, erschafft er die Welt neu, zumindest im Bild auf dem Computerbildschirm. Der Apfel vervielfältigt sich sofort in Massenproduktion, wird geklont, wie alle anderen Figuren in dieser Werktrilogie Miao Xiaochuns ständig in unendlich erscheinenden Vervielfältigungen geklont werden. Es gibt keine Originale mehr. Aus der Frucht vom Baum der Erkenntnis entsteht das Spie mit den im binären Code verfassten Befehlen. Eine anthropomorphe Maschine liest urendliche Reihen aus Nullen und Einsen, schleudert sie als Befehle in den Himmel. Fortwährend generiert der Apparat unter dem tosenden Beifall eines anonymen Publikums das, was wir Zivilisation nennen. Mächtige Wagner'sche Klänge künden von Größenwahn, Übermensch und Gesamtkunstwerk. Miao Xiaochun bricht dies sofort ironisch. Immer stärker setzt sich akustisch der klackernde Rhythmus der angeschlagenen Tasten des Keyboards durch. Schöpfung bedeutet hier Programmieren und Schreiben.

Der Schaffensdrang der Rechenmaschine und ihres Zauberlehrlings an der Tastatur läuft zunehmend Amok. Aus den anfänglichen paradiesischen Idyllen werden Albträume, der Verkehr kollabiert, aus Pfeil und Bogen mutieren Helikopter, Bomben und Raketen, die Begierde ist in fataler Lethargie eingeschlossen, kurz: die irdische Hölle entfaltet sich. In Referenz auf das Human Genome Project nordamerikanischer Mediziner wird der menschl che Körper scheibchenweise zerlegt wie eine Salatgurke, damit man ihn in seinen genet schen Codes vollständig entziffern kann. Musik, Tanz, Spiel: die Unterhaltungsmedien werden erfunden und formatiert, um die ständige Mangelerfahrung zu kompensieren. Am Ende des audiovisuellen Marathons kippt aus dem All alles das, was d e technologische Intelligenz erschaffen hat, auf den fliehenden Einzelnen herab, einschließlich der gerahmten Gemälde des Hieronymus Bosch und eines kinetischen Gebildes aus Monitoren, das wie ein früher Roboter Nam June Paiks anmutet. Auch die Medienkunst ist längst Teil des durch das All fliegenden kosmischen Mülls geworden.

Doch mit dieser apokalyptischen Vision einer gescheiterten technischen Rationalität endet das Video nicht. Alles, was ausgedehnt existiert, wird schließlich zurückverwandelt in das kosmische Ei, die ursprüngliche Materie der Hermetiker, bevor sie analytisch zerteilt und gemischt worden war. Das ist ein starkes Bild aus der Alchimie. In der chinesischen Tradit on heißt die prima materia, die in Europa durch das Ei symbolisiert wirc, das Tai Chi. Das Digitale ist die analoge Entsprechung zur alchemistischen Formel für Gold geworden. Das Paradies als (Aus)Geburt des Kopfes verschwindet, löst sich auf mit dessen Implosion. Das ist der eigentliche Schluss der Videoarbeit. Aus der zum Ursprung zurück gekehrten Materie heraus können neue Zerteilungen und Mischungen vorgenommen werden; die Entmischung scheint jederzeit möglich.

Miao Xiaochun hat mit seinem *Microcosm* ein gewaltiges Ton-Bild in der Zeit geschaffen. Über 15 Minuten lang entfaltet sich diese exemplarische Geschichte der Zivilisation aus der Maschine und spuckt ihre Hunderte Millionen sorgfältig organisierter Pixel aus. Der *Microcosm* existiert in einzelnen bildlichen Elementen, als eingefrorene Momente in der Form von analogen und digitalen Zeichnungen. Aber erst als große Projektion in der Zeitschleife eines endlosen Loops und in einem generösen Raum vermag sich die rasende Bewegung zu entfalten. Ich sah die Arbeit 2009 in diesem Format im riesigen Bauch des

Oriental Pearl Tower, des 468 Meter hohen Radio- und Fernsehturms in Pudong, im neuen geschäftigen Zentrum von Shanghai. Auf den Wolkenkratzern draußen flimmerten auf Hunderten von Quadratmetern die elektronischen Botschaften für die neuen Warenwelten, Dienstleistungen und künstlichen Paradiese aller Art in den nächtlichen Himmel über der mächtig erhitzten Metropole im fernen Osten Chinas.

„Das alltägliche Video-Fieber breitet sich in Shanghai unauffällig aus", schrieb Xinmin Wanbao, eine Shanghaier Abendzeitung, Anfang 1988, 20 Jahre bevor Miao Xiaochuns *Microcosm* entstand. „Es war ein Traum, sich eines Tages in der Zukunft in einem Bild von heute wieder zu sehen."[VI]

III.

Kunstkritiker und Kunsthistoriker tun sich immer noch schwer angesichts derartiger simulierter Welten, wie sie Miao Xiaochun herstellt und seit zehn Jahren an der zentralen Kunstakademie von Peking auch unterrichtet. Obgleich sie seit Jahrhunderten das Wechselverhältnis von Mathematik und Malerei oder Skulptur zu denken gelernt haben, sind ihnen die unverschämten Oberflächen, die aus Algorithmen erzeugt werden, höchst suspekt. Die etablierte Kunstgeschichte versuchte, die neuen Erscheinungen in der internationalen Kunst mit einem Trick zu vereinnahmen. Sie behauptet einfach, dass die Künstler, die mit den avancierten technischen Produktionsmitteln arbeiten, nichts wirklich Neues schaffen würden, sondern dem bereits sattsam Bekannten lediglich neue Kleider verliehen. Bilder, in die man aus unterschiedlichen Perspektiven regelrecht eintauchen kann, so genannte virtuelle Realitäten – welch ein lächerliches Konzept!, so skandierten sie zwischen Florenz, Rom, Paris und Madrid, wo die Schätze der künstlerischen Identität Europas argwöhnisch bewacht werden. Das hat Michelangelo Buonarroti im Deckenfresko der Sixtinischen Kapelle des Vatikans doch schon vor einem halben Jahrtausend realisiert und viel perfekter – und vor allem schöner – gemacht! Die totale Immersion ist schon immer das erklärte Ziel einer Ästhetik gewesen, die aristotelisch basiert ist!

Das sind vor allem verzweifelte Gesten der Selbstbehauptung eines besonderen intellektuellen Standes. Spätestens zu Beginn der 1990er Jahre gerieten Kunstgeschichte und Kunstkritik stark ins Hintertreffen angesichts einer experimentellen künstlerischen Praxis, die sie gründlich verschlafen hatten, und die wie auf einem rasenden Zug an ihnen vorbei fuhr. Mit den zeitbasierten Kunstpraxen des Fluxus und der Performance hatten sie schon beträchtliche Schwierigkeiten, weil ihre Phänomene nicht in einen Diarahmen einzuklemmen waren, um sie als zweidimensionale Oberflächen analysieren zu können. Gerade einmal hatten sie verkraftet, dass man den Film und die Fotografie als nach Möglichkeit künstlerische Medien zu respektieren hätte. Nun entstanden Bilder, die prinzipiell keine Referenzen in der Welt außerhalb des Rahmens benötigten, die nicht einmal irgend ein herkömmliches Material brauchten, um sich für andere veräußern zu können; Monitore, eine flüchtige Projektion, Lautsprecher reichten. Mit antiquierten Gedankenprothesen wie der Propagierung eines Iconic turn oder einer Bildwissenschaft als neuer Meisterdisziplin, die zuständig für alles piktoral gewordene Sichtbare in zwei, drei und vier Dimensionen wäre, versuchten sie sich in die Zukunft zu retten.

VI
Zit. aus der Untersuchung Ling Chens vom März 1988, S. 3.

Kunst, die mit fortgeschrittenen Medien arbeitet, hat unvermeidlich einen diskursiven Charakter. Sie handelt auch vom Verständnis von Künsten und ihrer verschiedenen Wahrnehmungen; genauso wie jeder gute künstlerische Film immer auch eine Abhandlung über das Kino ist und seiner bisherigen Geschichte etwas hinzuzufügen versucht. Mit seiner Trilogie zur europäischen Bilderpracht der Frühen Neuzeit begibt sich der chinesische Künstler, der in der zweiten Hälfte der 1990er in der Documenta-Stadt Kassel Kunst studierte, mitten in diesen Diskurs hinein und kommentiert ihn mit der Souveränität eines jungen Intellektuellen, der aus einer Kultur stammt, deren zivilisatorische Ablagerungen in der Geschichte weit tiefer liegen als diejenigen Europas. Eine Camera obscura zum Beispiel, mit deren apparativer Hilfe man vom Licht beschienene Objekte der Außenwelt in einer dunklen Kammer projizieren kann, und deren Erfindung die europäische Renaissance immer noch für sich beansprucht, wird im Textkanon der Mohisten spätestens im vierten Jahrhundert vor Christus recht exakt beschrieben.

The Last Judgment in Cyberspace eröffnet die Trilogie Miao Xiaochuns in der Mitte der ersten Dekade nach dem Wechsel zum dritten Jahrtausend unserer Zeit. Schon im Titel legt der Künstler offen, dass seine artifizielle Welt in historischer Hinsicht mindestens dreifach programmiert ist. Sie hat den offensichtlichen Bezug zur hohen Kunst der Spät-Renaissance, zu einem der herausragenden Freskengemälde der Kunstgeschichte überhaupt: *Das Jüngste Gericht,* an dem Michaelangelo bis zur völligen Verausgabung acht Jahre (1533–1541) gearbeitet hatte; zugleich operiert sie ganz in der Weltanschauung und der Technik der Gegenwart; und sie verweist mit deutlichem Gestus in eine Zeit, die erst noch kommen mag. In ihr werden Computer so selbstverständlich zu unserer Umgebung gehören wie heute schon der elektrische Strom.

Miao Xiaochuns Haltung gegenüber der Kunstgeschichte steht für die radikale Umkehrung der langweiligen These vom Alten, das immer schon im Neuen enthalten ist. Er dreht diese Sichtweise um und entdeckt Neues im Alten. Er betreibt prospektive Archäologie. In der Bewegung durch die Vergangenheit hindurch zeigt er uns heute, wie die Welt einmal aussehen mag.

Die Vollendung der Malerei und Architektur der Renaissance, die Michelangelos späte Ergänzung zur Inszenierung des Gewölbes der Sixtina darstellt, wird in der Interpretation des chinesischen Künstlers zugleich Ausgangspunkt einer Vorstellung vom Subjekt, wie sie sich erst im 17. Jahrhundert, mit dem Beginn der Moderne und der Hegemonie der Naturwissenschaften, zu entfalteten begann. Die vielen Figuren, welche die Szene bevölkern, sind schon bei Michelangelo nur auf den ersten Blick wohlgeformte Erscheinungen der Mannigfaltigkeit. Den Tag des Jüngsten Gerichts interpretiert der Meister als Tag der Rache und des Zorns: dies irae, dies illa. Die Gestalten, welche die Szene bevölkern, sind Verzweifelte und Verworfene. Das unerbittliche Rad der göttlichen Macht (und ihrer Stellvertreter auf Erden) hat sie nicht etwa neue Souveräne werden lassen, sondern zu Subjekten im direkten Sinn des Wortes gemacht: zu Unter-Geordneten, Unterworfenen. René Descartes formuliert gut hundert Jahre später sein Konzept von den Menschen als göttlichen Automaten. Sie funktionieren und leiden ungeheuer im Funktionieren, ein endloser Kreislauf von Vergehen/Sünde und Strafe. Am Fuße dieses Bildes hinter dem Altar der vatikanischen Kapelle wird seit gut 130 Jahren der jeweils neue Papst gewählt.

Indem er sich selber exakt ausmaß und an die Stelle jeder Figur von Michelangelos Gemälde ein berechnetes Bild seiner Physiognomie – eine Art geometrisches Physiogramm – setzte, hat Miao Xiaochun den Aspekt der Auflösung des Renaissance-Ideals radikal zugespitzt. In der Welt der Klone gibt es keine Originale mehr. Hinter den Masken der Gleichheit gibt es lediglich noch eine Ahnung von etwas Konsistentem, was mit sich selbst aber nicht mehr identisch sein kann. „Always the same, but never myself", wie man es in der Umkehrung eines Werbeslogans aus dem letzten Fin des siècle ausdrücken könnte, den die Werbestrategen Calvin Kleins für dessen Existenzialismus aus der Flasche erfunden haben; ausgerechnet für Kate Moss, die Prinzessin der künstlichen Paradiese, wie Charles Baudelaire die Welt der Drogen nannte. Die Zeit, nach der das Subjekt erkannt hat, dass es nie ganzheitlich war und davon ausgeht, dass es nie mehr ganzheitlich sein wird. Originär ist im Letzten Gericht Miao Xiaochuns nur noch das mögliche Verhältnis der einzelnen geklonten Charaktere zueinander, das der Künstler in der Maschine beliebig verändern kann. Die Besonderheit, das Sensationelle ist in die Relationale gerutscht, sie ist flexibel geworden, schwarz-weiß, eine Abstraktion. Aus ihr heraus, wird sich der Künstler nach dem letzten Gericht in den auch farblich prallen *Garten der Lüste* vorwagen und sich schließlich im *Jungbrunnen* allseitig erneuern.

Dass sich in diesem Prozess das klassische Subjekt ganz aufzulösen beginnt, inszeniert Miao Xiaochun in einer Dimension, die er selber als diejenige der Zukunft bezeichnet. „Where will I go?" ist der für das Gesamtwerk unverzichtbare Videobestandteil seines *The Last Judgment in Cyberspace,* der das stille Werk auf den Punkt bringt. Die großformatigen Computerdrucke (C-prints) frieren, wie die Fotografie, den Zeitfluss ein. Sie sind Momentaufnahmen, gewonnen aus einer komplexen Bewegung heraus. Was für den Computer eigentlich paradox ist, da er eine Zeitmaschine par excellence ist. Alles, was man auf einem Monitor sieht, geschieht im Moment der Betrachtung, oszilliert, ist Frequenz: prozessiertes Bild in der Zeit. Wenn man den Rechner ausschaltet ist die Erscheinung weg. Im elektronischen und noch mehr im digitalen Video ist eine Kunst, die sich derart als Zeitkunst versteht, bei sich selber. Die Figuren werden auch in der Wahrnehmung zu Existenzen auf Zeit, erscheinen und verschwinden nach Belieben des Künstlers. Der ins Unendliche vergrößerte Raum zwischen ihnen wird zur maschinell erzeugten Ewigkeit, Aion, wie die alten Griechen sagten, oder Gott als der schnellste Weg von Null bis Unendlich, wie es der Paraphysiker und exzentrische Dramatiker Alfred Jarry ausdrückte.

Der Cyberspace ist keine Realität, die man als objektiv bezeichnen könnte. Von Algorithmen erschaffen, ist er nach seiner Transformation ins sinnlich Wahrnehmbare eine Erfahrung in der ersten Person, also völlig subjektiven Charakters. Um sich in ihm mit unseren trägen Sinnen bewegen zu können, benötigen wir Krücken, technische Hilfsmittel. Genauso wie zum Beispiel die christliche Religion die Himmelsleiter als Prothese benötigte, um den Aufstieg der menschlichen Seele vom Irdischen zum Himmlischen und den Abstieg der Engel als Botschafter Gottes ins Bild setzen zu können. Die schwebenden Figuren Miao Xiaochuns haben den Boden unter den Füßen längst verloren. Auch sie benutzen Prothesen im stufenlosen Raum, die Leiter, das Zahnrad als Meisterartefakt der Mechanik, das Boot, die gebündelten Pfeile, die in der europäischen Mythologie sowohl für die Macht der Zerstörung als auch die Fähigkeit der Befruchtung stehen und in unzähligen allegorischen Darstellungen der Elektrizität wieder zu finden sind; vor allem in der Gründerzeit der neuesten Medien am Ende des 19. Jahrhunderts ...

IV.

Kunsthistorische Referenz für die 2007 entstandene Serie von computer-simulierten Bild-situationen über das Wasser – H2O – ist Lucas Cranachs (des Älteren) in der Mitte des 16. Jahrhunderts entstandenes Gemälde *Der Jungbrunnen*. Forever young: Die auf ihm dargestellte Szene handelt von der Sehnsucht, die lästige körperliche Hülle der eigenen Existenz abstreifen und in ewiges Leben eintauchen zu können.

Die Bildfläche des Cranach-Gemäldes ist dreigeteilt, auch ohne als Bildobjekt das Format eines Triptychons anzunehmen. Im linken Teil des Bildes werden offensichtlich alten Frauen an ein Badebassin gekarrt. Das Becken wird von Amor und Venus bewohnt, die dem Wasser die transmutative Kraft der Verjüngung verleihen. Auf der rechten Seite steigen die Figuren als junge Frauen wieder aus dem Bad. Sie treten in ein Zelt ein, in dem sie für die lustvollen Sensationen, die sie nun wieder leben dürfen, neu eingekleidet und geschmückt werden.

Das Becken oder der Brunnen mit dem Wasser in der Mitte erfüllt die Funktion eines Mediums par excellence. Nur aufgrund des Durchgangs durch das von den Liebesgöttern durchwirkte flüssige Element ist die Verwandlung möglich. Das Wasser bekommt eine ähnliche Funktion wie das Elektrische es im Mediendiskurs der Aufklärung innehatte. An der Grenze von Materialität und Auflösung derselben verkörpert es die Kraft zur Trans-formation. Es ist Zentralphänomen und ursprüngliches Lebenselexier. Erst einmal elektri-fiziert können die Körper unsterblich werden, durchaus auch in dem Sinn, wie Juliette in de Sades berühmtem Doppelroman von 1792 (*Justine et Juliette*) – entstanden im Zenith des Enlightenment – ständig elektrisiert wird durch das Bad im Bösen und der morali-schen Verkommenheit.

Im kybernetischen Raum kann es schließlich immer während Jugend geben, weil dieser Raum keine Leibhaftigkeit kennt. Er lässt sich im Bild und in der Zeit ewig herstellen und mit Figuren bevölkern, so lange der Strom fließt. Hier kann auch das Paradies wieder auferstehen, das Hieronymus Bosch gemalt hat. Im kybernetischen Raum hat das letzte Gericht ja bereits stattgefunden.

In der künstlerischen Fiktion stellt H2O aber auch den konsequenten Schluss dieser Tri-logie Miao Xiaochuns dar. Sie entwirft die Zeit nach den Medien. Das Elektrische stellt für das Lebendige keine Sensationen mehr zur Verfügung. Wasser ist der wertvollste Rohstoff alles dessen, was Bios [βιοσ] ist. Die irdischen Däumlinge haben ihn über Jahrhunderte missachtet und zur extremen Mangelware werden lassen. Die Volksrepublik China beginnt heute schon, darunter zu leiden.

Miao Xiaochuns eigenwillige Adaptationen und Interpretationen von Meisterwerken der europäischen Kunst der frühen Neuzeit sind unverschämt im direkten Sinn des Wortes. Ohne Scham führt er uns regelrecht unsere eigene (Kunst)Geschichte vor und öffnet die eigene Gegenwart zugleich spielerisch in eine mögliche Zukunft hinein, die schon einmal ihre Vergangenheit gewesen sein könnte. Nur eine künstlerische Persönlichkeit, die aus einer tiefenzeitlichen Kultur wie derjenigen Chinas stammt, und die – trotz aller ihrer Bezüge zum Europäischen – in diesem Bewusstsein auch arbeitet, kann sich so etwas leisten.

H2O
2007

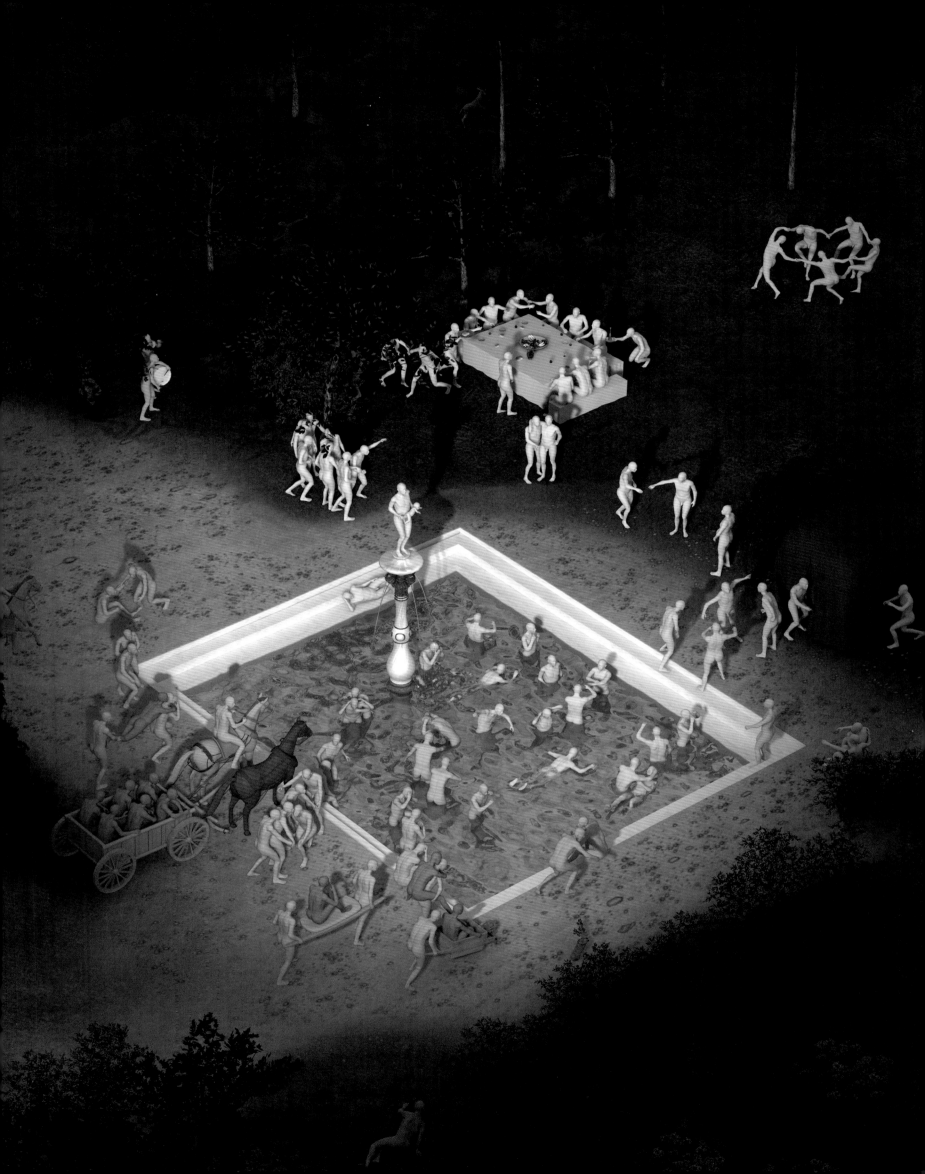

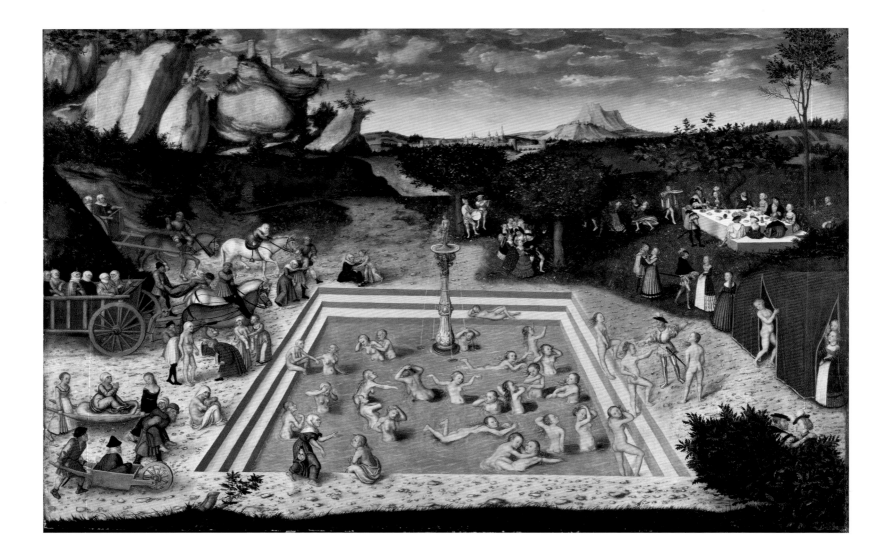

Lucas Cranach the Elder, **Fountain of Youth**, 1546

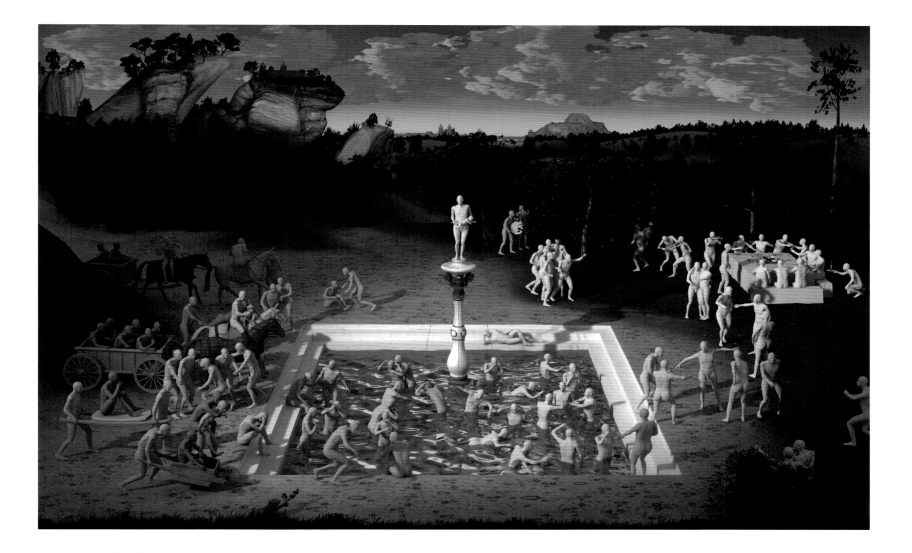

H2O – Fountain of Youth(F), 2007
C-Print, 228 x 360 cm

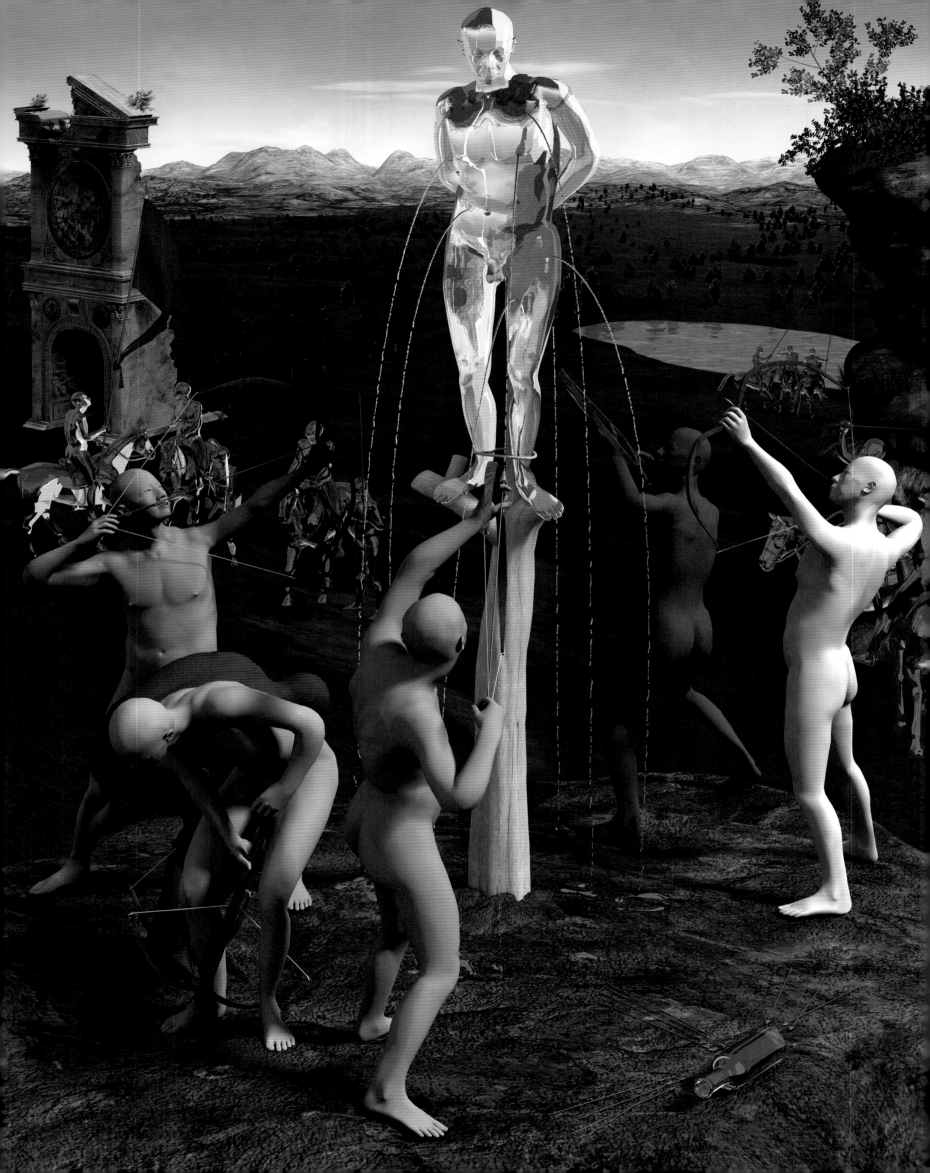

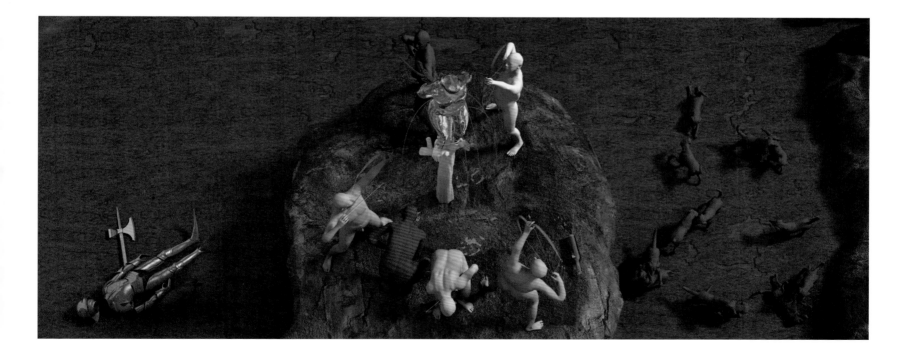

H2O – The Martyrdom (F), 2007
C-Print, 151 x 120 cm

H2O – The Martyrdom (S), 2007
C-Print, 122 x 304 cm

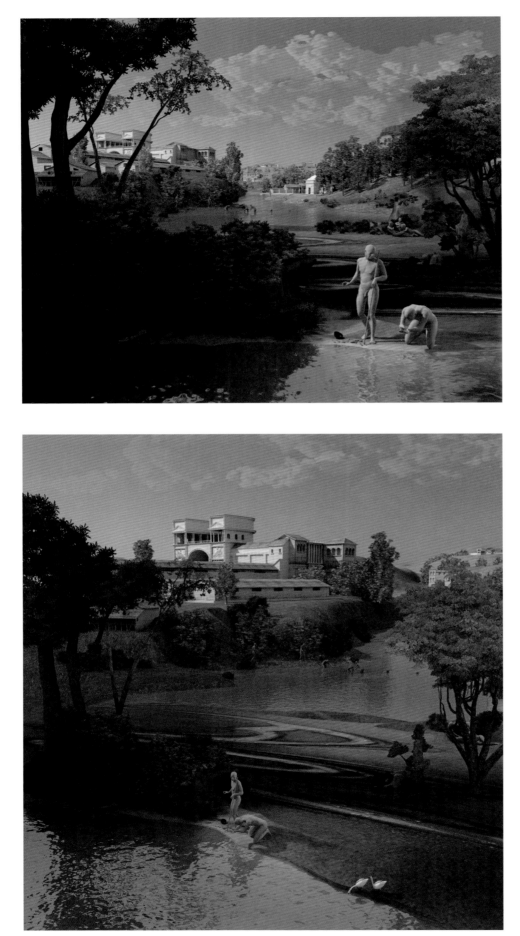

H2O – Landscape with Diogenes (F), 2007
C-Print, 170 x 204 cm

H2O – Landscape with Diogenes (S), 2007
C-Print, 188 x 176 cm

Next page: **H2O – Genesis** (Detail), 2007
C-Print, 243 x 480 cm

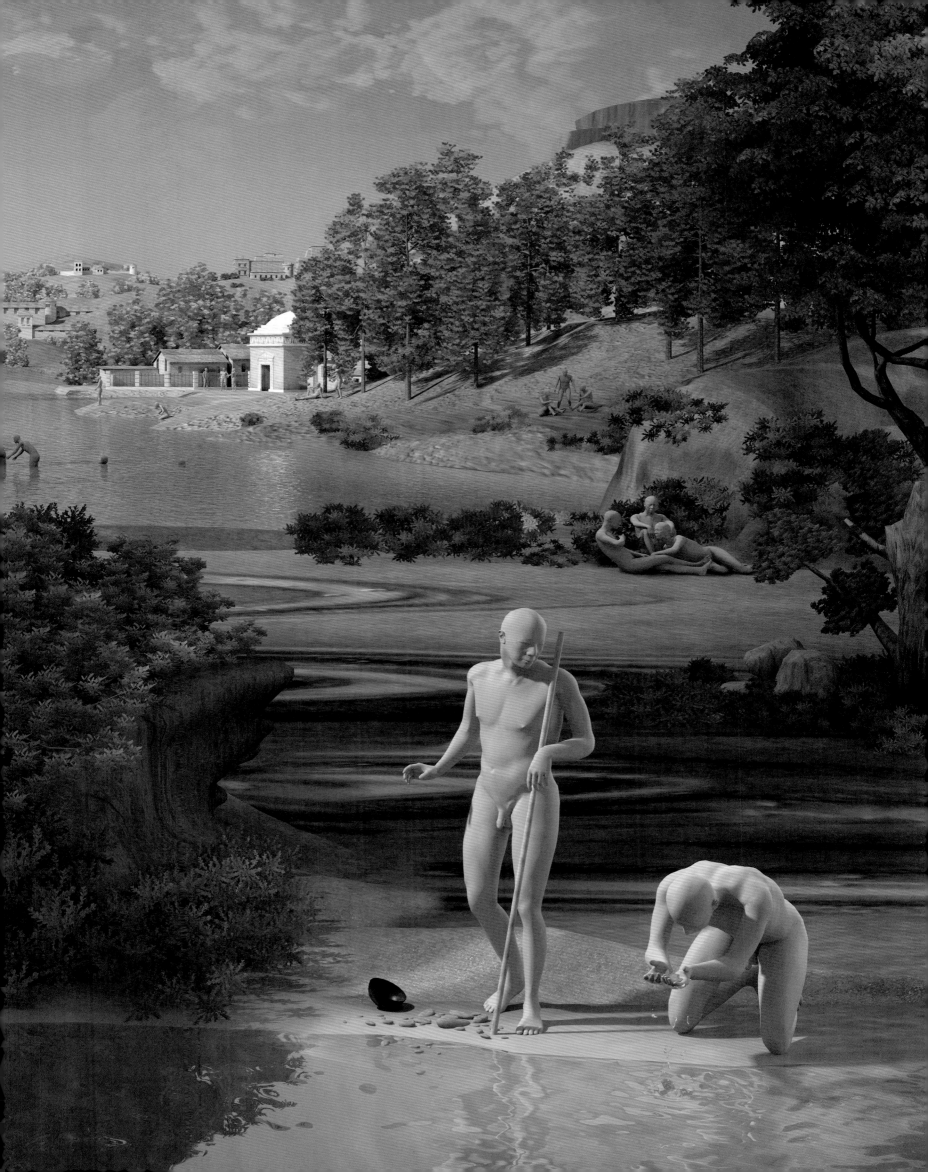

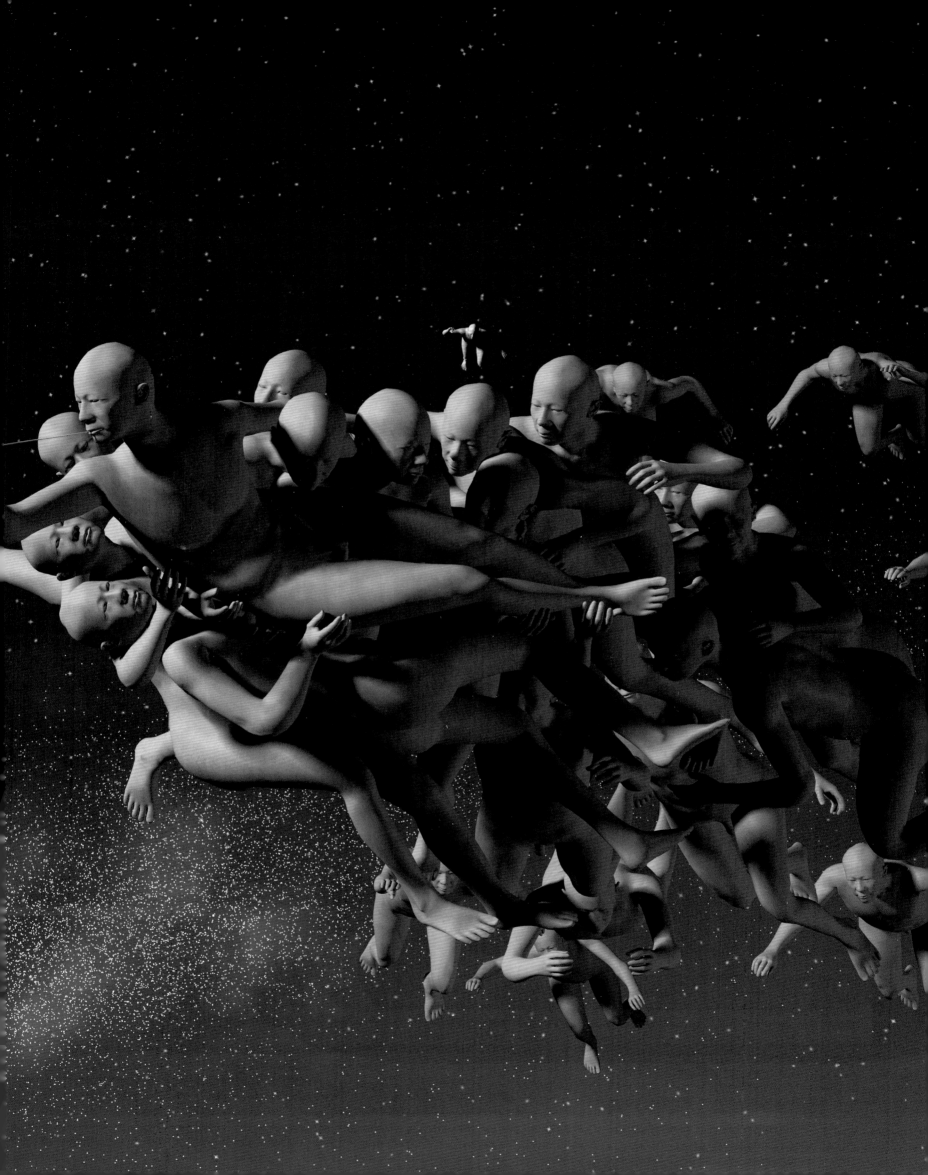

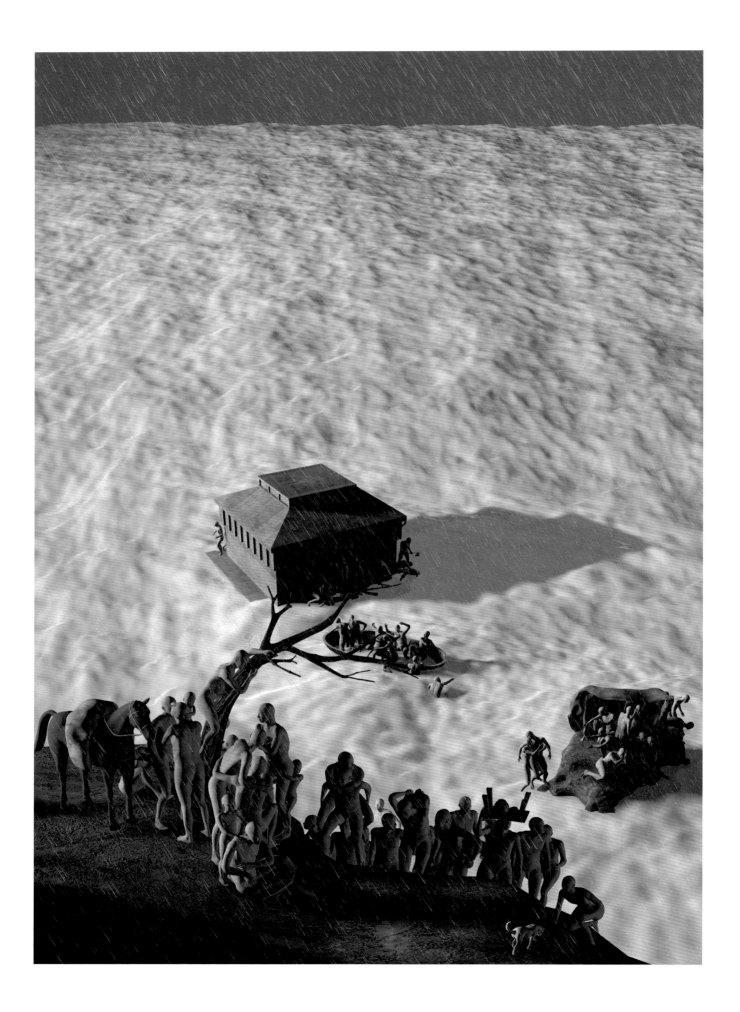

H2O – The Deluge (S), 2007
C-Print, 306 x 217 cm

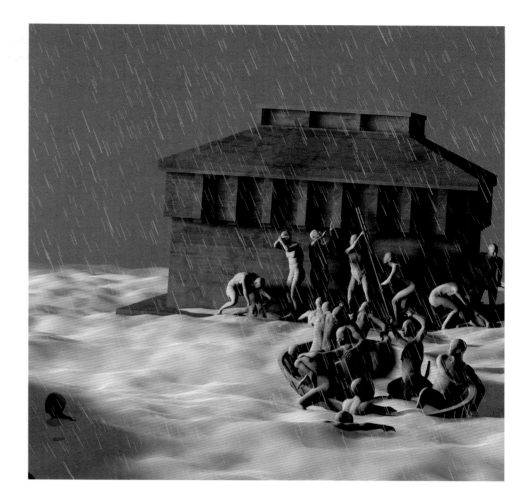

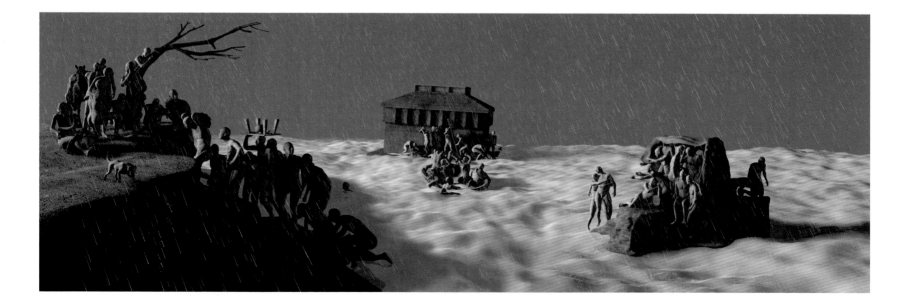

H2O – The Deluge (F), 2007
C-Print, 165 x 480 cm

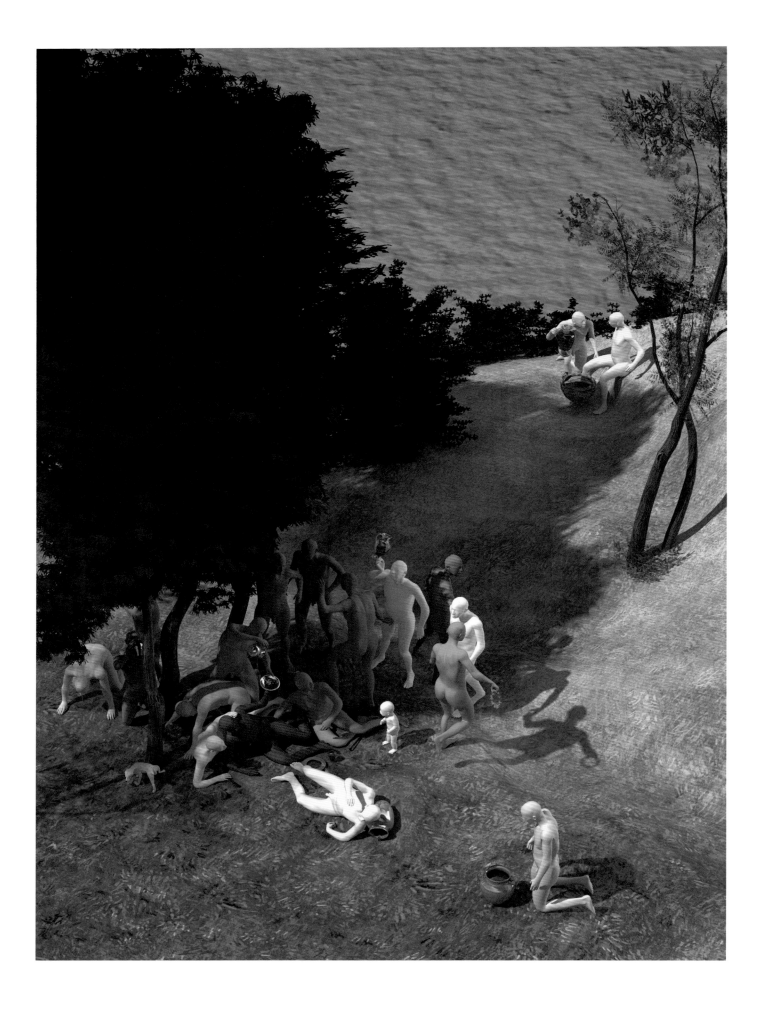

H2O – Bacchanal (S), 2007
C-Print, 306 x 224 cm

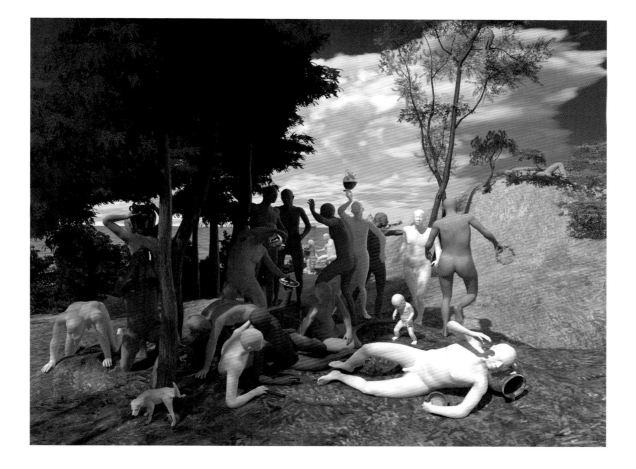

H2O – Bacchanal (F), 2007
C-Print, 276 x 360 cm

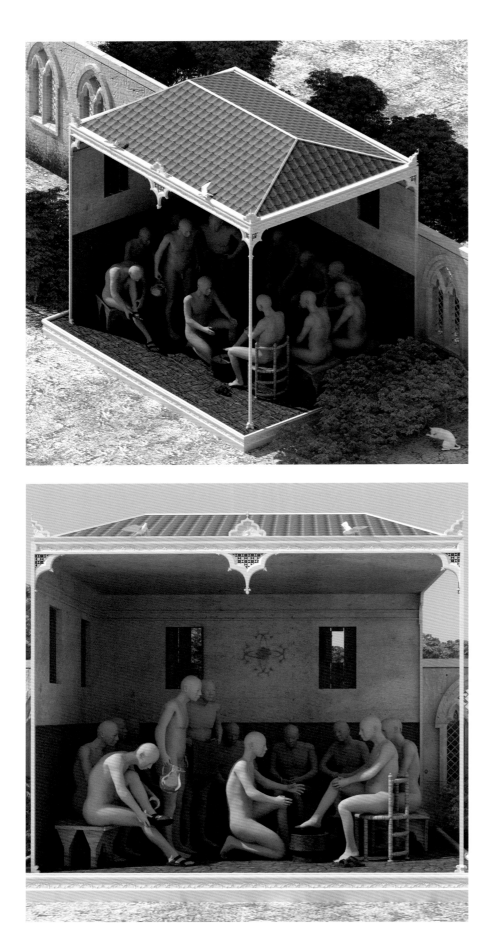

H2O – The Washing of the Feet (S), 2007
C-Print, 173 x 174 cm

H2O – The Washing of the Feet (F), 2007
C-Print, 174 x 170 cm

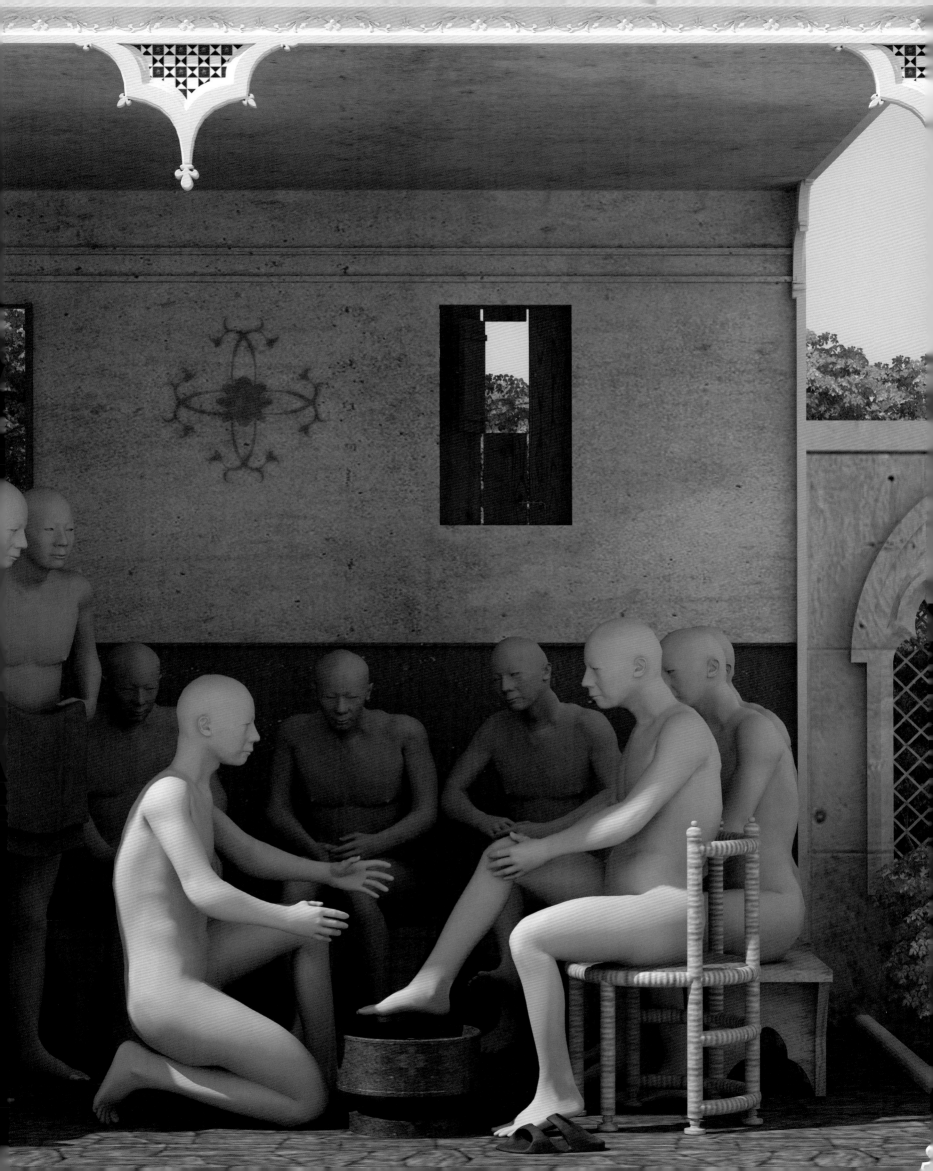

THE LAST JUDGMENT
IN CYBERSPACE 2005–2006

The Last Judgment in Cyberspace – The Rear View, 2006
C-Print, 418 x 348 cm

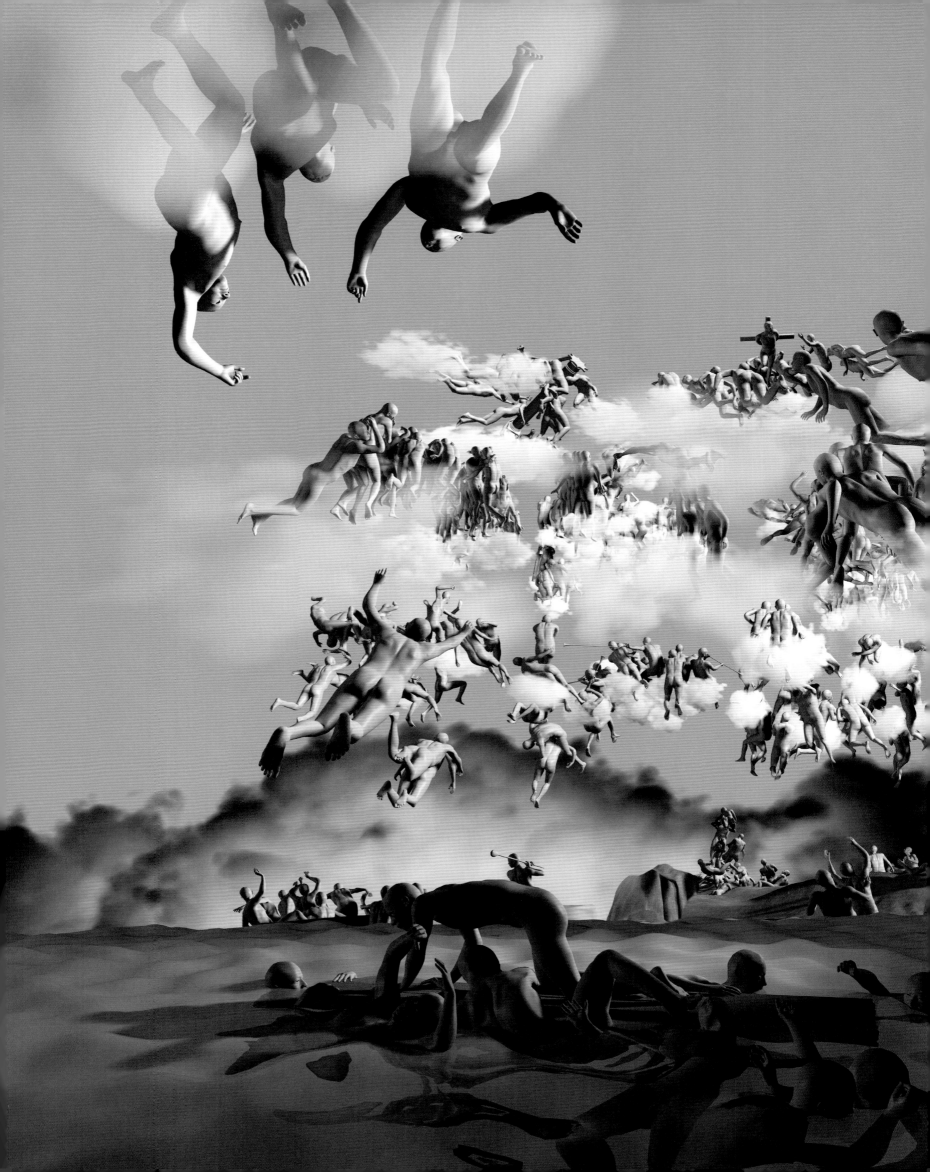

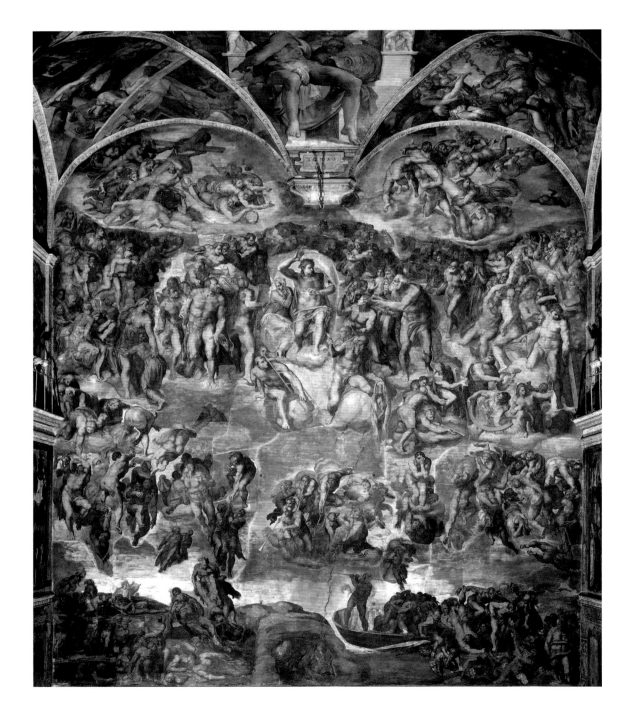

Michelangelo, **The Last Judgment**, Sistine Chapel, 1533–1541
Right: **The Last Judgment in Cyberspace – The Front View**, 2006
C-Print, 418 x 360 cm

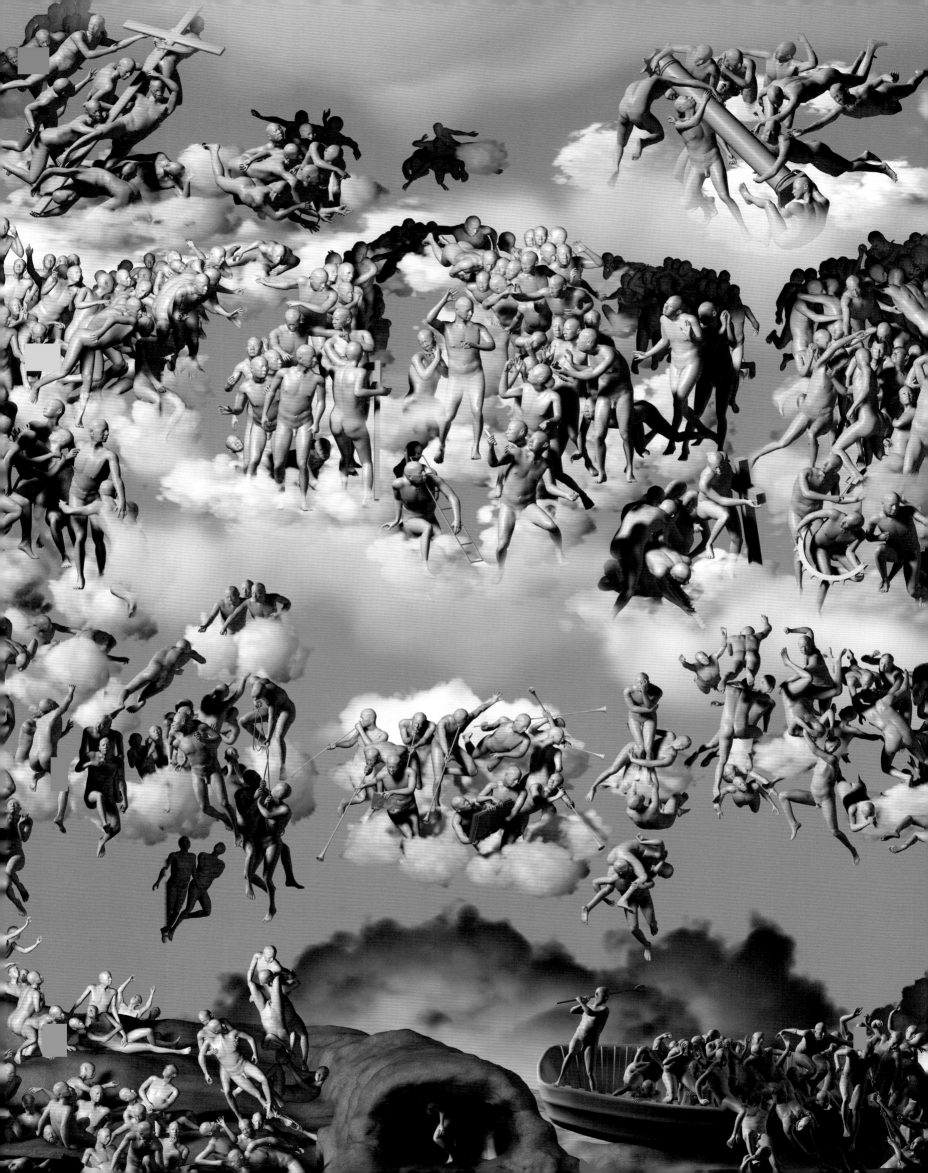

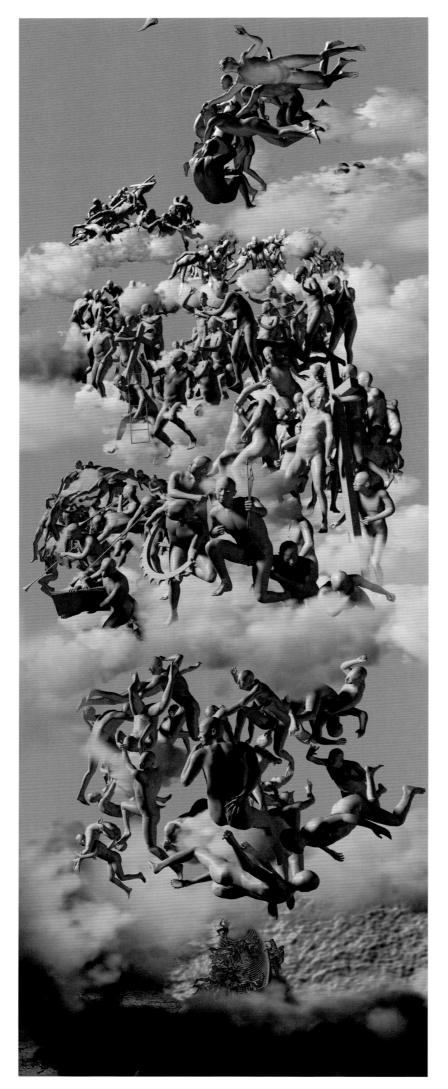

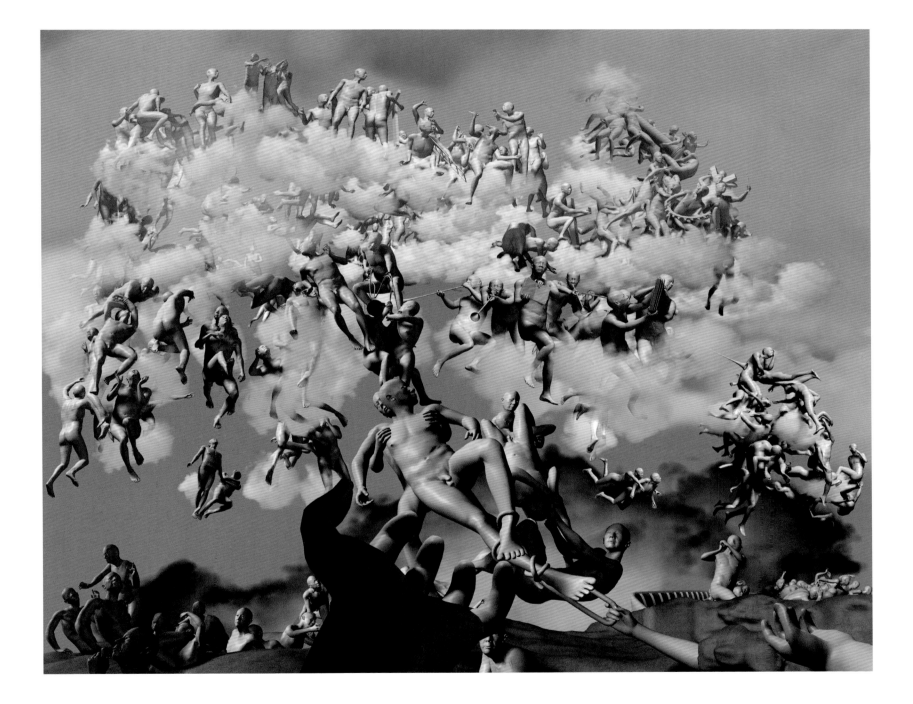

Left: **The Last Judgment in Cyberspace – The Side View**, 2006
C-Print, 428 x 160 cm

The Last Judgment in Cyberspace – The Below View, 2006
C-Print, 385 x 480 cm

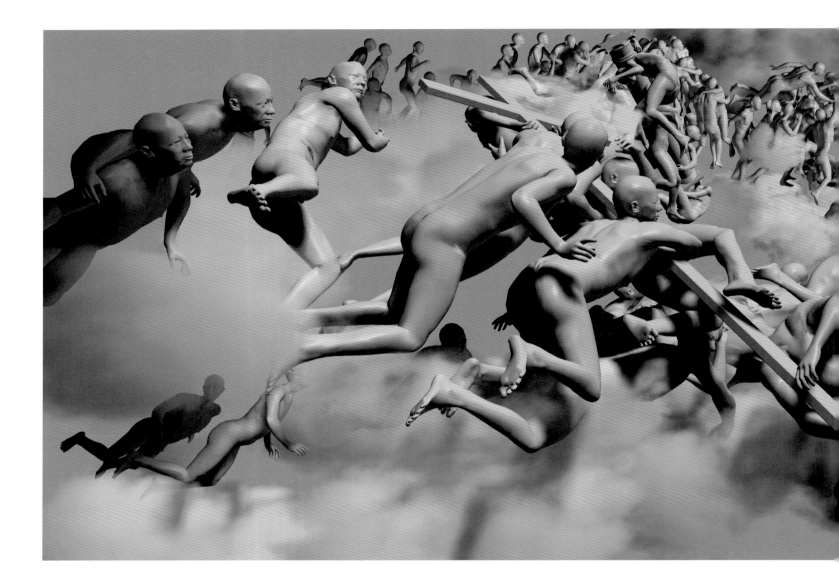

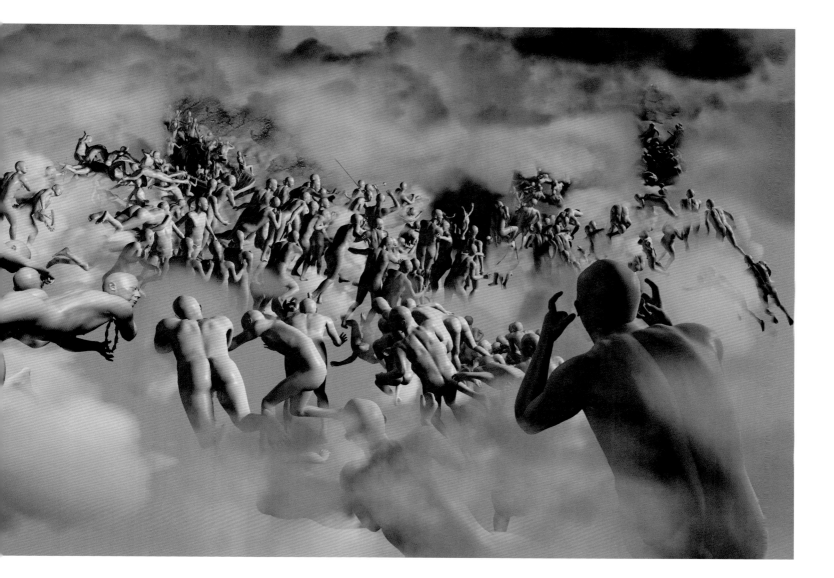

The Last Judgment in Cyberspace – The Vertical View, 2006
C-Print, 244 x 720 cm

BEIJING INDEX
2007–2009

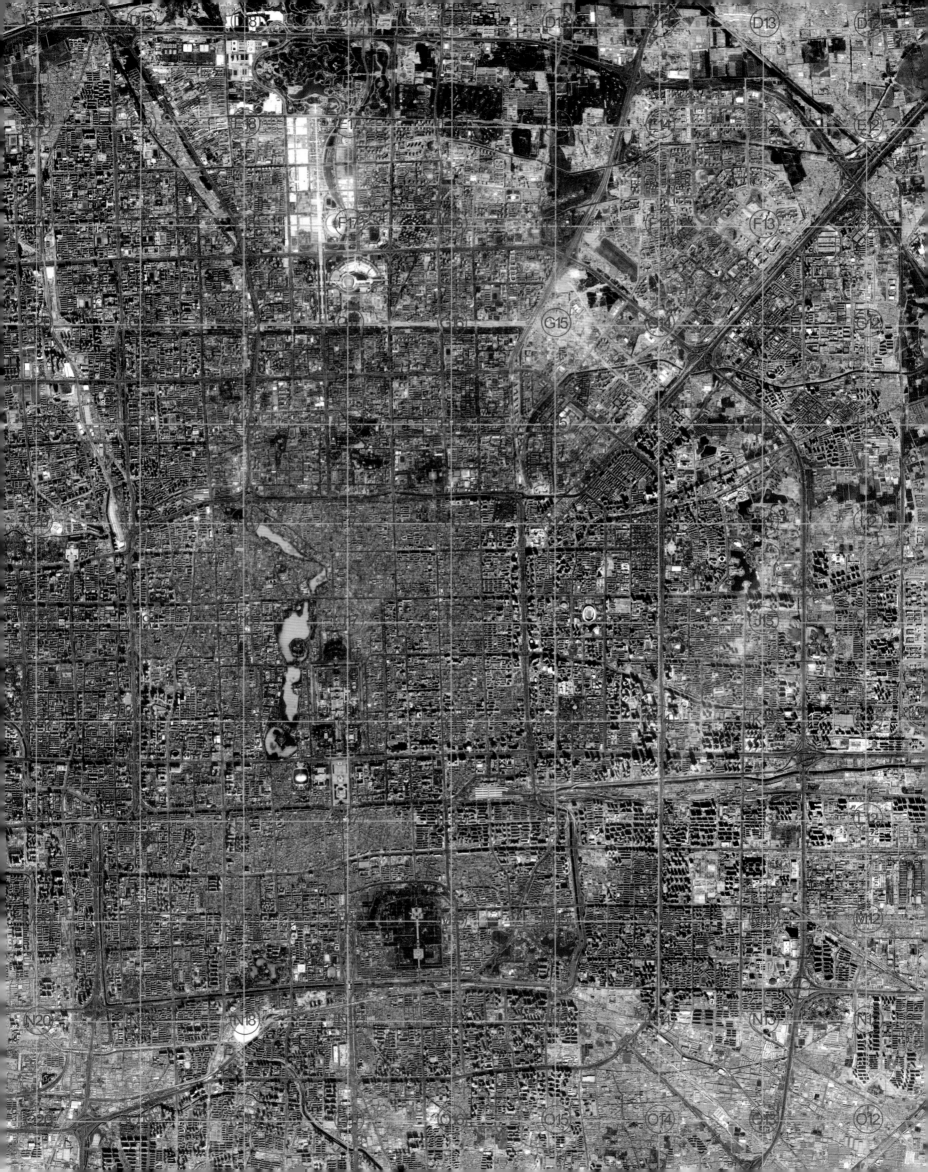

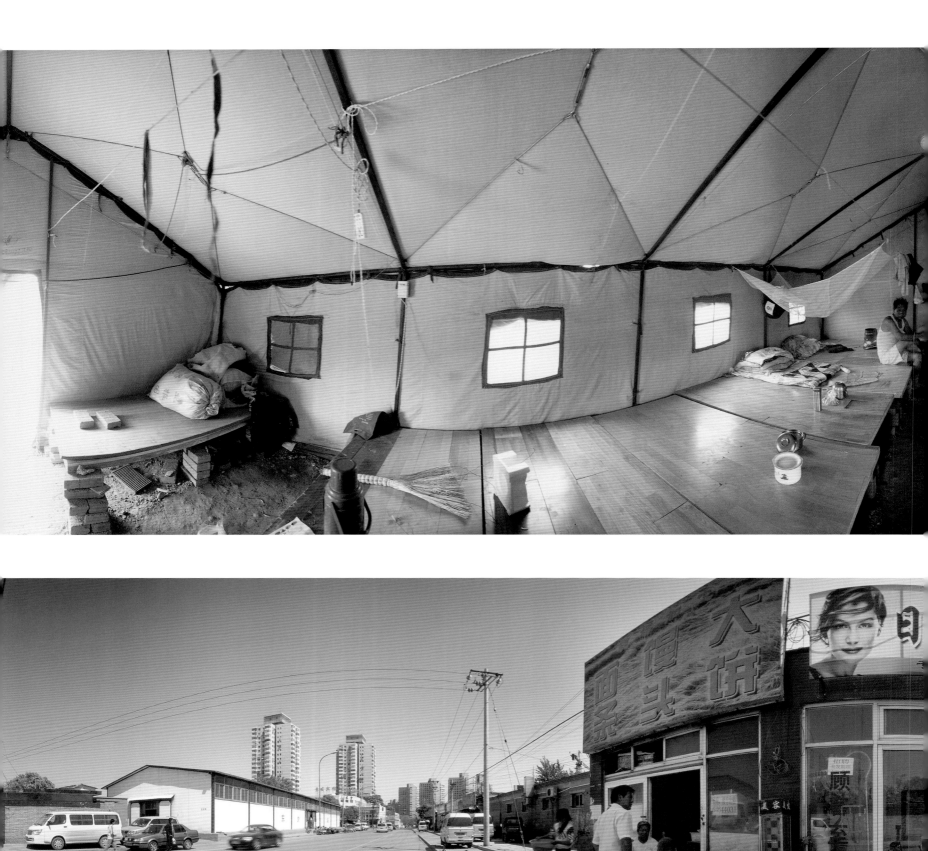

Above: **Beijing Index – I15,** 2007–2009
Archival print, 25 x 95 cm

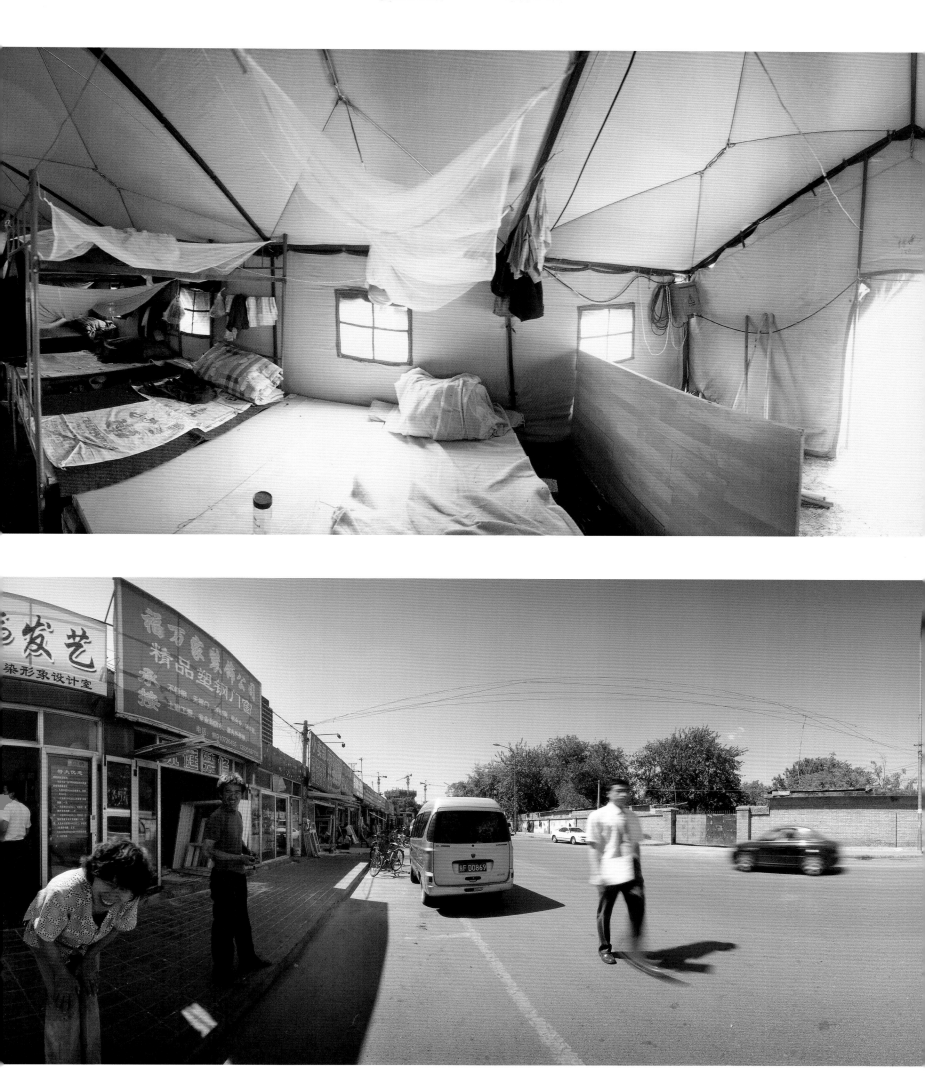

Below: **Beijing Index – D18,** 2007–2009
Archival print, 25 x 95 cm

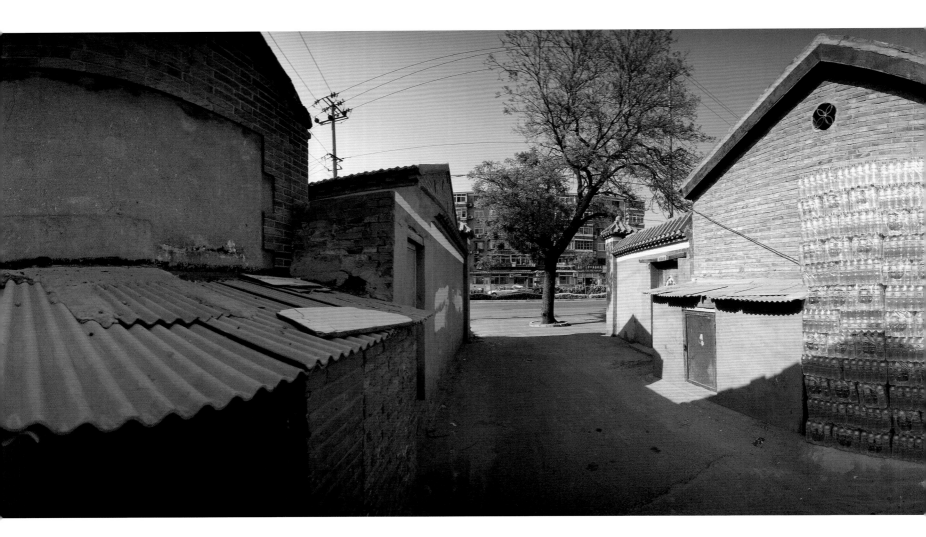

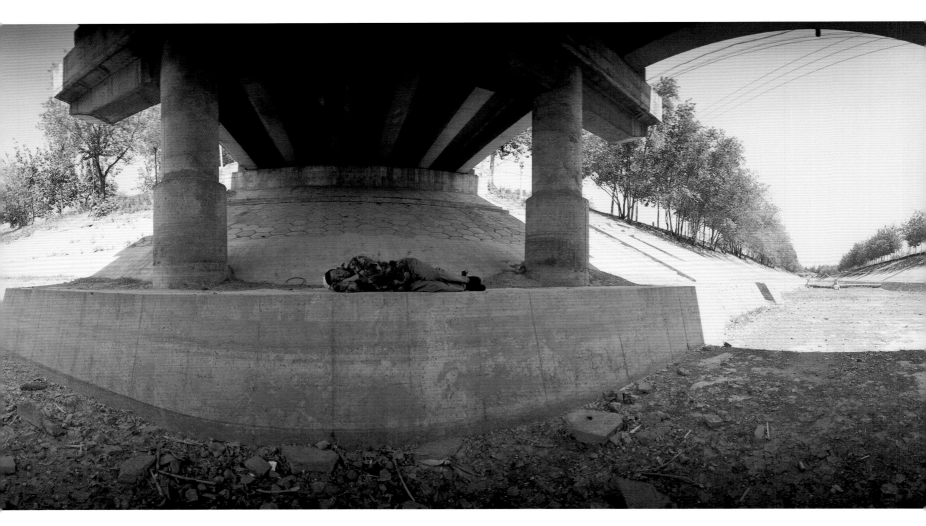

Above: **Beijing Index – M19**, 2007–2009
Archival print, 25 x 95 cm

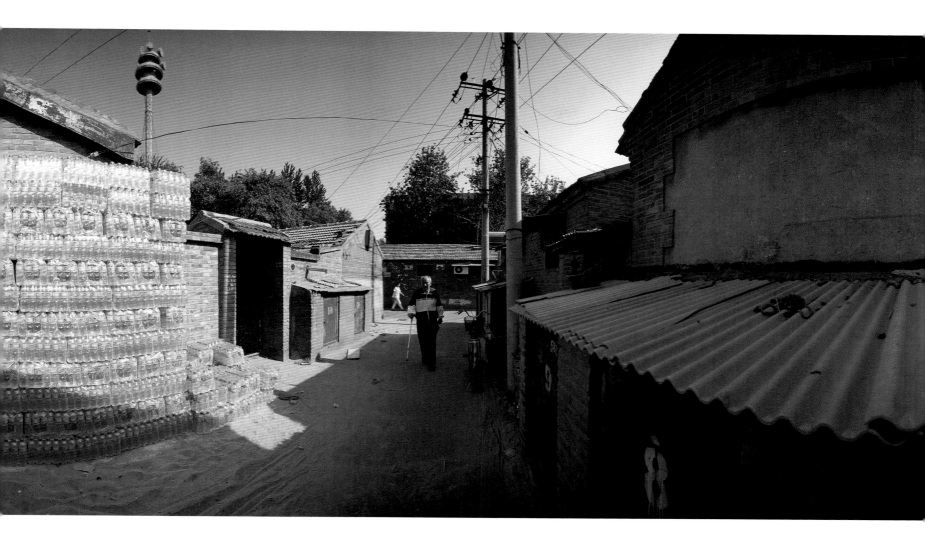

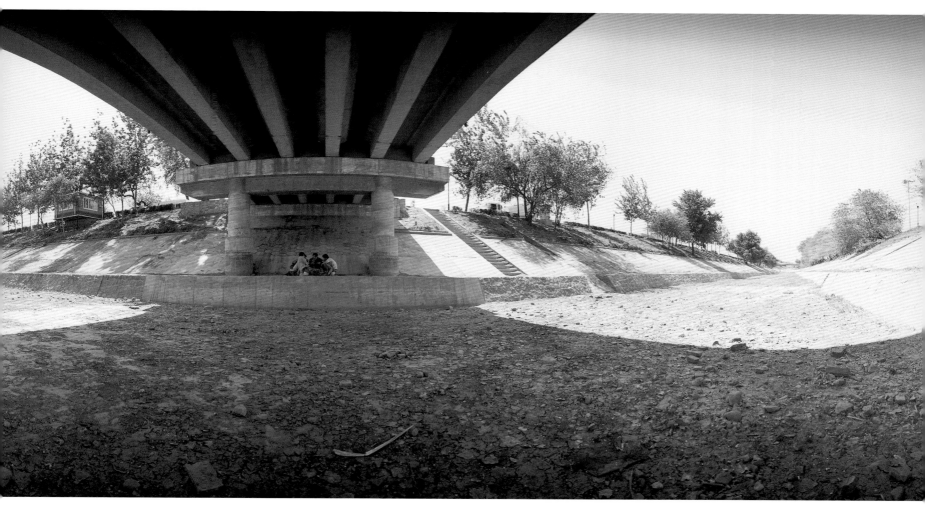

Below: **Beijing Index – N20**, 2007–2009
Archival print, 25 x 95 cm

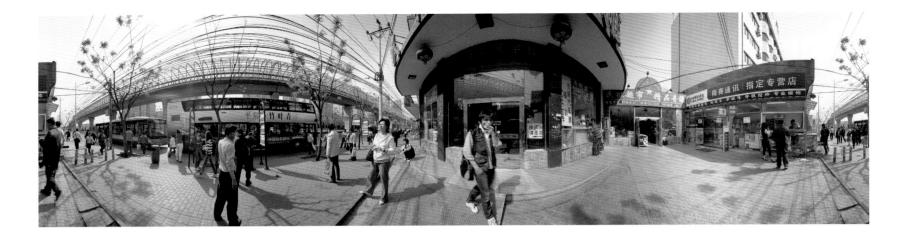

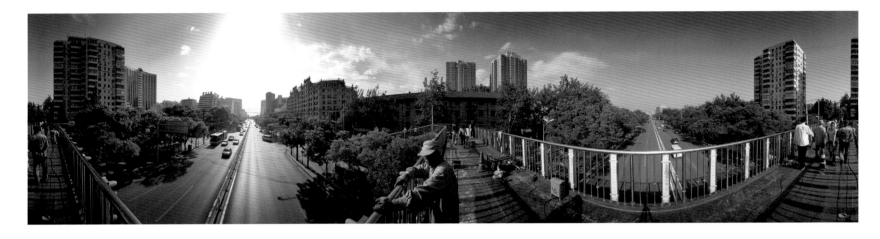

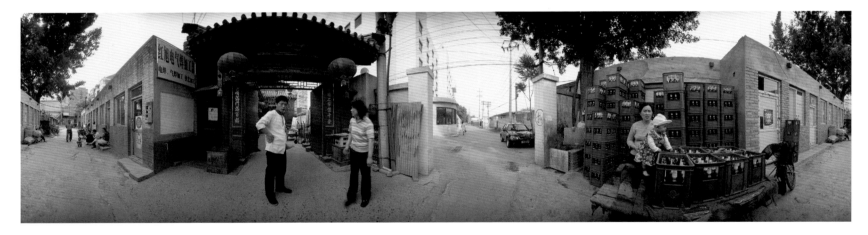

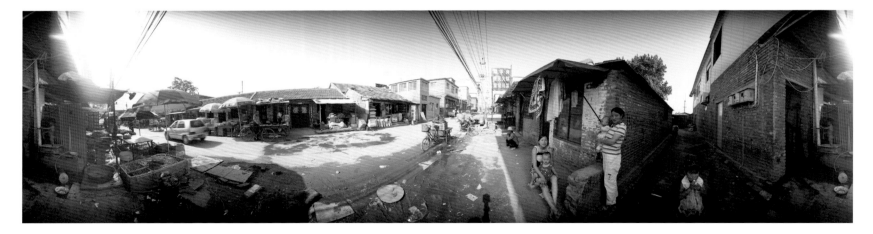

Beijing Index – D16 | J15 | G16 | M26, 2007–2009
Archival print, 25 x 95 cm

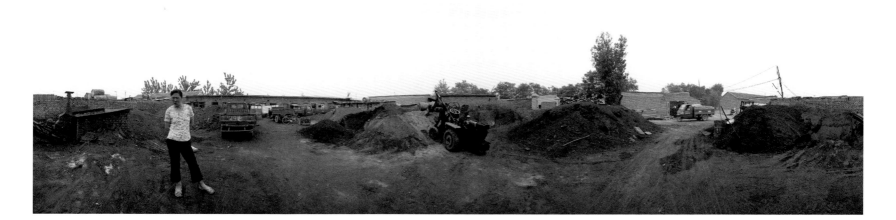

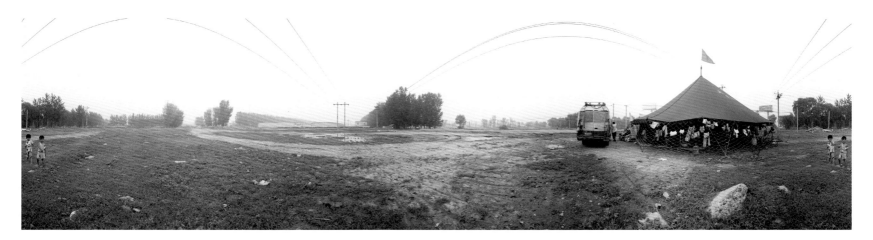

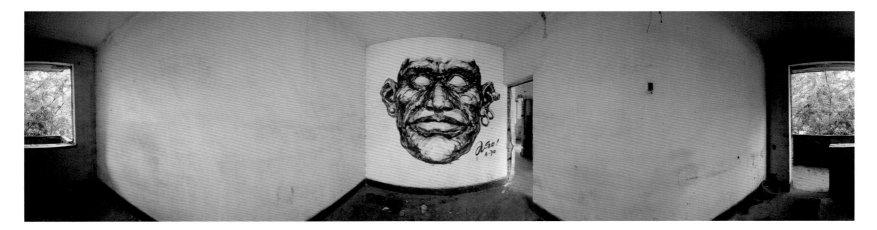

Beijing Index – A18 | C5 | B19 | A7, 2007–2009
Archival print, 25 x 95 cm

Beijing Index – R18 | O22 | N31 | Q27, 2007–2009
Archival print, 25 x 95 cm

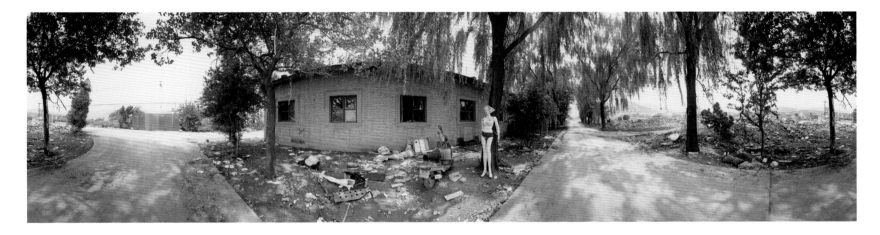

Beijing Index – N32 | U22 | N30 | R17, 2007–2009
Archival print, 25 x 95 cm

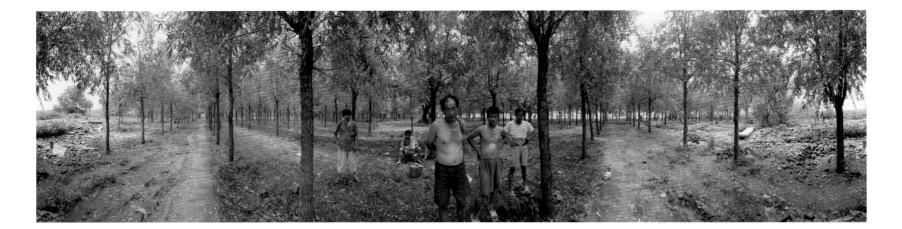

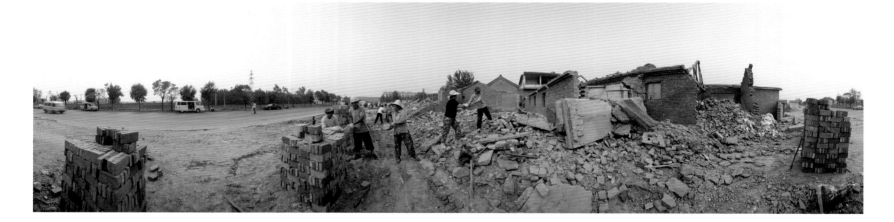

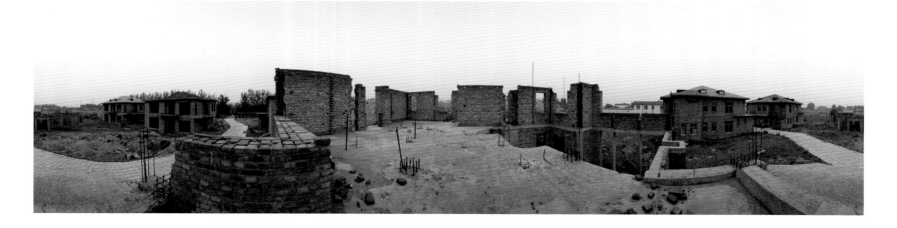

Beijing Index – C18 | B2 | B9 | C11, 2007–2009
Archival print, 25 x 95 cm

104

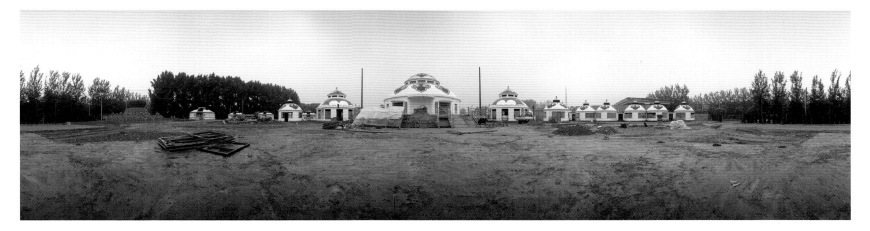

Beijing Index – C2 | D29 | D9 | E26, 2007–2009
Archival print, 25 x 95 cm

Above: **Beijing Index – B15**, 2007–2009
Archival print, 25 x 95 cm

Below: **Beijing Index – B10**, 2007–2009
Archival print, 25 x 95 cm

NEW URBAN REALITY
2003–2007

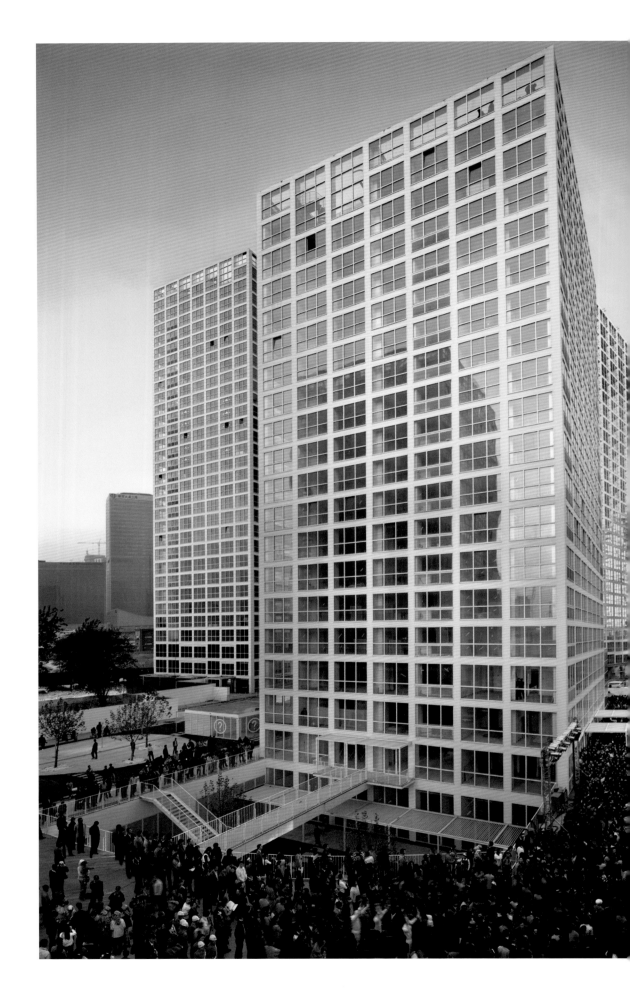

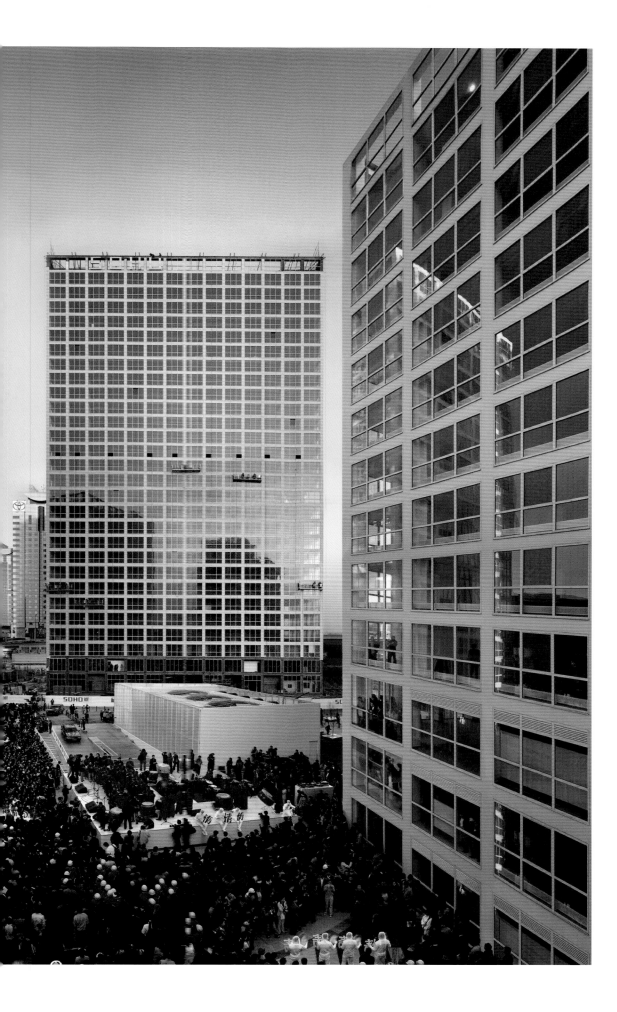

Celebration, 2004
Photograph, 372 x 480 cm

Orbit, 2005
Photograph, 217 x 480 cm

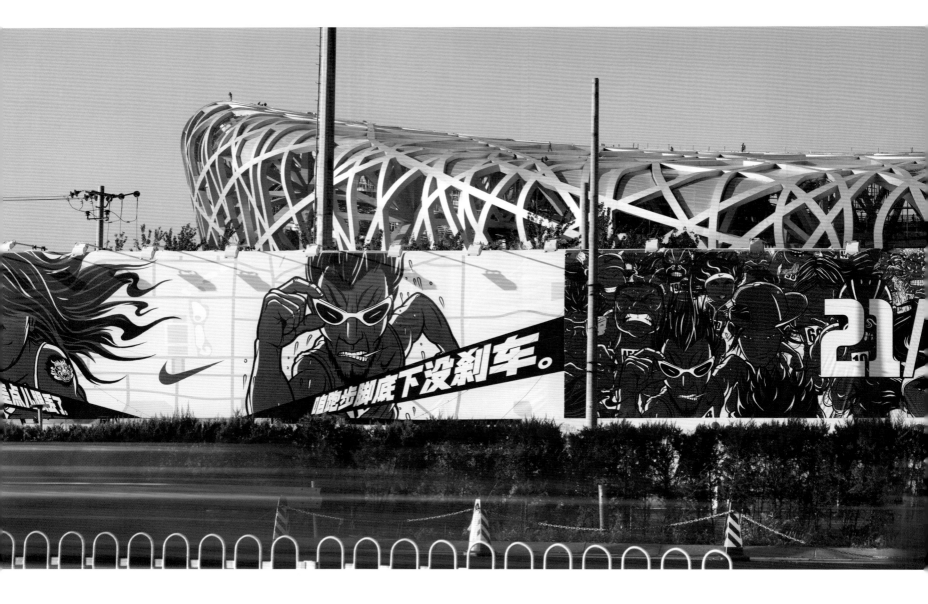

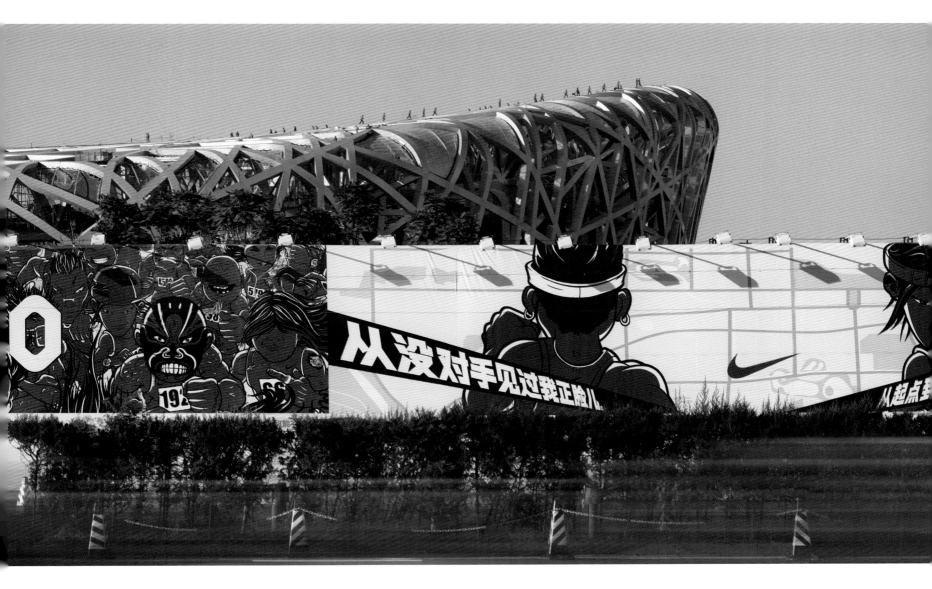

Nest, 2007
Photograph, 176 x 600 cm

Stand, 2007
Photograph, 274 x 480 cm

Surplus, 2007
Photograph, 268 x 750 cm

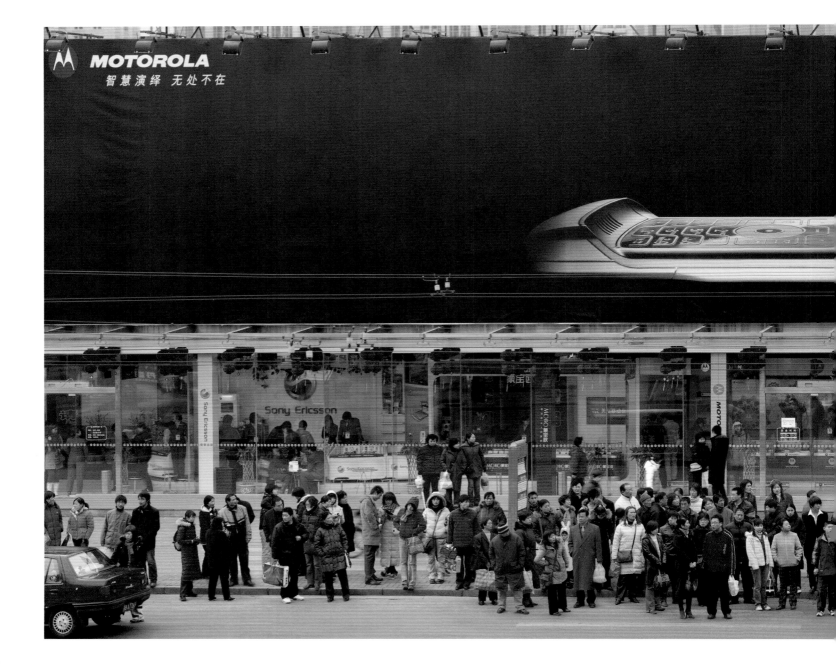

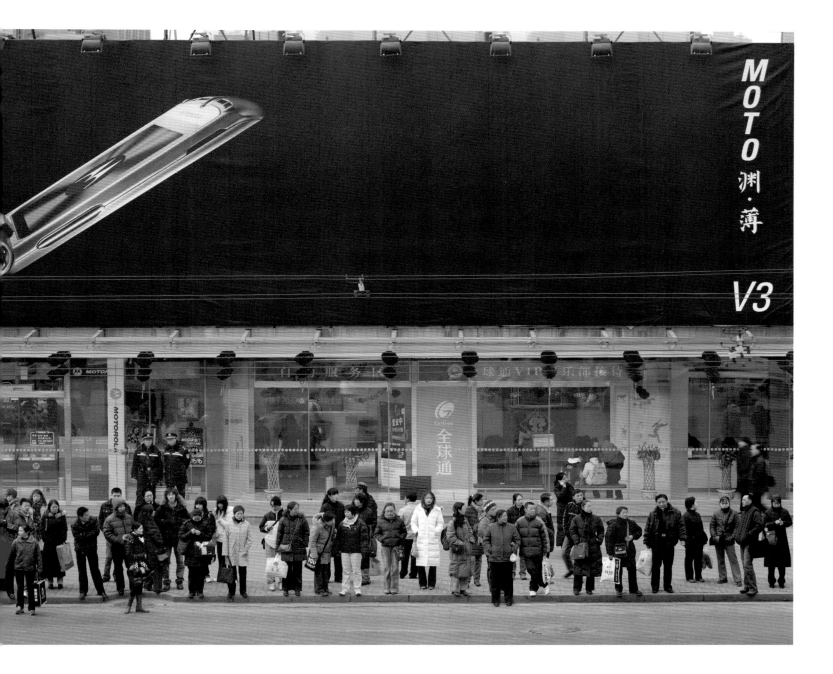

Await, 2005
Photograph, 235 x 600 cm

GREGOR JANSEN

POST-HISTORY'S BEING JUST SO
DAS SO-SEIN DER POSTMODERNE

Photographs, especially instantaneous photographs, are very instructive, because we know that they are in certain respects exactly like the objects they represent. But this resemblance is due to the photographs having been produced under such circumstances that they were physically forced to correspond point by point to nature. In that aspect, then, they belong to the second class of signs [indices].
—Charles Sanders Pierce, "Logic as Semiotic: The Theory of Signs"

Total city, informal city, northern city, Forbidden City, desert city, imperial city, capital of the Middle Kingdom, city of wind, city of bicycles, city of objects, grid city, interwoven city: Beijing is a city with many names and faces. After spending some time in the midst of the many ring roads and the millions of people in this megalopolis, one learns to treasure their names and faces and to understand their way of life. Beijing is a city that can hardly be grasped, a uniform city, ugly for many foreigners, a city that does not speak to them. Its mere size, horizontal extension, and uniformity, however, have changed radically in recent years: from the Forbidden City, the Imperial Palace, to a national village, and to the city with a strong wall of fortification, today's second ring road, to a gigantic megalopolis with 18 million residents and seven ring streets, at the same time the global "village" as a center of the most populated country in the world.

Those more familiar with Beijing like the city. Miao Xiaochun, born in Wuxi Jiangsu in 1964, likes it too. He lives in the midst of the largest city development area, in Wangjing: there he has his studio and his apartment, his favorite restaurant, his art school, and his art academy, the Central Academy of Fine Arts (CAFA), where he teaches media art. This part of Beijing to the northeast of the city center between the fourth and the fifth ring roads, to the west of Dashanzi with Art District 798, has emerged as it were from

nothing over the last ten years as a completely new metropolis with almost three million people. Here, old Beijing has given way to the new business logic of skyscraper real estate: Motorola, Siemens, or Mercedes have erected their China headquarters here at a frantic pace, mercilessly and without taking account of losses. Real estate and rent prices in Wangjing skyrocketed 20 percent in 2009, and that can even surprise or even horrify a resident like Miao Xiaochun.

In any case, in 2008 and 2009 he carried out an idea that can only be understood before the backdrop of this high-speed urbanism: while it does not document the radical transformation of the cityscape, it does explore this question.[I] Miao placed a dense grid over a city map of Beijing, and at each point of intersection he took a photograph in the actual city situation, using a 360-degree panorama camera.

During the ca. 18-month project, using this random coordinate system 639 shots of the current Beijing could be taken that Miao's team using GPS technique could carry out minutely within the topography of Beijing. Translated to a digital visual language, this means mapping the world using location on the ground and a panoramic view using the example of Beijing. Here, the master plan of Beijing shows, with its fortifications built in the twelfth century on what is today the second ring road of the gigantic ring road system, while the first ring incidentally forms the Forbidden City as the center of an empty middle. Decisive for this unique project was the neutrality, the objectivity of the technique and the ignoring and blocking out of an artistic and thus subjective relation to the system of an index, that Miao sought to avoid. The result contains viewing, capturing, and documenting the current appearance of the city with its sometimes quite village-like character, its introspection and individuality, but also its "genericity" (Rem Koolhass), its interchangeability lacking identity.

Photography had always been the best of all the media of representation.[II] With its help, all other media are subsumed, analyzed, and distributed. Time seemed to be stored, concentrated, and condensed with it. Today, however, photography has been supplanted by computer graphics, and has been forced to take on a different, tragic role: it has degenerated to one of the reproducible forms of representation. With electronic image processing, the digital photographic apparatus approaches what Hollis Frampton calls the "dubitative process" in painting. Like the painter, the digital photographer now plays with the picture until it looks right.[III]

Those who want to derive a theory for photography from the advent of the dubitative —which the dictionary translates as "tending towards doubt," or "dubious"—can think in various directions, the most well-known being the one that William J. Mitchell took in *The Reconfigured Eye*, as he studied the destruction of photographic truth content that Susan Sontag referred to with the statement that "a photograph is considered the clear evidence that something particular has happened."[IV] While postmodern theorists have long since argued with this claim of the truth content for photography, the violent debate on digital image processing shows that the public still maintains the evident essence of photography. As Mitchell and others have shown, recipients in the age the dubitative digital photography are forced to have faith in the source of the image or the truth of the visual context.[V] In these terms, the digital photograph must be understood as having the same truth content as a written text. Thus, we have returned in a certain sense to the aesthetic of a pre-photographic age and to a sign world that is once again reduced to the

I

See Gregor Jansen (ed.), *Totalstadt. Beijing Case. Kulturelle Aspekte der Hochgeschwindigkei surbanisierung in China* (Cologne, 2006).

II

See Hubertus von Amelunxen, Stefan Iglhaut, and Florian Rötzer (eds.): *Fotografie nach der Fotografie. Ein Projekt des Siemens Kulturprogramms* (Dresden and Basel 1996, esp. 93–99).

III

Hollis Frampton, "Degressions on the Photographic Agony," *Circles of Confusion: Film, Photography, Video: Texts 1968–1980* (New York, 1983): 190.

IV

William J. T. Mitchell *The Reconfigured Eye: Visual Truth in the Post-Photographic Era* (Cambridge 1992): 24. See also *Digital Photography* im San Francisco Camerawork 1988, die von Marnie Gillett und Jim Pomeroy organisiert wurde. *Digital Photography: Captured Images, Volatile Images, New Montage* has two essays Timothy Druckreys "L'Amour Faux" 12–9) und Martha Roslers "Image Simulations, Computer Manipulations: Some Ethical Considerations" (28–33).

V

Occasionally the demand has been made that digitally changed image should be marked with a special sign and thus made identifiable. A Norwegian suggestion is to use the word "Montasje" and the capital letter M as a standardized indicat on for an alteration. John Larrish: *Digital Photography: Pictures of Tomorrow* (Torrance 1992): 60.

dichotomy between word and image, but this time linked in that both word and image are amalgamations of the binary code. This insistence on context and interpretation is not only true of digital photography, but applies in general. The explosion of the indexical relationship between photography and its object is of great significance for the epistemology of post modernism and represents a clear disturbance for the politics of a culture saturated with images (an issue that is far reaching and sensitive China). Yet the overwhelming attention placed on issues of subterfuge, deception, and truth content can rob our attention from a different realm of discourse that has to do with photography. The collapse of the indexical link between photography and its referent and the related liquidation of the truth-value of photography had the same impact as the decay of the aura with the coming of photography itself. To that extent, Miao Xiaochun intuitively acted correctly when with his idea of creating an index of Beijing he blocked out all influence using a random pattern and had the project carried out others. In so doing, he seems to allow no manipulation, no deception, and no lies.

Miao Xiaochun was occupied with a complementarily distinct project during *Beijing Index*'s autonomous process of emergence: the modern, timely, digital execution and translation of Hieronymus Bosch's 1516 triptych *The Garden of Delights* from Madrid's Prado. A monumental homage that presented a new cosmos of pseudo-religious revelation of world mysticism using photography, sketches, stick figures, and computer graphics. *Microcosm* is the title, and was completed in 2008 after a year of work, a process that was preceded by several years of engaging with the cosmology of Western historical painting, usually religiously inspired. In his engagement with fundamental questions of human existence, birth, death, life, heaven, God, and the meaning of life in general, for Miao the adaptation of familiar visual motifs of Western provenance and generating strong statements with current methods of image creation. A kind of screen with nine huge panels shows his interpretation of Bosch's winged altar that as a surrealist masterpiece of the Renaissance inspires has repeatedly inspired to new world formulas. On chromogenic prints, Miao, like Alice, takes us behind the looking glass to a garden of delights generated using computer technology, thus virtually accessible, which in turn allows for a view into his own brain.

The Last Judgment, Michelangelo's fresco from the Sistine Chapel in Rome, is also a gigantic cyber epic that Miao transferred to a post-modern worldview. The fresco is located far from Beijing, on the other, Western side of the globe, and in the old center of the Christian world empire. For the Chinese artist, it represents at the same time a significant part of the cultural memory of those today mad about images. He never saw the actual work, which was cleaned a good 20 years ago to a high polish by Japanese restorers: but detailed illustrations from art volumes were sufficient to enter virtually the neo-Platonic mix of figures and colors of the *Last Judgment*. These images, once rich in iconographic meaning, become in Miao's work dreams of his own space of imagination and life translated to the contemporary that can be playfully transformed with surreal combinations into new images. In the photograph series and the colossal video triptych *The Last Judgment in Cyberspace* from 2007, Miao shows how an almost introspective change of perspective changes the foundational construction of meaning in the work. The recasting of Michelangelo's almost 400 figures with the alter ego of the artist takes on a hybrid appearance, since we enter the Sistine Chapel with him, with his imagination.

In 2000, before this virtual phase of anthropological visual reality, Miao Xiaochun tried to approach his new hometown Beijing by way of large format C-prints. Outstanding here are his photographs of the SOHO district with the title *Celebration* (2004) and *Await* (2005) of Beijing's so-called "Silicon Valley" or the nighttime shot of a new shopping center alongside an "old-style" restaurant, *Surplus* (2007). With these wall-filling C-prints, he created icons of a contemporary architectural cityscape. Miao combined the rapid changes to Beijing and assembled a new, dynamic image of the Chinese capital, a modern world city, using numerous photographs. During this phase, he found his way to his later, all dominating use of digital programs of visual processing that also quote global film production in a Hollywood style, especially the special effects in disaster movies.

2004/2005 can be considered a turning point in Miao Xiaochun's work, for his engagement with differences and analogies between Western and Eastern culture moves from the rather meditative, static context of the photographic snapshot to a more complex structure of several shots taken over time and very time-intensive digital processing on the computer. The beholder of *Celebration* (2004) for example is given the impression that it was taken as only one picture using a fish-eye lens. Upon closer inspection, we see that something isn't right, for there are repetitions and details that are extremely focused. The work was created using around 90 individual shots. A group of workers with yellow helmets for example surfaces in several places in the image. Just as in traditional Chinese landscape painting, we see one and the same figure walking though nature in various locations. Photography thus not only can hold onto a single moment, but also a longer span of time.

Using the technical refinements of digital photography, Miao comes close to the possibilities of human vision. For the human eye, it is no problem to direct the gaze repeatedly towards objects at different distances, to bring them into focus. Photography in contrast usually works with a fixed focal distance, so that the things are increasingly unfocused the further they are from the center. By combining numerous digital photographs at the computer, Miao simulates the eye's way of working, simultaneously destroying the illusion of an authentic representation of reality. Photography has for twenty years been suffering the fate of all analog media whose qualities are being abolished with their integration into the digital code. Information, digitizable or digital, can now be randomly changed on the computer. With the universal machine of the computer, a profound intervention in our understanding of reality is thus undertaken. It is just this transformation that fascinated him as a person living between cultures. On the other hand, this form of visual creation is closely related to the techniques of landscape painting in which certain objects in the foreground or background are emphasized or represented as smaller. Equally, the construction of the image often pursues methods of classical landscape presentation, for it is just as in painting, where in a selective and as it were subjective take on the world compositional techniques are used that are similar to the momentary view of reality. In so doing, Miao holds a special place in art history, due to his visual understanding trained in both East and West.

Before his return to China, he spent five years studying in Germany, from 1995 to 1999. Miao Xiaochun studied at the Kassel art school photography, and became an outsider in two senses: first, in a different, Western culture, and back in Beijing, as a foreigner in

his own country. At the end of the 1990s, he created a sculpture, his alter ego made of fiberglass in the figure of a classical Confucian scholar. This became his trusted partner on foreign terrain. In the midst of usually urban scenes, this dignified figure stands monolithic and sublime, a bit unworldly and yet full of self-confidence in light of his worldview and deeper understanding of life.

His first photographs were black and white, and quite simple, with a modest and reticent feel, in the spirit of the old man in Germany. These photographs represent him as a "mysterious traveler in the West from an unidentifiable time and an unidentifiable place in China" (Wu Hung). Miao himself sees here a mixture of the intellectual and the artist, who in China from the Han to the Song Dynasty (206 BC-1279 AD) had something to say when it came to socially relevant issues. These life conditions, excellent for an artist, also existed in Europe (around 200 years later) with the universal scholars at the courts of the Medici and other Renaissance princes. To that extent, cultural memory, as Miao Xiaochun understands it, when at issue are central questions of our existence, is set no temporal or geographic limits. He does not distinguish between Western and an Eastern visual memory. He thus makes lovely links between this figure at rest in the photographic works of this series between East and West, between old China and a postmodern global zeitgeist. The photograph *As a Guest of a German Family* (1999) shows his alter-ego in the midst of a German family, but where he remains the silent guest. The statue of the old, honorable man can never become part of real life, but remains a symbolic object where at issue is the "loss of context of a native language." "The self is a stranger," as Arthur Rimbaud already knew. For the relationship of the modern Chinese individual to his or her surroundings and own self, this statement is surely more than fitting.

The series ends with the symbolic widescreen photograph *Mirage* (2004). From a raised standpoint, we have a view of a city landscape, a view of Miao Xiaochun's hometown Wuxi Jiangsu near Shanghai. Moving uphill in a cabin on a lift, we see the statue, while we see the artist himself moving downhill. His is moving, leaving history behind him, to a new life, his future. The scholar returns with his creator to the place of his origin, and they look together—in memory and in the present—at the highly changed city structure. In the horizontal format of Mirage, we can see the rapid urban development, from traditional courtyard buildings on the edge of the forest to row houses, tall buildings, the highway, the center with skyscrapers... If he departs from the figure of the scholar, the issue of high-speed urbanization with its impact on residents is clearly visible and culminates precisely in his *Beijing Index* from 2009.

Miao Xiaochun's photographs are in the best sense a conversation the artist holds with himself on the spirit as being and the aura of the analog and the digital image, as a memory and storage of the real absent, albeit momentarily evident. Man as a photographer in analogy to the *Last Judgment* takes on both the role of the judging and the judged. And finally, the possibility of being in the image, of recognition, and at the same time of the spatial, of the panoramic is the most fascinating characteristic of this visual medium. For it is our limited view of the artificial world and its beauty by way of the absolute power of photography that tears apart what belongs together and grants autonomy to the appearance.

„Fotografien, besonders direkte Fotografien, sind sehr lehrreich, weil wir wissen, dass sie in gewisser Hinsicht exakt den Objekten gleichen, die sie repräsentieren. Aber diese den Fotografien verdankte Ähnlichkeit wurde unter derartigen Umständen geschaffen, dass die Fotografien physikalisch gar nicht umhin können, Punkt für Punkt der Natur zu entsprechen. In dieser Hinsicht gehören sie also zu der ... Klasse von Zeichen, die man Index nennt."[I]

Totalstadt, Informelle Stadt, Nordstadt, Verbotene Stadt, Wüstenstadt, Kaiserstadt, Hauptstadt des Reichs der Mitte, Stadt des Windes, Stadt der Fahrräder, Stadt der Objekte, Rasterstadt, Verflochtene Stadt ... Peking oder besser Beijing ist eine Stadt mit vielen Namen und Gesichtern. Weilt man eine zeitlang inmitten der vielen Ringstraßen und den Millionen Menschen der Megapolis, lernt man deren Namen und Gesichter zu schätzen und ihre Lebensart zu verstehen. Peking ist eine kaum zu erfassende, gleichförmige, für viele Fremde jedoch hässliche, nichtssagende Stadt. Ihre schiere Größe, horizontale Ausdehnung und ihre Gleichförmigkeit haben sich in den letzten Jahren jedoch radikal verändert. Von der Verbotenen Stadt, dem Kaiserpalast, zum nationalen Dorf und zur Stadt mit starkem Befestigungswall, dem heutigen zweiten Ring, zur gigantischen 18-Millionen-Megapolis mit sieben Ringstraßen, gleichwohl auch zum globalen „Dorf" als Zentrum des bevölkerungsreichsten Landes der Erde.
Wer Peking ein wenig besser kennt, mag diese Stadt. Auch der 1964 in Wuxi Jiangsu geborene Miao Xiaochun mag sie. Er selber lebt inmitten des größten Stadtentwicklungsgebiet, in Wangjing, dort liegen sein Studio und seine Wohnung, seine Lieblingsrestaurants, seine Akademie, die Central Acadamy of Fine Arts CAFA, an der als Professor Medienkunst lehrt. Dieser Stadtteil im Nordosten des Zentrums von Peking zwischen dem vierten und fünften Ring, westlich von Dashanzi mit dem Kunstviertel 798, ist in den letzten zehn Jahren als eine komplette neue Groß-Stadt mit fast drei Millionen Menschen gleichsam aus dem Nichts entstanden. Dort ist das alte Peking dem neuen Hochhaus-Real-Estate-Geschäftssinn gewichen, dort haben Motorola, Siemens oder Mercedes ihre China-Zentralen errichtet, rasend schnell, ohne Gnade und ohne Rücksicht auf Verluste. Die Immobilien- und Mietpreise in Wangjing sind im Jahr 2009 um 20% gestiegen, was selbst einen Einwohner wie Miao Xiaochun verwundert bis erschreckt.

Jedenfalls setzte er 2008 und 2009 eine Idee um, die nur vor diesem Hintergrund des Hochgeschwindigkeitsurbanismus verständlich ist und die radikale Veränderung des Stadtbildes nicht dokumentiert, aber doch thematisiert.[II] Miao legt ein dichtes Raster über den Stadtplan von Peking und an den Schnittstellen, den Kreuzungspunkten des gleichförmigen Gitters lässt er – in der realen Stadtsituation – unter Verwendung einer 360°-Panorama-Kamera eine Fotografie machen. Während des gut 18 Monate dauernden Vorhaben entstanden auf Basis eines willkürlichen Koordinatensystems 639 Aufnahmen des heutigen Pekings, die Miaos Team dank GPS-Technik minutiös vom Rasterplan auf die Topographie Pekings umsetzen konnte. In die digitale Bildsprache übersetzt, bedeutet dies die Kartographierung der Welt durch Bodenstandorte und einen Rundumblick am Beispiel Pekings. Hiermit zeigt den Masterplan von Peking auf, mit seiner im 12. Jahrhundert angelegten Stadtbefestigung am heutigen innerstädtischen zweiten Ring des gigantischen Ringstraßensystems – den ersten Ring bildet übrigens die „Verbotene Stadt" als Zentrum einer leeren Mitte. Entscheidend bei diesem einzigartigem Projekt war die Neutralität, die Objektivität des Verfahrens und die von der Ursprungsidee ausgehende

[I]
The collected Papers of Charles Sanders Pierce, hrsg. von Charles Hartshorne und Paul Weiß, Cambridge, Mass. 1931, Bd.II: 159.

[II]
Vgl. Ausst-Kat. ZKM 2006, *Totalstadt. Beijing Case. kulturelle Aspekte der Hochgeschwindigkeitsurbanisierung in China*, hrsg. von Gregor Jansen. Köln 2006.

Ignorierung und Ausblendung eines künstlerischen und damit subjektiven Bezugs zum System eines Index, den Miao unbedingt zu vermeiden wollte. Das Ergebnis beinhaltet die Sichtung, die Erfassung und Dokumentation des heutigen Erscheinungsbildes der Stadt mit ihrem bisweilen sehr dörflichen Charakter, ihrer Introspektion und Individualität, aber auch ihrer „Genericity" (Rem Koolhaas), ihrer identitätslosen Austauschbarkeit.

Die Fotografie war schon immer das Beste aller Repräsentationsmedien.[III] Mit ihrer Hilfe wurden alle anderen Medien subsumiert, analysiert und distribuiert. Die Zeit schien mit ihr und in ihr geborgen, konzentriert und kondensiert. Heute ist die Fotografie durch die Computergrafik von dieser Position in eine neue, andere und tragische Rolle gedrängt, oder verdrängt worden; sie ist zu einer der reproduzierbaren Repräsentationsformen verkommen. Mit der elektronischen Bildverarbeitung nähert sich der digitale fotografische Apparat dem an, worauf sich Hollis Frampton mit dem Begriff des „dubitativen Prozesses" in der Malerei bezieht: Wie der Maler spielt der digitale Fotograf „solange mit dem Bild herum, bis es richtig aussieht".[IV]

Diejenigen, die aus dieser Einführung des Dubitativen – was das Wörterbuch mit „zum Zweifel neigend" oder „zweifelhaft" übersetzt – für die Fotografie eine Theorie ableiten wollen, können dabei in verschiedene Richtungen denken. Am bekanntesten ist die, die William J. Mitchell in *The Reconfigured Eye* eingeschlagen hat, als er die Zerstörung des fotografischen Wahrheitsgehaltes untersuchte, auf den sich Susan Sontag mit ihrer Aussage bezog, dass „... eine Fotografie als unbezweifelbarer Beweis dafür gilt, dass etwas Bestimmtes geschehen ist".[V] Während postmoderne Theoretiker diese Behauptung des Wahrheitsgehaltes für die Fotografie schon seit Langem bestreiten, beweist die heftige Debatte über die digitale Bildverarbeitung, dass die Öffentlichkeit noch immer am evidenten Wesen der Fotografie festhält. Wie Mitchell und andere gezeigt haben, werden die Rezipienten im Zeitalter der anzweifelbaren digitalen Fotografie dazu gezwungen, der Bildquelle oder der Wahrhaftigkeit des Bildkontextes zu vertrauen.[VI] In dieser Hinsicht muss die digitale Fotografie so verstanden werden, dass sie denselben Wahrheitsgehalt wie ein geschriebener Text besitzt. Daher sind wir gewissermaßen in die Ästhetik des präfotografischen Zeitalters und zu einer Zeichenwelt zurückgekehrt, die sich wieder einmal auf die Dichotomie zwischen Wort und Bild reduziert, aber diesmal dadurch verbunden wird, dass sowohl das Wort als auch das Bild Amalgamierungen des binären Codes sind. Dieses Beharren auf dem Kontext und auf der Interpretation gilt natürlich nicht nur für die digitale Fotografie, sondern ganz allgemein. Die Zersplitterung der indexikalischen Beziehung zwischen der Fotografie und ihrem Gegenstand ist für die Epistemologie der Postmoderne von großer Bedeutung und stellt für die Politik einer von Bildern gesättigten Kultur eine offensichtliche Beunruhigung dar. (Ein weitreichendes und heikles Thema in China). Doch die überwältigende Aufmerksamkeit, die den Themen Betrug, Täuschung und Wahrheitsgehalt zuteil wird, kann der Entwicklung in einem andern Diskursbereich, der mit der Fotografie zu tun hat, den Blick entziehen: Der Zusammenbruch der indexikalischen Beziehung zwischen der Fotografie und ihrem Referenten und die damit einhergehende Tilgung des Wahrheitsgehaltes der Fotografie hatte dieselben Auswirkungen wie die Zersetzung der Aura beim Aufkommen der Fotografie selbst. Insofern hat Miao Xiaochun intuitiv richtig gehandelt, wenn er bei seiner Idee, einen Index von Peking auf Basis eines willkürlichen Rasters zu erstellen, alle Einflussnahme ausblendet und diesen von anderen Personen umsetzen lässt. Somit scheint er keine Manipulation, keinen Betrug und keine Lüge zuzulassen.

III

Vgl. für diesen Absatz: Hubertus von Amelunxen, Stefan Iglhaut und Florian Rötzer (Hrsg.): *Fotografie nach der Fotografie. Ein Projekt des Siemens Kulturprogramms*, Dresden und Basel 1996, vor allem: S. 93–99.

IV

Hollis Frampton: *Digressions on the Fotografic Agony*, in: *Circles of Confusion: Film, Photography, Video: Texts 1968–1980*, New York 1983, S. 177–191, hier: S. 190.

V

Zit. nach William J. Mitchell: *The Reconfigured Eye: Visual Truth in the Post-Photographic Era*, Cambridge 1992, S. 24. Vgl. auch den Katalog der Ausstellung *Digital Photography* am San Francisco Camerawork 1988, die von Marnie Gillett und Jim Pomeroy organisiert wurde. Der Katalog mit dem Titel *Digital Photography: Captured Images, Volatile Images, New Montage* enthält zwei Essays: Timothy Druckreys *L'Amour Faux* (S. 2–9) und Martha Roslers *Image Simulations, Computer Manipulations: Some Ethical Considerations* (S. 28–33).

VI

Man hat gelegentlich gefordert, dass digital veränderte Bilder durch ein besonderes Zeichen markiert und damit identifizierbar gemacht werden sollten. Ein norwegischer Vorschlag lautet, dafür das Wort „Montasje" zu verwenden und den Großbuchstaben „M" als standardisierten Hinweis für eine Veränderung einzusetzen. John Larrish: *Digital Photography: Pictures of Tomorrow*, Torrance 1992, S. 160.

Miao Xiaochun war während des autonomen Entstehungsprozesses von *Beijing Index* mit einem komplementär anderen Projekt beschäftigt: Mit der modernen, zeitgemäßen, digitalen Umsetzung und Übersetzung von Hieronymus Boschs Triptychon *Der Garten der Lüste* von 1516 aus dem Prado in Madrid. Eine monumentale Hommage, die als Animation aus Fotografien, Skizzen, Stickbildern und Computergrafiken einen neuen Kosmos pseudo-religiöser Offenbarung der Weltenmystik darlegte. *Microcosm* lautete sein Titel und wurde 2008 nach einem einjährigen Arbeitsprozess fertig gestellt, dem jedoch eine mehrjährige Beschäftigung mit der Kosmologie westlicher, meist religiös inspirierter Historienmalerei voraus ging. Zur Auseinandersetzung mit den grundlegenden Fragestellungen menschlicher Existenz, Geburt, Tod, Liebe, Himmel, Gott und dem Sinn unseres Lebens schlechthin, schien Miao die Adaption bekannter Bildmotive westlicher Provenienz und starke Aussagen mit heutigen Bildfindungsmethoden zu generieren hilfreich. Eine Art Paravent mit neun riesigen Bildtafeln schildert seine Interpretation des Flügel-Altares von Bosch, der als surreales Meisterwerk der Renaissance immer wieder zu neuen Weltformeln inspirierte. Auf Chromogenetic-Prints nimmt Miao uns wie Alice hinter den Spiegeln mit in den mittels Computertechnologie gerechneten und somit virtuell begehbaren Garten der Lüste, der wiederum einen Blick in sein eigenes Gehirn erlaubt.

Das Jüngste Gericht, Michelangelos Fresko aus der Sixtinischen Kapelle in Rom, ist ebenfalls ein gigantisches Cyberepos, welches von Miao in eine postmoderne Weltensicht übertragen wurde. Das Fresko befindet sich weit entfernt von Peking, auf der anderen westlichen Seite des Globus und im alten Zentrum des christlich regierten Weltreichs. Für den chinesischen Künstler stellt es zugleich einen bedeutenden Teil des kulturellen Gedächtnisses heutiger Bildernarren dar. Gesehen hat er dieses von Japanern vor gut 20 Jahren auf Hochglanz polierte Gesamtkunstwerk aus vormals rußgeschwärzten Bildzyklen nie, aber detaillierte Abbildungen in Kunstbänden genügen ihm, um sich virtuell in das neoplatonische Figuren- und Farbengemisch des *Jüngsten Gerichts* zu begeben. Die vormals ikonographisch vieldeutigen Bilder werden bei Miao zu zeitgemäß übersetzten Träumen des eigenen Vorstellungs- und Lebensraumes, der sich spielerisch und mit surrealen Kombinationen zu neuen Bildern transformieren lässt. In der Fotoserie und im kolossalen Video-Triptychon *The Last Judgment in Cyberspace* von 2007 zeigt Miao, wie sich durch einen beinah introspektiven Perspektivenwechsel die grundlegende Sinnkonstruktion des Werks verändert. Hybrid mutet die Neubesetzung der annähernd 400 Figuren Michelangelos durch das Alter Ego des Künstlers an, da wir mit ihm, mit seiner Imagination, in die Sixtinische Kapelle eintreten.

Vor dieser virtuellen Phase der anthropologischen Bildrealität versuchte sich Miao Xiaochun ab dem Jahr 2000 mit großformatigen C-Prints in einer Annäherung an seine neue Heimatstadt Peking. Herausragend sind seine Aufnahmen des Stadtteils SOHO mit dem Titel *Celebration* (2004) und *Await* (2005) des sogenannten „Silicon Valley" in Peking oder der Nachtaufnahme eines neuen Shopping Centers neben einem auf alt gestylten Restaurant *Surplus* (2007). Mit diesen wandfüllenden C-Prints schuf er Ikonen einer zeitgenössischen Stadtvedute. Miao kombinierte die rasanten Veränderungen Pekings und setzte aus zahlreichen Fotografien ein neues, dynamisches Bild der Hautstadt Chinas, einer modernen Weltmetropole zusammen. In dieser Phase fand er zu seinem später alles dominierenden Umgang mit digitalen Bildverarbeitungsprogrammen, die auch globale Filmproduktionen à la Hollywood, vor allem wenn es um Spezialeffekte in Katastrophenfilmen geht, zitieren.

2004/05 darf als Wendemarke in Maio Xiaochuns Schaffen verstanden werden, denn seine Auseinandersetzung mit den Differenzen und Analogien der westlichen zur östlichen Kultur greift aus dem eher meditativen, statischen Kontext der fotografischen Momentaufnahme in eine komplexere Struktur von mehreren Aufnahmemomenten und sehr zeitintensiver digitaler Nachbearbeitung am Computer über. So hat der Betrachter von *Celebration* (2004) den Eindruck, diese sei mit einer Fisheye-Linse als nur ein Bild gemacht. Bei genauerer Betrachtung fällt jedoch auf, dass etwas nicht stimmt, denn es gibt Wiederholungen und gestochen scharfe Details. Die Arbeit ist aus etwa 90, in größeren Zeitabschnitten ent-standenen, Einzelaufnahmen zusammengesetzt worden. Eine Gruppe von Arbeitern mit gelben Helmen beispielsweise taucht an mehreren Stellen im Bild auf. Wie in der traditio-nellen chinesischen Landschaftsmalerei sieht man ein und dieselbe Figur an verschiedenen Stellen durch die Natur schreiten. Fotografie kann also durchaus nicht nur den Augenblick festhalten, sondern auch eine längere Zeitspanne.

Durch die technischen Raffinessen der Digitalfotografie kommt Miao den Möglichkeiten des menschlichen Sehens nahe. Für das menschliche Auge ist es kein Problem den Blick immer wieder auf unterschiedlich entfernte Objekte zu richten, zu fokussieren, „scharf zu stellen". Die herkömmliche Fotografie hingegen arbeitet mit einer festen Brennweite, so dass die Dinge vom Zentrum ausgehend unschärfer werden. Durch die Zusammensetzung zahlreicher Digitalfotos am Computer simuliert Miao die Funktionsweise des Auges, zer-stört simultan und endgültig aber auch die Illusion einer authentischen Abbildung von Wirklichkeit. Die Fotografie erleidet seit 20 Jahren das Schicksal aller analogen Medien, deren Eigenschaften mit der Integration in den digitalen Code aufgehoben werden. Die gelieferten digitalisierbaren oder digitalen Daten werden am Computer beliebig veränder-bar. Mit der Universalmaschine Computer wird somit tief in das Verständnis von Wirklich-keit eingegriffen. Genau diese Veränderung hat ihn als interkulturell lebenden Menschen fasziniert. Andererseits ist die Art und Weise der Bildherstellung stark mit den Techniken der Landschaftsmalerei verwandt, in der bestimmte Gegenstände im Vorder- oder Hinter-grund betont oder aber verkleinert dargestellt werden. Ebenso folgt der Bildaufbau häufig Methode klassischer Landschaftsdarstellung, denn es ist dieselbe wie in der Malerei, bei der in einer selektiven und gleichsam subjektiven Weltsichtung kompositorische Verfahren angewandt werden, die dem augenscheinlichen Anblick der Realität ähnlich sind. Dabei nimmt Miao durch sein in der östlichen und westlichen Welt trainiertes visuelles Verständ-nis eine kunsthistorische Sonderstellung ein.

Vor seiner Rückkehr nach China stand von 1995 bis 1999 ein fünfjähriger Studienaufenthalt in Deutschland. Miao Xiaochun studierte an der Kasseler Kunsthochschule Fotografie und wurde in doppelter Hinsicht zum Fremden: einmal in einem anderen, westlichen Kultur-kreis und – zurück in Peking – als Auswärtiger im eigenen Land. Ende der 1990er Jahre schuf er eine Skulptur, sein aus Fiberglas gefertigtes Alter Ego in Gestalt eines klassischen Gelehrten konfuzianischer Prägung. Dieser wird zu seinem vertrauten Partner auf einem fremden Terrain. Inmitten der meist städtischen Szenarien steht diese würdevolle Figur monolithisch und erhaben, ein wenig weltfremd und doch voller Selbstbewusstsein ange-sichts seines Weltgeistes und tieferen Verständnis des Lebens.

Seine ersten Fotografien waren schwarzweiß und eher schlicht gehalten, von bescheidener und zurückgenommener Anmutung im Zeichen des alten, weisen Mannes in Deutschland. Diese Fotografien repräsentieren ihn als „mysteriösen Reisenden im Westen aus einer nicht identifizierfarben Zeit und einem nicht identifizierbaren Ort aus China" (Wu Hung). Miao selbst sieht in ihm eine Mischung aus Intellektuellem und Künstler, die im China der Han-, bis Song-Dynastie (206 v.–1279 n. Chr.) ein wesentliches Mitbestimmungsrecht bei gesellschaftlich relevanten Fragen besaßen. Diese für einen Künstler vortrefflichen Lebens-umstände gab es auch in Europa (etwa zweihundert Jahre später) mit den Universalgelehr-ten an den Höfen der Medici und anderer Renaissancefürsten. Insofern kennt das kulturelle Gedächtnis, wie es Miao Xiaochun versteht, wenn es um die zentralen Fragen unseres Daseins geht, keine zeitlichen oder geografischen Begrenzungen. Er unterscheidet nicht zwischen westlichem und östlichem Bildgedächtnis. So knüpft seine der Ruhe verhaftete Figur in den Fotoarbeiten dieser Serie wunderschöne Verbindungslinien zwischen Osten und Westen, zwischen altem China und postmodernem globalen Zeitgeist. Die Fotografie *As a Guest of a German Family* (1999) zeigt sein Alter Ego inmitten einer deutschen Tisch-gesellschaft, zu der er zwar geladen ist, bei der er aber stummer Gast bleibt. Die Statue des alt-ehrwürdigen Mannes kann nie Teil des realen Lebens werden, sondern bleibt ein sym-bolisches Objekt, bei dem es auch um den um den „Kontextverlust der eigenen Sprache" geht. „Das Ich ist ein Anderer", wusste schon Arthur Rimbaud. Für das Verhältnis des modernen chinesischen Menschen zu seiner Umwelt und zu seinem eigenen Ich ist diese Aussage sicherlich mehr als zutreffend.

Mit der symbolträchtigen Breitbildaufnahme *Mirage* (2004) endet die Serie. Von einem erhöhten Standpunkt aus haben wir einen weiten Blick auf eine Stadtlandschaft. Es handelt sich hierbei um Miao Xiaochuns Heimatstadt Wuxi Jiangsu in der Nähe von Shanghai. In einer Kabine einer Sesselbahn bergaufwärts fahrend, sehen wir die Statue, in einer anderen bergabwärts, den Künstler selber. Er fährt, die Historie hinter sich lassend, in ein neues Leben, seine Zukunft. Der Gelehrte kehrt mit seinem Urheber an den Ort des Ursprungs zurück und sie blicken gemeinsam – in der Erinnerung und in der Gegenwart – auf das stark veränderte Stadtgefüge. Im Längsformat von *Mirage* lässt sich somit die rasante urbane Entwicklung nachvollziehen, von traditionellen Hofhäusern am Waldrand zu Reihenhäu-sern, Hochhäusern, der Autobahn, dem Zentrum mit Wolkenkratzern... Wenn er auch die Figur des Gelehrten verabschiedet, ist das Thema der Hochgeschwindigkeitsurbanisierung mit seinen Auswirkungen auf den Menschen klar ersichtlich und mündet präzise in seinen *Beijing Index* aus dem Jahr 2009.

Miao Xiaochuns Fotografien sind im besten Sinne ein Selbstgespräch über den Geist als Wesen und die Aura des analogen und digitalen Bildes, als ein Gedächtnis und Speicher des real Abwesenden, gleichwohl augenscheinlich Evidenten. Der Mensch als Fotograf übernimmt in Analogie zum *Jüngsten Gericht* sowohl die Rolle des Richtenden als auch die des Gerichteten. Und letztlich ist die Möglichkeit des im Bilde-Seins, der Erkenntnis und gleichzeitig des Räumlichen, Panoramatischen, das faszinierendste Charakteristikum jenes Bildmediums, da es unsere begrenzte Sicht auf die künstliche Welt und ihre Schön-heit mittels der absoluten Macht der Fotografie, die auseinanderreißt, was zusammen-gehört und der Erscheinung Autonomie verleiht.

A VISITOR FROM THE PAST
COLORED 2002–2004

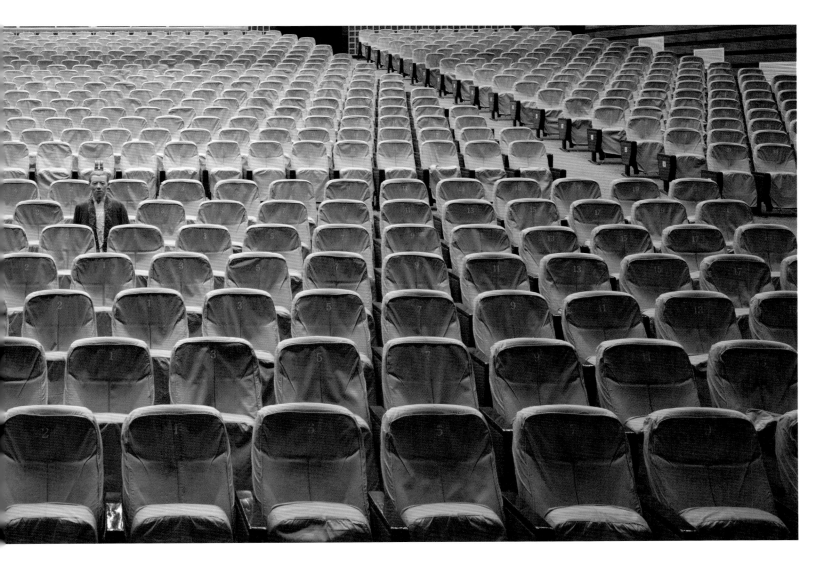

Congressman, 2002
Photograph, 222 x 600 cm

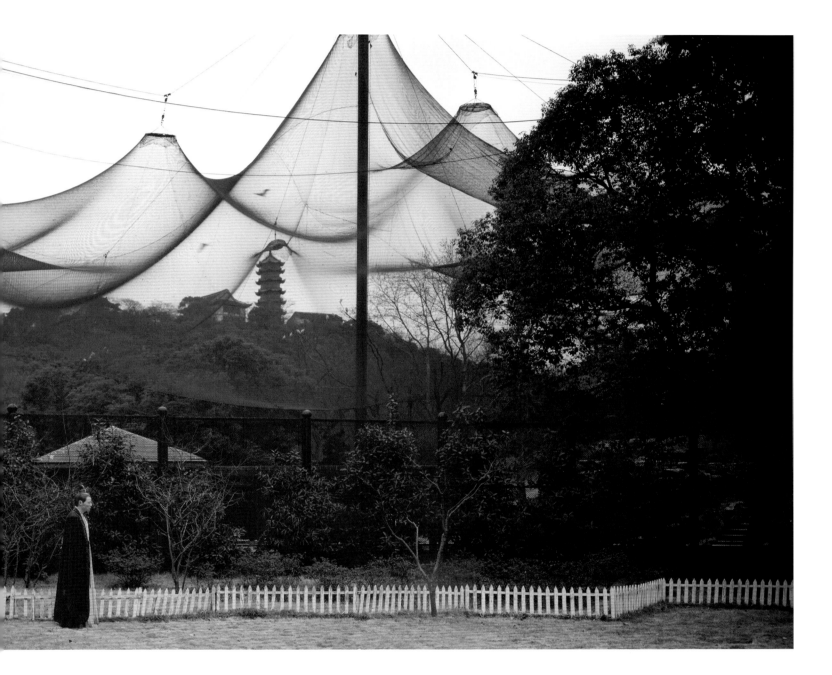

Fly, 2002
Photograph, 122 x 290 cm

Next page: **Opera** (Detail), 2003
Photograph, 236 x 600 cm

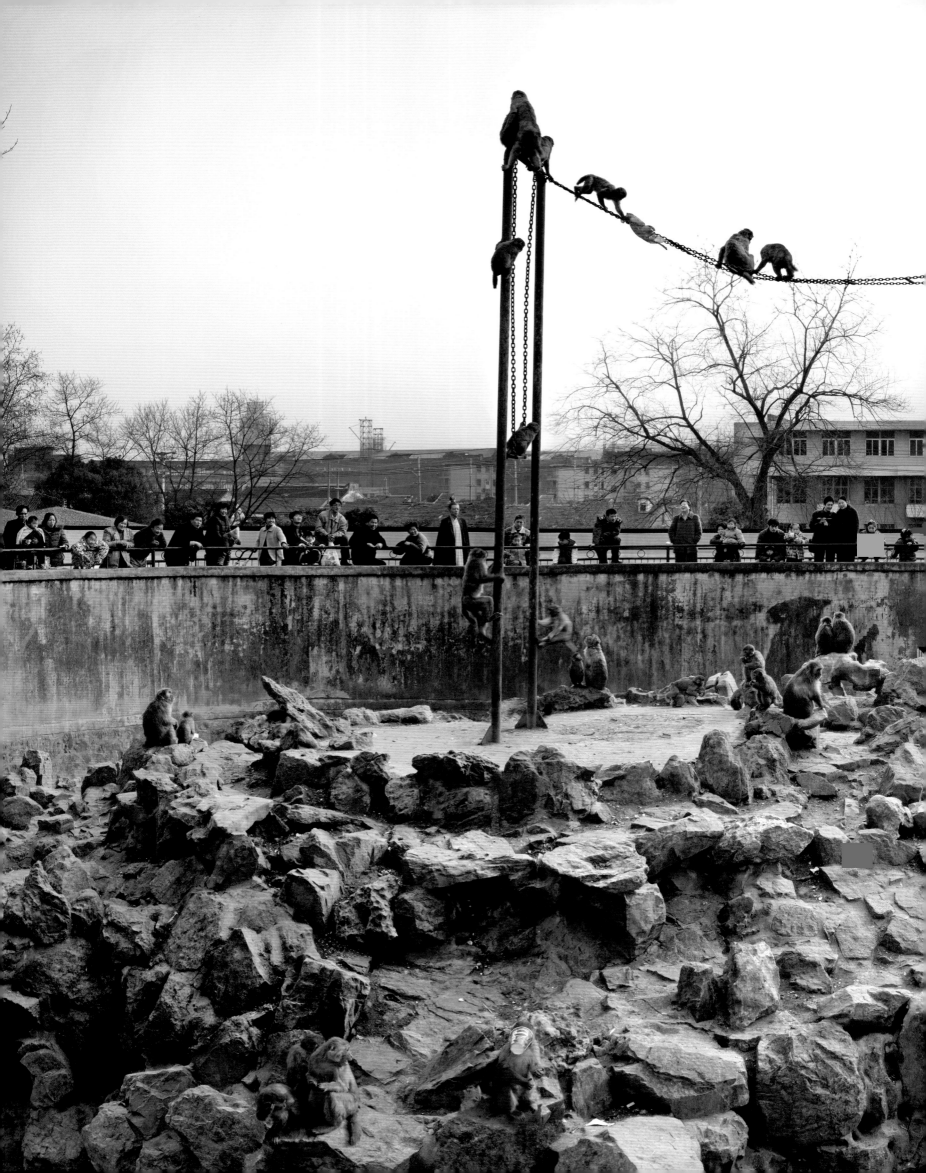

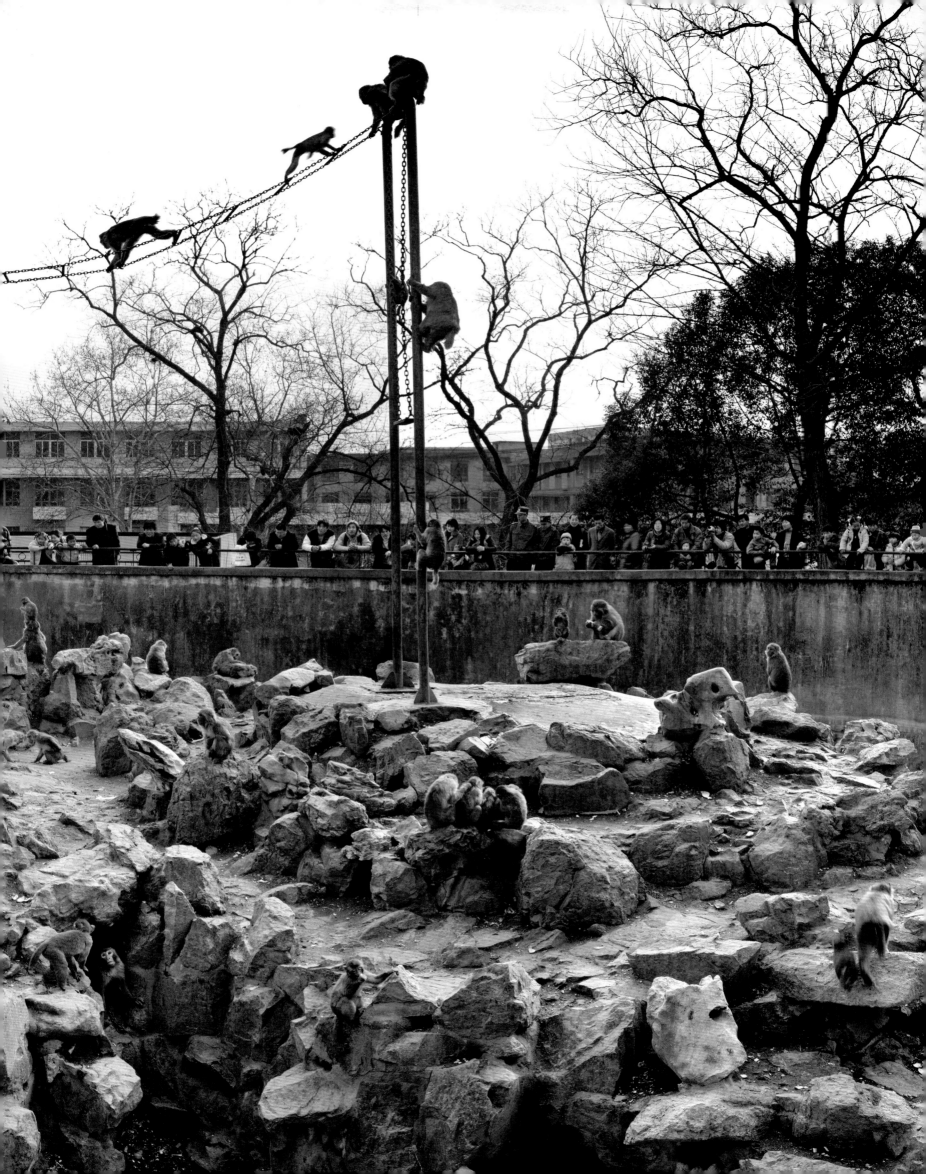

How Time Flies!, 2002
Photograph, 122 x 267 cm

Therapy, 2002
Photograph, 345 x 120 cm

Ferry, 2002
Photograph, 304 x 122 cm

144

Voyage, 2002
Photograph, 356 x 120 cm

Capital, 2003
Photograph, 376 x 120 cm

146

Contribution, 2002
Photograph, 362 x 120 cm

Towering, 2002
Photograph, 408 x 120 cm

148

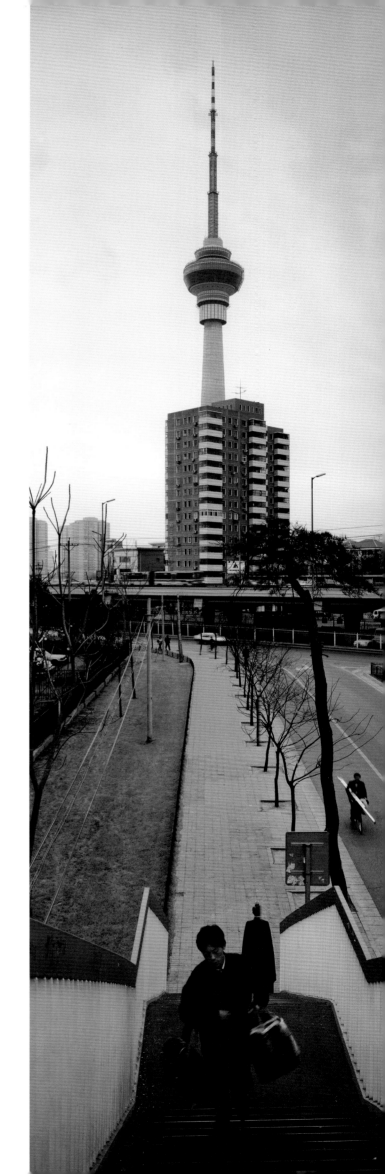

Lingering under a lone Pine, 2002
Photograph, 402 x 120 cm

Mirage, 2004
Photograph, 180 x 800 cm

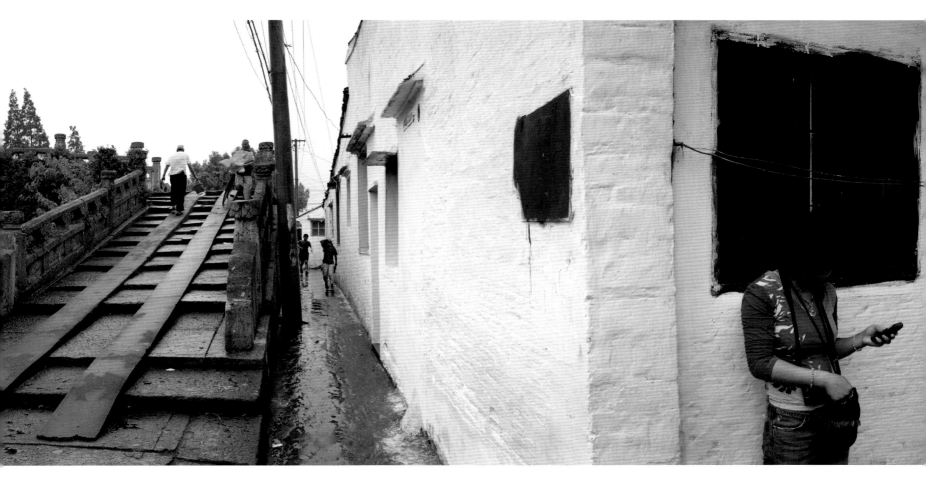

Transmission, 2002
Photograph, 120 x 500 cm

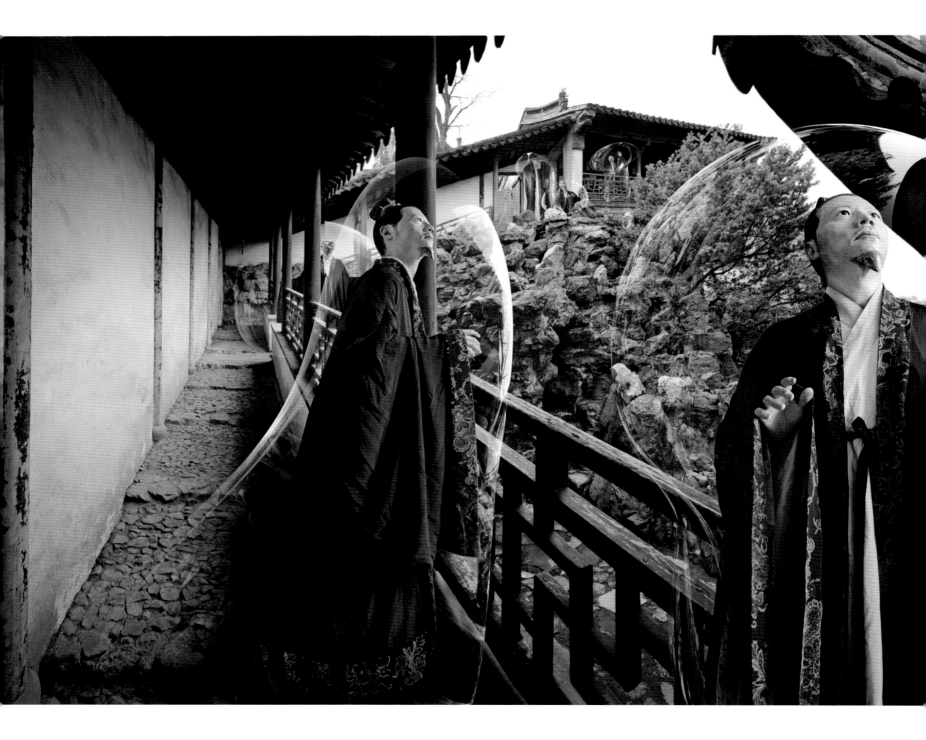

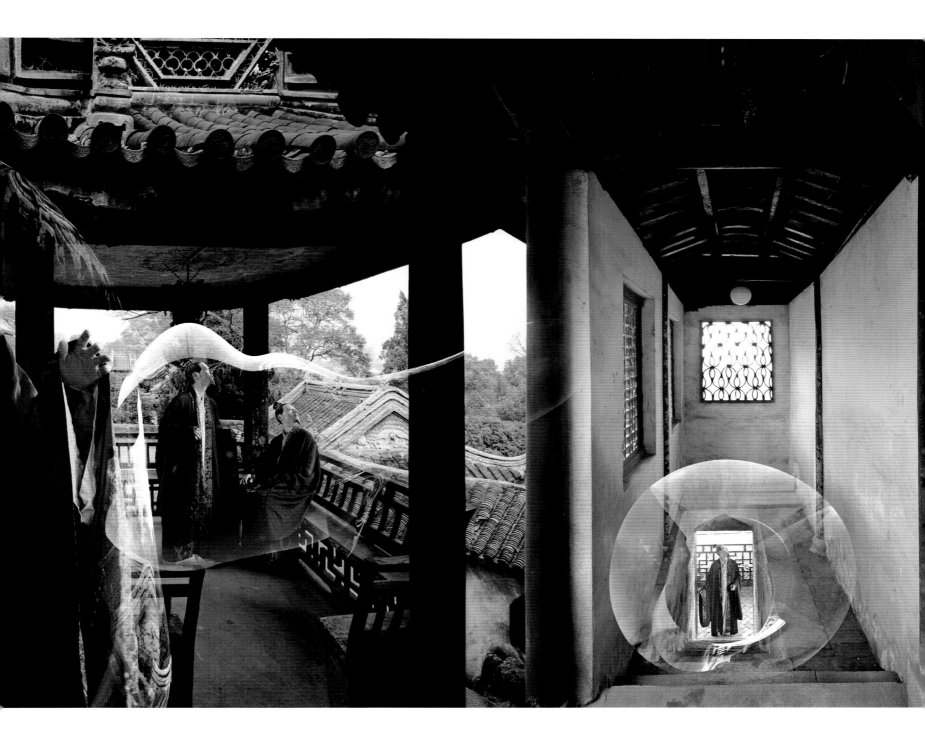

Terror, 2003–2005
Photograph, 180 x 480 cm

A VISITOR FROM THE PAST
B&W 1999–2001

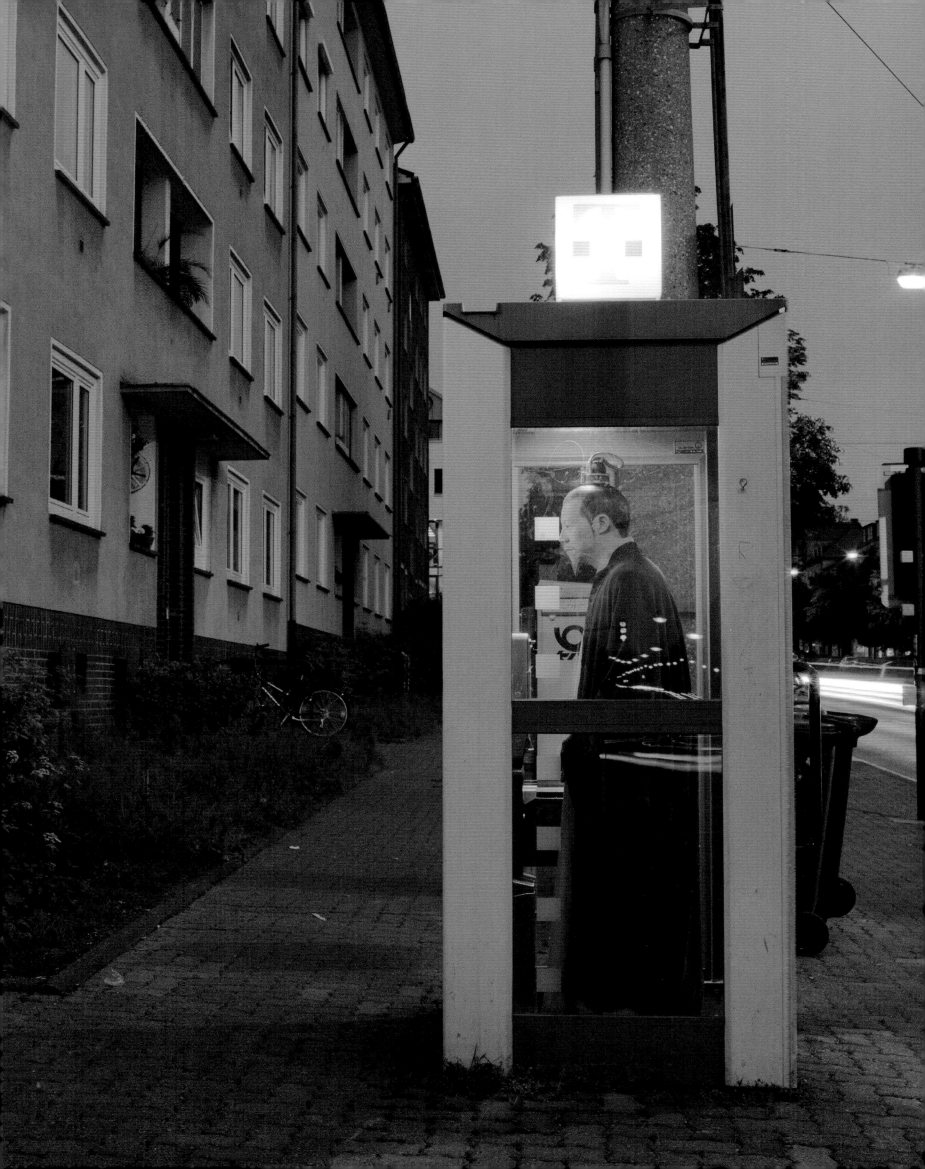

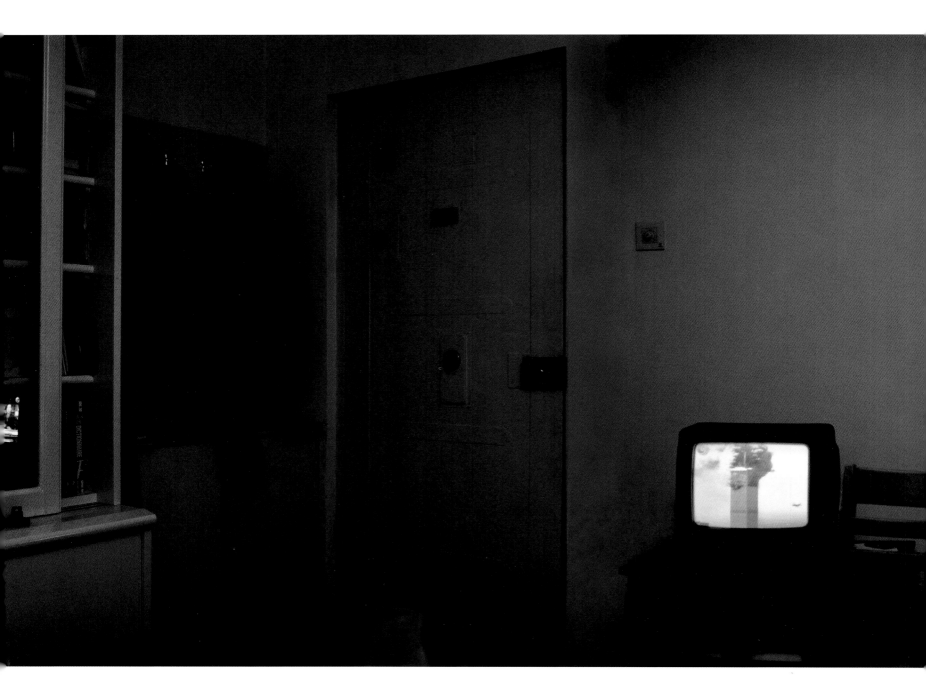

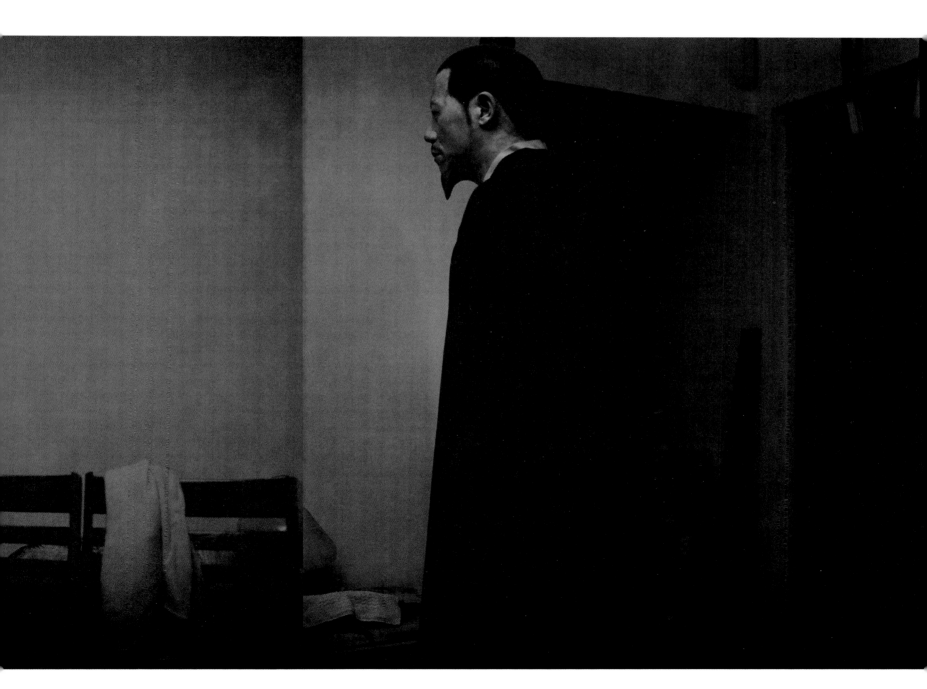

September 11, 2001
b&w Photograph, 122 x 390 cm

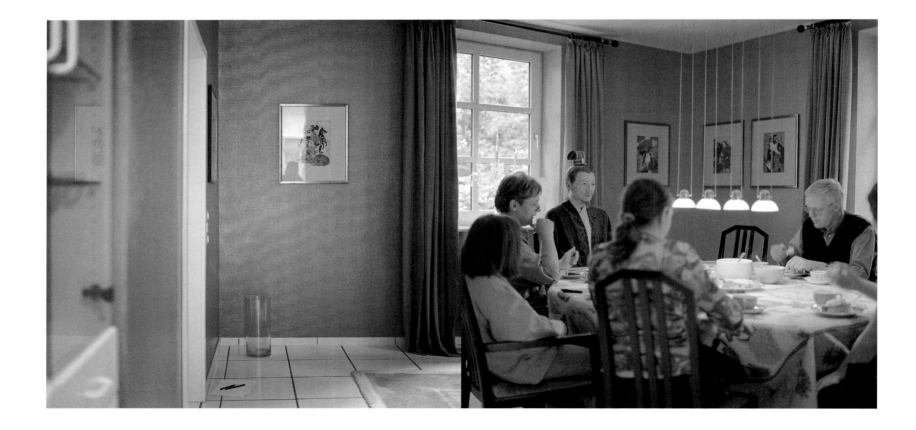

As a Guest in a German Family, 1999
b&w Photograph, 127 x 262 cm

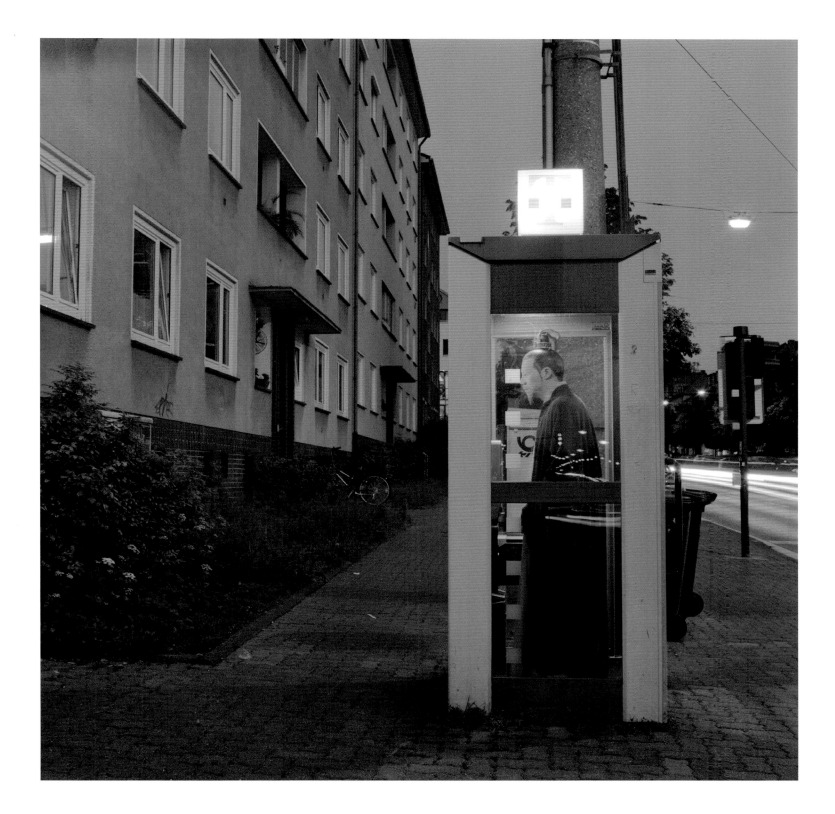

Telephone Booth, 1999
b&w Photograph, 120 x 120 cm

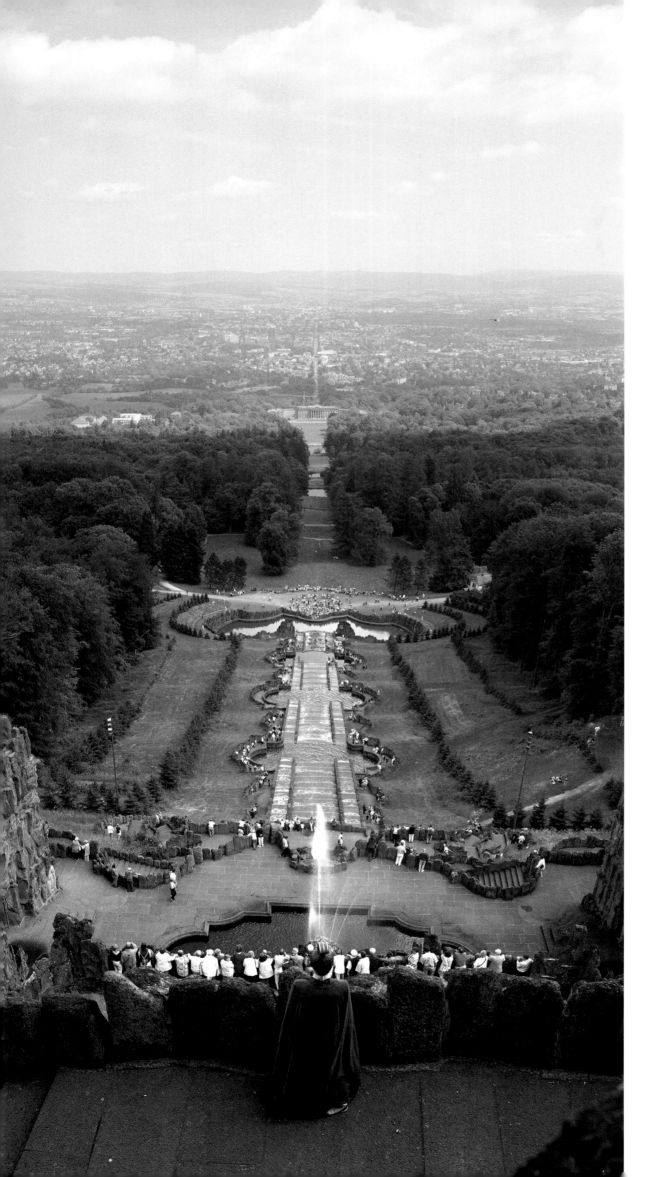

Image, 2001
b&w Photograph, 122 x 287 cm

On Herkules, 1999
b&w Photograph, 233 x 120 cm

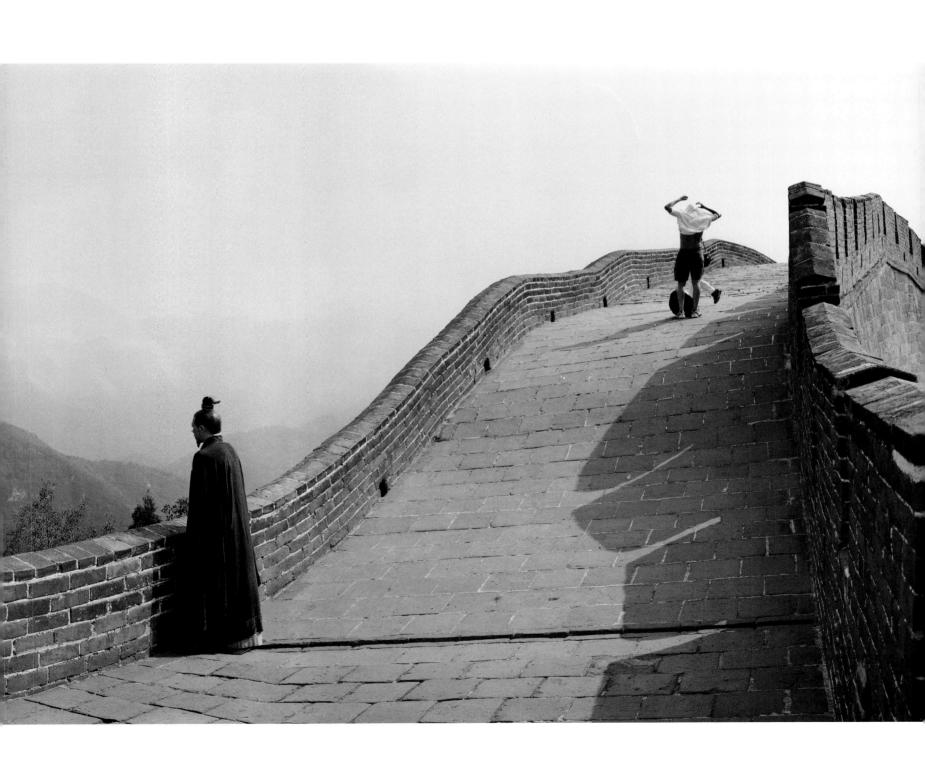

The Great Wall two thousand years ago, 2001
b&w Photograph, 120 x 336 cm

No Hostility, 2001
b&w Photograph, 122 x 390 cm

Restaurant, 2001
b&w Photograph, 122 x 287 cm

Industrial World, 1999
b&w Photograph, 122 x 247 cm

WU HUNG IN CONVERSATION WITH MIAO XIAOCHUN
WU HUNG UND MIAO XIAOCHUN IM GESPRÄCH

'YOU MIGHT THINK I WAS JAPANESE OR KOREAN'
ON SELF-PORTRAYAL IN MIAO XIAO-CHUN'S WORK

Wu Hung (hereafter WH) Let's start with your education and career. Yesterday you said that you first studied art history.

Miao Xiaochun (hereafter MXC) Actually my college major was German. Although I had always loved to paint, I was turned down twice by the Nanjing Art Academy—my paintings showed too much influence from modern Western art, and the people in the academy decided that I was not the right student for them. However, because

my grades in humanities were good, I was able to pass the entry exam to enter the German Department at Nanjing University and could begin my studies there. I still couldn't forget art, however, so after graduating from college I applied for the Master's program in the Department of Art History of the Central Academy of Fine Arts, and was admitted. In that program I focused on the history of modern Chinese art, but I continued to paint and eventually became a freelance painter after graduating from the Central Academy.

WH Which years were you a freelance artist?

MXC From 1989 to 1995. However toward the end of this period I decided that I should study art abroad, so I went to Germany.

WH What kind of painting were you doing then? Are your photographs related to these earlier paintings?

MXC The paintings were oil and semi-abstract. My photographs place a strong emphasis on composition, and I think that this comes from my training as a painter. Actually, I've always wanted to practice traditional painting but this hope has never come true for me. Many of my photographs have elongated compositions similar to a horizontal hand scroll or a vertical classical hanging scroll. Other features of traditional painting, such as an altered perspective, also have a definite impact on my photographs.

WH What did you study in Germany?

MXC My training there included various artistic techniques, not just painting but also sculpture, ceramics, and photography.

WH Why did you choose Kassel?

MXC At that time my professor at Kunsthochschule Kassel had just established an exchange program with China. Through him I went to Kassel as an exchange student. I was attracted by Kassel as the location of the documenta exhibitions, and thought that it would be a good place to become familiar with new developments in contemporary art. When I arrived I found Kassel a quiet, mid-sized town. It was easy to travel from there to other cities in Germany and Europe, to visit museums in surrounding areas. In Kassel I pursued an art project that then became my first photographic series.

WH Was it your graduation exhibition at Kunsthochschule Kassel?

MXC Yes. It was a set of black and white photographs, which marked the beginning of a much larger project. After I returned to China I continued this project but in a new direction.

WH Now we can move on to discuss your photographic works. For example, from your point of view, how has your photography developed? From the very beginning you included a mannequin in your photographs—a Chinese gentleman with your face but dressed in ancient clothes. Of course the meaning of this figure may have changed over the years, but what was your original impulse to create and photograph this figure?

MXC At the time I was a Chinese living in Europe. I wanted to express some of the complex and deep feelings I had there in my photographs. Then the question became how I could achieve this goal. I couldn't simply photograph myself because my appearance, my clothes and my gestures had nothing particular about them and I couldn't really reveal my inner feelings through them. People who saw

me might think I was Korean or Japanese. Then I began to think about what kind of self-image I should communicate in my pictures. This image of myself should make me feel proud—I wanted him to represent Chinese culture at its prime moment, such as during the Tang or Song dynasty.

Of course, there had already been contemporary artists who had photographed themselves in disguise. However I wanted to have complete control over this self-image and the entire composition at the same time. There is a major difference between my work and a self-portrait in disguise: while a self-portrait in disguise focuses exclusively on the figurative image, my picture would exist even if you did not see the figure. The mannequin is only one of many elements in the picture, not the central one. This feature is again related to ancient Chinese ink-painting. Many old landscape paintings have tiny figures called "dianjing renwu" in them. Although these figures are very important to the composition, the whole painting still remains coherent and expresses the artist's intention when you cover them.

WH So this figure represents both an individual and a cultural tradition, and is part of a larger pictorial construct. This seems to have been very clear from your first series on. However these works created in Germany also differ from your later photographs in that they often situate the figure within social occasions such as a classroom seminar or a family gathering. These pictures seem to revolve around communication and lay their emphasis on the figure's relationship with real human beings.

MXC Cultural communication is indeed a dominant theme in these photographs from my German period, which have a strong narrative component. But later, especially in the works I created in China,

this figure merged increasingly into the surrounding environment, becoming one of many elements in a picture.

WH So if your early photographs are about your relationship with an alien culture, are your later photographs then about your relationship with Chinese culture itself? But it seems that these later works shows a consistent "disharmony" between the figure and the environment. So my question is: If this figure represents Chinese culture, then what is the source of such continuous disharmony?

MXC Actually, the relationship between this figure and contemporary China is even more "disharmonious" than in my German pictures—its appearance in a Chinese city seems even more abrupt and illogical. I think this is because China's changes in recent years have been extremely abrupt and fast.

WH Yes. In these pictures this figure looks blank and seems at a loss.

MXC When I made this figure I was attracted by the unchanging, mysterious look on his face. This is why I didn't want to photograph myself: in reacting to different situations, I would have shown too much expressiveness.

WH How did the German audience react to this figure? Although you created this image as an authentic representation of Chinese cultural tradition, I wonder whether it couldn't also be perceived as another stereotypical image of China. Does it only reflect your own notion of China, or can it also reflect an outsider's conception of Chinese culture?

MXC In Germany I read many books about China. Most of them describe Chinese as Manchus of the last dynasty, with a queue

and thin moustache. However I wanted to represent the Chinese people through a different image from a glorious and brilliant period, such as the Han or Tang periods. Westerners know little about these periods. They know more about the era of decline and the chaotic periods such as the late Qing era or the Cultural Revolution. This is regrettable. I didn't want to consider these periods of decline as representative of China. I prefer to see and depict Chinese as shidafu—people who are cultured and intellectual. I think that if I had been born a thousand or two thousand years ago, I would have probably been such a person, to whom learning is more important than anything else.

WH That could have been your conceptualization of this figure. However the pictures you made in Germany seem to say something different: arriving at a train station or standing in a telephone booth, this figure seems lost and misplaced, while the people around him look real and active. One feels that he does not have a language and thus he keeps silent while other people are talking to each other. It seems as though you wanted to glorify a great tradition, but this tradition has no place in the situation you represent.

MXC Yes, we can say that this is a "state of loss of language" (shiyu zhuangtai), which was related to my personal experience in Europe. In that environment it was very difficult for me to express my feelings and to communicate with other people. For example, if I was prompted by an event to recite Tao Yuanming's famous lines: "Picking chrysanthemums beneath the eastern fence, I leisurely turn my eyes to the southern peaks," only a few people could understand what I was thinking and talking about. It is a "symptom of loss of language" (shiyu zheng) because the context of language (yujing) has disappeared.

You are right to say that it is a kind of misplacement. The context of Tao Yuanming's poetic expression has been withdrawn.

WH I can understand this problem well because I also lived for a long time in the West. Discussions of your early work have often focused on the issue of the gaze. This is certainly an interesting issue, because in my view, this figure actually doesn't have an aligned gaze or a clearly defined field of vision. But language and communication are equally important to understanding your works. Now, if we move on to examine your later works, does this problem of the loss of language still exist there?

MXC I think that it is still there—at least partly.

WH In what way has the figure partly recovered his ability to communicate?

MXC Perhaps I should first talk about the part in which the problem of the loss of language continues. Let me use the photograph *Ferry* as an example. This picture shows a modern bridge over the Huangpu River. In a car, we can drive across the river over this bridge. What an ancient poet wrote: "At an empty ferry station in the wilderness, only a boat floats on the water" is today no longer the case. If someone crossed the river on a small wooden boat now, it could only be an art project.

WH So here we return to the concept of yujing, the context of an expression. Once this context has disappeared, though you can of course still quote one or two sentences of an ancient poet, their meaning is different. But as you have said, this problem has been partly solved in China. How is this so?

MXC I think that in China, an ancient expression can still be somehow related to

a current situation, although such connections are not straightforward and must be established by a kind of indirect imagination. For example, my photograph *Fly* represents an aviary in a zoo. When I saw birds flying around in it in the evening light, I immediately thought of the line of poetry "Flying birds return home in pairs" ("Feiniao xiangyu huan"). In the centre of the photograph *Lingering Under a Lone Pine*, a cement road leads to a modern high-rise and a TV tower. Suddenly there is a lonely pine tree standing beside the road. It reminded me of the line "Lingering in a spot to caress a lonely pine" ("Fu gusong er panhuan").

WH Talking about this last picture, your mannequin is small and facing inward, away from the audience. If he's facing the tree, then the situation seems closer to the original cultural context; but if he's looking at the buildings, then his relationship to the environment is disharmonious and ironical. These three pictorial elements —the figure, the buildings, and the pine tree—form a triangular relationship. This type of relationship also seems to arise in other works you have created in China. For example, in *Transmission* the figure faces a small river in a traditional city; the mood seems bound to its own time and space.

MXC Yes, but there are also other images that disrupt this harmony. For example, a western-style church stands beyond an old wooden bridge, and a young woman is making a call with her cell phone. Other details in the picture, such as the kids running in a narrow lane, are also important to me. Perhaps they have just finished watching a TV program and are imitating the story, running out of their houses with toy guns in their hands.

WH This leads us back to a point you made earlier, that the horizontal composition of these photographs is related to traditional hand scroll painting. Does a work such as *Transmission* have multiple focal- and vanishing points like the hand scroll does, which connect with different parts of the image? With the ancient gentleman who looks contemplatively across the little river, the modern woman making a phone call, the kids running out of the house? When did you first make such long pictures?

MXC I developed this style when my abilities in digital photography were advanced enough that I could realize my artistic vision, which is based on classical Chinese painting. A picture taken with a conventional camera necessarily has a single vanishing point. My later photographs are fundamentally different because each of them unites several images in a single composition. In this way I can show aspects of an object in a way that is not possible in conventional photography. It's not enough for me to just represent an object, such as the bridge in *Transmission*. Rather, it's important to show various aspects of this bridge in a single picture. This is actually based on the multiple perspective (sandian toushi) in traditional Chinese painting. A vertical photograph such as *Capital* for example is close to a traditional hanging scroll, in which images are built up according to the principle of the "three distances" (san yuan) where you have a focus on high mountain peaks (gao yuan), the scenery in the middle distance (zhong yuan), and the long view into the distance (ping yuan). If you used a conventional camera to take this picture, the old woman in the foreground would inevitably be much larger, blocking the view behind her. The horizon would be in the middle of the composition. This goes against my intention to represent different views. So what I have done in this picture is elevate the background and lower the figures in the foreground. Their size and spatial relationship

a so change correspondingly. In an ancient Chinese painting, the elements in the foreground, such as figures or a pine tree, are often quite small. This is incorrect according to a linear perspective system, but correct in one's own subjective perception: a person or a tree is always smaller than a mountain. I hope to emphasize this subjective perspective in my pictures.

WH The tiled ground in *Capital* is fascinating: the angle of perspective changes gradually and the ground seems to move.

MXC This is because I used two different lenses to photograph the ground and pieced the pictures together seamlessly. Again, here I was inspired by traditional art.

WH How many images were used to compose this photograph?

MXC Many. Two images would only produce an awkward combination. Only many images can create a subtle transition.

WH Yes. This is why the ground forces the viewer to shift his gaze. Very subtle and interesting.

MXC Then I recognized that there are two kinds of truth: the truth of the camera and the truth of the photographer. Now I hope that the camera will serve my inner vision. Zhang Zeduan's masterpiece *Spring Festival Along the River* must be "scientifically" wrong in many respects. However I prefer to believe that the Song Dynasty was exactly the way he depicted it in this marvellous work. The painting is encyclopaedic, representing a whole city. To me, it's more truthful than a picture that represents reality objectively.

WH How about the photograph *Opera*? Is it a single shot?

MXC No. It also integrates many images. If I had only used a powerful telephoto lens to take the picture from a distance, the perspective would be different. The figures in the picture, people and monkeys, would be more varied in size and their expression would be impossible to make out.

WH This kind of reconstructed photograph raises an interesting issue. Like Zhang Zeduan's scroll painting that synthesizes many details, your work *Opera*, though combining many individual shots, seems still to represent a single moment. While other types of representation in modern art are often the result of abstraction, your pictures are rich in detail and at the same time convey a strong feeling of spontaneity—as we can see in *Opera*. For example, every person has a vivid expression on his or her face. When we realize that this picture actually synthesizes many individual shots, we start to wonder about the temporal dimension of such a composition.

MXC I've discovered that I can use photography—a modern visual technology and medium—to represent ideals of traditional Chinese art. Although I'm not using traditional brush and paper, I can certainly employ traditional concepts and aesthetic principles. Traditional viewing focuses on details. When a viewer unrolls a scroll painting, he examines it section by section, detail by detail, synthesizing fragmentary mental images into a continuous viewing experience.
Here I would also like to comment on the difference between photography and video art. Viewing a video is an ongoing experience in real time. Viewing a single photograph is necessarily an instantaneous act. My intention is to integrate many moments of such instantaneous viewing into it. This has become increasingly clear in my most recent works. For example,

my work *Stumble* shows a young girl walking up a staircase and falling. I separate individual moments in this process and organize them into an overlapping sequence in a single frame.

WH This picture seems to be related to Marcel Duchamp's *Nude Descending a Staircase*.

MXC Yes. I actually made this picture in reaction to Duchamp's oil painting, which was created almost a century ago. I tried to reinterpret it in my photography. At the same time, this picture also consciously recalls Rodchenko's works, which frequently use diagonal compositions.

WH It's interesting that you explicitly relate your work to these historical pieces that place a strong emphasis on combining visual elements. Are there other Western artists who have had a strong influence on you?

MXC I very much like Jeff Wall and Andreas Gursky's works, but they have not influenced me.

WH Which aspect of their work do you value the most?

MXC Jeff Wall impresses me with the depth and breadth of his social representations. Although he finds his subjects mainly in a limited area around Vancouver, his photographs transmit the spirit of an entire historical era. Gursky's sensitivity in seeing a composition (kan changmian) is very unusual. Whereas a painter can demonstrate his style through brush work and other means, it's difficult for a photographer to develop an individual style. In my view only great photographers can put this conception of art into practice, and Gursky is one of them.

WH Style cannot be separated from progress—both include continual artistic experiments

MXC But it also means developing a unique way of seeing the world. I feel that photography is more about seeing than doing. I only photograph what I see.

,MAN KÖNNTE GLAUBEN, ICH SEI JAPANER ODER KOREANER'
ÜBER DAS SELBSTBILD IN MIAO XIAOCHUNS ARBEIT

Wu Hung (WH) Lass' uns bei deiner Ausbildung und deinem beruflichen Werdegang beginnen. Gestern sagtest du, dass du zunächst Kunstgeschichte studiert hast.

Miao Xiaochun (MXC) Tatsächlich war mein Hauptfach an der Universität Deutsch. Obwohl ich immer gerne gemalt hätte, wurde ich zweimal an der Nanjing Art Academy abgelehnt. Meine Gemälde zeigten zu viel Einfluss durch moderne westliche Kunst, und die Leute an der Akademie meinten, dass ich nicht der richtige Student für sie war. Aber weil meine Noten in den Geisteswissenschaften gut waren, bestand ich die Aufnahmeprüfung für das Germanistische Institut an der Nanjing Universität und konnte dort anfangen zu studieren. Die Kunst konnte ich jedoch immer noch nicht vergessen, deshalb bewarb ich mich nach meinem Abschluss am College für einen Master Studiengang am Institut für Kunstgeschichte an der CAFA – Central Academy of Fine Arts und wurde zugelassen. In diesem Studiengang konzentrierte ich mich auf die Geschichte der modernen chinesischen Kunst. Doch habe ich weiter gemalt und nach meinem Studienabschluss an der Central Academy, wurde ich schließlich freischaffender Maler.

WH In welchen Jahren warst du freischaffender Künstler?

MXC Von 1989 bis 1995. Doch gegen Ende dieser Zeit beschloss ich, im Ausland Kunst zu studieren. So ging ich nach Deutschland.

WH Welche Art Bilder machtest du damals? Beziehen sich deine späteren Fotografien auf diese Gemälde?

MXC Ich habe in Öl gemalt, die Bilder waren halb abstrakt. Meine Fotografien legen eine starke Betonung auf die Komposition und ich denke, dass dies von meiner Ausbildung als Maler herrührt. Tatsächlich hätte ich immer gerne traditionell gemalt, doch diese Hoffnung erfüllte sich für mich nie. Viele meiner Fotografien weisen langgezogene Kompositionen auf, ähnlich einer horizontal angelegten Querrolle oder einem vertikalen klassischen Rollbild. Andere Eigenschaften traditioneller Malerei, wie eine veränderte Perspektive, hatten definitiv ebenfalls Auswirkung auf meine Fotografien.

WH Was hast du in Deutschland studiert?

MXC Meine Ausbildung umfasste verschiedene Kunsttechniken, nicht nur Malerei, Bildhauerei, Keramik und Fotografie.

WH Warum hast du dich für Kassel entschieden?

MXC Zu dieser Zeit hatte mein Professor an der Kunsthochschule Kassel gerade ein Austauschprogramm mit China organisiert. Durch ihn kam ich als Austauschstudent nach Kassel. Kassel zog mich als Ort der documenta an, und ich dachte, dies wäre ein guter Platz, um neue Entwicklungen in der zeitgenössischen Kunst kennenzulernen. Als ich dort ankam, erlebte ich Kassel als eine ruhige, mittelgroße Stadt. Es war einfach, von dort aus in andere Städte in Deutschland und in Europa zu reisen und Museen in der Umgebung zu besuchen. In Kassel verfolgte ich ein künstlerisches Projekt, das dann zu meiner ersten fotografischen Serie wurde.

WH Hast du das für deine Abschlussausstellung an der Kunsthochschule Kassel gemacht?

MXC Ja. Es war eine Reihe von Schwarzweißfotografien, die den Beginn eines viel größeren Projekts markierten. Als ich später nach China zurückkehrte, führte ich dieses Projekt fort, allerdings in eine neue Richtung.

WH Nun sollten wir über deine fotografische Arbeit diskutieren. Zum Beispiel, wie sich deine Fotografie deiner Ansicht nach entwickelt hat? Von Anfang an hast du eine lebensgroße Puppe in deine Fotografien einbezogen – einen chinesischen Herrn mit deinem Gesicht, bekleidet mit einem altertümlichen Gewand. Natürlich kann sich die Funktion dieser Figur über die Jahre verändert haben, aber was war dein ursprünglicher Impuls, diese Figur zu kreieren und zu fotografieren?

MXC Zu dieser Zeit war ich ein Chinese, der in Europa lebte. Ich wollte einige meiner komplexen und tiefen Gefühle, die ich dort hatte, in meinen Fotografien ausdrücken. Es stellte sich die Frage, wie ich dieses Ziel erreiche. Ich konnte mich ja nicht einfach fotografieren, da meine Erscheinung, meine Kleidung, meine Gesten nichts Spezielles hatten und ich damit meine inneren Gefühle nicht offenbaren konnte. Menschen, die mich sahen, konnten meinen, ich sei Koreaner oder Japaner. Dann begann ich darüber nachzudenken, welche Art von Selbstbild ich in meinen Bildern vermitteln wollte. Dieses Bild von mir sollte mich stolz machen – ich wollte, dass es die chinesische Kultur auf ihrem Höhepunkt, in der Tang- oder Song-Dynastie, darstellte. Natürlich

hat es schon vorher zeitgenössische Künstler gegeben, die sich selbst in Verkleidung fotografiert haben. Ich wollte aber die vollständige Kontrolle über dieses „Selbstbild" und gleichzeitig die gesamte Komposition haben. Es gibt einen signifikanten Unterschied zwischen meiner Arbeit und einem Selbstporträt in Verkleidung: Während sich dieses ausschließlich auf die Person konzentriert, existierte mein Bild auch dann noch, wenn man die Figur nicht sehen würde. Sie ist nur eines von vielen Elementen im Bild, nicht das zentrale. Dieses Merkmal bezieht sich wieder auf die traditionelle chinesische Tuschmalerei: Viele alte Landschaftsgemälde enthalten winzige Figuren, die dianjing renwu. Obwohl diese Figuren sehr wichtig für die Komposition sind, bleibt das gesamte Gemälde auch dann noch kohärent und drückt die Absicht des Künstlers aus, wenn man sie verdeckt.

WH So steht diese Figur sowohl für eine individuelle als auch für eine kulturelle Tradition und ist Teil einer größeren Bild-Konstruktion. Dies scheint von deinen ersten Serien an sehr klar gewesen zu sein. Doch diese Arbeiten, die in Deutschland entstanden sind, unterscheiden sich auch von deinen späteren Fotografien, indem sie die Figur in einer sozialen Konstellation verankern, wie in einer Lehrveranstaltung in einem Klassenzimmer oder bei einem Familientreffen. Diese Bilder scheinen sich um Kommunikation zu drehen und legen ihre Betonung auf die Beziehung der Figur zu realen menschlichen Wesen.

MXC Kulturelle Kommunikation ist in der Tat ein dominantes Thema in den Fotografien aus meiner Zeit in Deutschland, die eine starke erzählerische Komponente aufweisen. Doch später, vor allem bei den Arbeiten, die ich in China gemacht habe, verschmilzt diese Figur mehr und mehr mit ihrer Umgebung und wird zu einem von vielen Elementen im Bild.

WH Wenn deine ersten Fotografien also von ihrer Beziehung zu einer fremden Kultur handeln, drehen sich die neueren dann um deine Beziehung zur chinesischen Kultur selbst? Aber es scheint, dass diese späteren Arbeiten eine beständige „Disharmonie" zwischen der Figur und ihrer Umgebung zeigen. Daher meine Frage: Wenn diese Figur die chinesische Kultur repräsentiert, was ist dann die Ursache einer solchen anhaltenden Disharmonie?

MXC In der Tat ist die Beziehung zwischen dieser Figur und dem zeitgenössischen China sogar noch „unharmonischer" als in meinen in Deutschland entstandenen Bildern – das Auftauchen der Figur in einer chinesischen Stadt scheint dort noch unerwarteter und unlogischer. Ich denke, dies kommt daher, dass sich der Wandel Chinas in den letzten Jahren extrem schnell und abrupt vollzogen hat.

WH Ja, in diesen Bildern schaut die Figur ausdruckslos und ratlos drein.

MXC Als ich diese Figur schuf, war ich angezogen von ihrem unveränderlichen mysteriösen Gesichtsausdruck. Deshalb wollte ich mich nicht selbst fotografieren: Ich hätte in der Reaktion auf verschiedene Situationen zu viel Expressivität gezeigt.

WH Wie hat das deutsche Publikum auf diese Figur reagiert? Obwohl du das Bild als eine authentische Repräsentation der chinesischen Kultur geschaffen hast, denke ich darüber nach, ob es nicht auch als ein weiteres stereotypes Chinabild wahrgenommen werden könnte? Reflektiert es nur deine eigene Auffassung von China, oder kann es auch die Wahrnehmung der chinesischen Kultur durch einen Außenstehenden wiedergeben?

MXC In Deutschland habe ich viele Bücher über China gelesen. Die meisten von ihnen

beschreiben die Chinesen als die Mandschuren der letzten Dynastie, mit einem Zopf und einem dünnen Bart. Aber ich wollte das chinesische Volk durch ein anderes Bild aus seinen glorreichen und glanzvollen Zeiten, wie der Han- oder Tang-Zeit, darstellen. Die Menschen im Westen wissen wenig über diese Epochen. Sie wissen mehr über die Ära des Niedergangs und die chaotischen Zeiten, wie die späte Qing-Zeit oder die Kulturrevolution. Das ist bedauerlich. Ich wollte diese Zeiten des Niedergangs nicht als repräsentativ für China nehmen. Ich bevorzuge es, die Chinesen als shidafu zu sehen und zeigen – Menschen, die kultiviert und intellektuell sind. Ich denke, dass ich, wäre ich tausend oder zweitausend Jahre früher geboren worden, wahrscheinlich so eine Person gewesen wäre, einer, der das Lernen wichtiger gewesen wäre als alles andere.

WH Das könnte dein Konzept von dieser Figur gewesen sein. Doch die Bilder, die du in Deutschland geschaffen hast, scheinen etwas anderes zu erzählen: In einem Bahnhof ankommend oder in einer Telefonzelle stehend, erscheint die Figur verloren und deplatziert, während die Menschen um sie herum real und aktiv wirken. Man fühlt, dass sie keine Sprache hat und deshalb still bleibt, während andere Menschen miteinander sprechen. Es scheint, als wolltest du eine große Tradition glorifizieren, doch diese Tradition hat keinen Platz in der Situation, die du darstellst.

MXC Ja, man kann sagen, dass dies ein Zustand des Sprachverlustes (shiyu zhuangtai) ist, der mit meiner persönlichen Erfahrung in Europa zu tun hatte. In dieser Umgebung war es für mich sehr schwierig, meine Gefühle auszudrücken und mit anderen Menschen zu kommunizieren. Wenn ich zum Beispiel durch ein Ereignis angeregt wurde, Tao Yuanmings berühmte Zeilen „Am Zaun im Osten pflücke ich Chrysanthemen und blicke in Muße auf die Gipfel im Süden" zu

rezitieren, konnten nur wenige Menschen verstehen, worüber ich nachdachte und sprach. Es ist ein Symptom des Sprachverlustes (shiyu zheng), denn der Kontext der Sprache (yujing) ist verschwunden. Du hast Recht, wenn du von einer Art Deplatzierung sprichst. Der Kontext des poetischen Ausdrucks von Tao Yuanming ist aufgehoben.

WH Ich kann dieses Problem gut verstehen, auch ich habe lange Zeit im Westen gelebt. Diskussionen über dein frühes Werk legten oft den Schwerpunkt auf das Thema des Blickes. Das ist sicher ein interessantes Thema, denn so wie ich es sehe, hat die Figur tatsächlich keinen ausgerichteten Blick oder ein klar umrissenes Sichtfeld. Aber Sprache und Kommunikation sind gleich wichtig, um deine Arbeiten zu verstehen. Wenn wir nun dazu übergehen deine späteren Arbeiten zu untersuchen, besteht dort das Problem des Sprachverlustes fort?

MXC Ich denke, dass es immer noch vorhanden ist – zumindest teilweise.

WH In welcher Weise hat die Figur ihre Fähigkeit zu kommunizieren teilweise wiedergewonnen?

MXC Vielleicht sollte ich zuerst über den Teil sprechen, in dem das Problem des Sprachverlustes noch weiter fortbesteht. Lass' mich als Beispiel die Fotografie *Ferry* nehmen. Dieses Bild zeigt eine moderne Brücke über den Huangpu-Fluss. Im Auto können wir über diese Brücke über den Fluss fahren. Was ein alter Dichter schrieb „An einer leeren Fährstation in der Wildnis treibt nur ein Boot auf dem Wasser", gilt heute nicht mehr. Wenn jemand jetzt den Fluss mit einem kleinen hölzernen Boot überqueren würde, könnte es sich nur um ein Kunstprojekt handeln.

WH Damit kehren wir zurück zum Konzept des yujing, dem Kontext eines Ausdrucks.

Wenn dieser Kontext einmal verschwunden ist, obwohl man natürlich immer noch ein oder zwei Sätze eines alten Dichters zitieren kann, verändert sich die Bedeutung. Aber wie du gesagt hast, wurde dieses Problem in China zum Teil behoben. Wie kommt das?

MXC Ich denke, dass in China eine alte Ausdrucksform immer noch Bezug zu einer aktuellen Situation haben kann, auch wenn solche Verbindungen nicht mehr geradlinig sind und durch eine Art indirekte Vorstellungskraft erzeugt werden müssen. Zum Beispiel zeigt meine Fotografie *Fly* ein Vogelhaus in einem Zoo. Als ich die Vögel im Abendlicht darin herumfliegen sah, dachte ich sofort an die Gedichtzeilen „Fliegende Vögel kehren paarweise heim" („Feiniao xiangyu huan"). Im Zentrum der Fotografie *Lingering Under a Lone Pine* führt eine Betonstraße zu einem modernen Hochhaus und einem Fernsehturm. Plötzlich steht dort eine vereinzelte Pinie am Rand der Straße. Es erinnerte mich an die Zeile „An einer Stelle verweilen, um eine einsame Pinie zu streicheln" („Fu gusong er panhuan").

WH Wo wir gerade über dieses Bild reden, deine Figur erscheint klein und nach innen gekehrt, vom Betrachter weggedreht. Falls die Figur den Baum ansieht, so erscheint die Situation näher am ursprünglichen kulturellen Kontext; falls sie aber auf die Gebäude blickt, so ist die Relation zur Umgebung unharmonisch und ironisch. Diese drei Bildelemente – die Figur, die Gebäude und die Pinie – formen ein dreipoliges Bezugssystem. Diese Art von Beziehung scheint auch in anderen Arbeiten vorzukommen, die du in China geschaffen hast. Zum Beispiel wendet sich die Figur in *Transmission* einem kleinen Fluss in einer traditionellen Stadt zu; die Stimmung wirkt ihrer eigenen Zeit und ihrem eigenen Raum verhaftet.

MXC Ja, aber es gibt auch andere Bildelemente, die diese Harmonie stören. Zum Beispiel steht eine Kirche westlichen Stils hinter einer alten Holzbrücke und eine junge Frau spricht in ihr Mobiltelefon. Andere Details, wie die Kinder, die eine schmale Gasse hinunter laufen, sind ebenso wichtig für mich. Vielleicht haben sie gerade eine Fernsehsendung gesehen und spielen nun, mit Spielzeugpistolen aus ihren Häusern rennend, die Geschichte nach.

WH Das führt uns zurück zu einem schon angesprochenen Punkt, nämlich dass die horizontale Komposition dieser Fotografien auf die traditionellen Querrollen Bezug nimmt. Hat eine Arbeit wie *Transmission* multiple Blick- und Fluchtpunkte wie die Querrolle, die mit unterschiedlichen Bildteilen in Verbindung stehen? Mit dem altertümlichen Herrn, der nachdenklich über den kleinen Fluss schaut, der modernen Frau, die telefoniert, den Kindern, die aus dem Haus laufen? Wann hast du zum ersten Mal so lange Arbeiten gemacht?

MXC Ich entwickelte diesen Stil, nachdem meine Fertigkeiten in der digitalen Fotografie soweit fortgeschritten waren, dass ich meine künstlerische Vision realisieren konnte, deren Grundlage die klassische chinesische Malerei darstellt. Ein Bild, das von einer konventionellen Kamera aufgenommen wird, hat notwendigerweise einen einzigen Fluchtpunkt. Meine späteren Fotografien unterscheiden sich hiervon grundlegend, da jede von ihnen mehre Bilder in einer einzigen Komposition vereint. Auf diese Weise kann ich Aspekte einer Sache zeigen, wie es in der konventionellen Fotografie nicht möglich ist. Mir reicht es nicht, einfach ein Objekt darzustellen, so wie die Brücke in *Transmission*. Vielmehr ist es wichtig, unterschiedliche Aspekte dieser Brücke in einem einzigen Bild zu zeigen. In der Tat basiert dies auf der multiplen Perspektive (sandian toushi) aus der traditionellen chinesischen Malerei. Eine vertikale Arbeit wie *Capital* zum Beispiel steht einem traditionellen

Rollbild nahe, in dem Bilder gemäß dem Prinzip der drei Distanzen (san yuan) aufgebaut werden, wo man einen Fokus auf hohe Berggipfel (gao yuan), die Szenerie in der mittleren Distanz (zhong yuan) und den weiten Ausblick in die Ferne (ping yuan) hat. Würde man eine konventionelle Kamera benutzen, um dieses Bild aufzunehmen, wäre die alte Frau im Vordergrund unausweichlich größer und würde die Sicht auf das, was hinter ihr liegt, verstellen. Der Horizont würde in der Mitte der Komposition liegen. Dies wäre gegen meine Absicht, verschiedene Ansichten abzubilden. So habe ich in diesem Bild den Hintergrund nach oben verschoben und die Figuren im Vordergrund nach unten. Ihre Größe und räumliche Beziehung verändert sich entsprechend. In einem alten chinesischen Gemälde sind die Bildelemente im Vordergrund, wie Figuren oder ein Pinienbaum oft sehr klein angelegt. Das ist nicht korrekt in Bezug auf ein linearperspektivisches System, aber richtig in der eigenen subjektiven Wahrnehmung: eine Person oder ein Baum sind immer kleiner als ein Berg. Ich hoffe, diese subjektive Perspektive in meinen Bildern zu betonen.

WH Der gepflasterte Weg in *Capital* ist äußerst faszinierend, der perspektivische Winkel ändert sich langsam und der Boden scheint sich zu bewegen.

MXC Das kommt daher, dass ich zwei verschiedene Linsen verwendet habe, um den Boden zu fotografieren und die Bilder übergangslos zusammengefügt habe. Auch hier wurde ich von der traditionellen Kunst inspiriert.

WH Wieviele Bilder wurden benutzt, um diese Arbeit zu komponieren?

MXC Viele. Zwei Bilder würden nur eine unbeholfene Kombination hervorbringen. Nur sehr viele Bilder können einen subtilen Übergang herstellen.

WH Ja, das ist der Grund warum der Boden den Betrachter dazu zwingt, seinen Blickwinkel zu ändern. Sehr subtil und interessant.

MXC Dann erkannte ich, dass es zwei Arten von Wahrheit gibt: Die Wahrheit der Kamera und die Wahrheit des Fotografen. Nun hoffe ich, dass sich die Kamera meiner inneren Vision dienstbar macht. Zhang Zeduans Meisterwerk *Spring Festival along the River* muss aus „wissenschaftlicher" Sicht in einigen Punkten fehlerhaft sein. Aber ich möchte lieber glauben, dass die Song-Dynastie genau so war wie er sie in seinem großartigen Werk dargestellt hat. Das Gemälde ist enzyklopädisch, repräsentiert eine ganze Stadt. Für mich ist es „wahrhaftiger" als ein Bild das die Realität objektiv festhält.

WH Wie steht es mit der Arbeit *Opera*? Ist sie mit einer einzigen Einstellung gemacht?

MXC Nein, auch sie beinhaltet viele Aufnahmen. Hätte ich nur ein leistungsstarkes Teleobjektiv benutzt, um das Bild aus der Entfernung aufzunehmen, wäre die Perspektive eine andere. Die Figuren im Bild, Affen und Menschen, würden in ihrer Größe unterschiedlicher sein und es wäre unmöglich, ihren Gesichtsausdruck zu erkennen.

WH Diese Art digital bearbeiteter Fotografie wirft ein interessantes Problem auf. Wie in Zhang Zeduans Rollbild, das viele Details zu einer Synthese vereint, scheint deine Arbeit *Opera*, trotzdem sie viele individuelle Einstellungen kombiniert, einen einzigen Moment abzubilden. Während andere Darstellungen in der zeitgenössischen Kunst oft Ergebnisse von Abstraktion sind, sind deine Bilder detailreich und vermitteln zugleich ein starkes Gefühl von Spontanität – so wie wir es in *Opera* sehen können. Jede Person hat zum Beispiel einen lebhaften Gesichtsausdruck. Wenn wir erkennen, dass dieses Bild eigentlich aus vielen

individuellen Einstellungen zusammenge-
setzt ist, dann beginnen wir, uns über die
zeitliche Dimension so einer Komposition
Gedanken zu machen.

MXC Ich habe entdeckt, dass ich die Foto-
grafie – eine moderne visuelle Technologie
und ein ebenso modernes Medium – be-
nutzen kann, um Ideale der traditionellen
chinesischen Kunst darzustellen. Obwohl
ich keinen traditionellen Pinsel und kein
traditionelles Papier verwende, kann ich si-
cherlich traditionelle Konzepte und ästheti-
sche Prinzipien anwenden. Das traditionelle
Sehen fokussiert Details. Wenn ein Betrach-
ter ein Rollbild entrollt, begutachtet er es
Abschnitt für Abschnitt, Detail für Detail,
und baut durch die Synthese fragmenta-
rischer mentaler Bilder ein kontinuierliches
Sehen auf.
An dieser Stelle möchte ich auch etwas zum
Unterschied von Fotografie und Videokunst
sagen. Ein Video anzusehen, ist eine anhal-
tende Erfahrung in Echtzeit. Eine einzige
Fotografie zu betrachten, ist notwendiger-
weise ein unmittelbarer Vorgang. Meine
Absicht ist, viele Momente solch eines un-
mittelbaren Sehens in sie zu integrieren.
Das wurde in meinen letzten Arbeiten im-
mer klarer. Meine Arbeit *Stumble* zeigt zum
Beispiel ein junges Mädchen, das eine
Treppe hinaufgeht und stürzt. Ich spalte in-
dividuelle Momente dieses Prozesses auf
und organisiere sie in einer überlappenden
Sequenz in einem einzigen Bildfeld.

WH Dieses Bild scheint verwandt mit Marcel
Duchamps *Akt, eine Treppe herabsteigend*.

MXC Ja, in der Tat schuf ich dieses Bild
als Reaktion auf dieses Ölgemälde von
Duchamp, das vor fast einhundert Jahren
entstand. Ich versuchte, es in meiner Foto-
grafie neu zu interpretieren. Gleichzeitig

erinnert dieses Bild bewusst an Alexander
Rodtschenkos Arbeiten, in denen oft eine
diagonale Komposition eingesetzt wird.

WH Es ist interessant, dass du deine Arbeit
explizit mit diesen historischen Werken, die
eine starke Betonung auf das Zusammen-
setzen visueller Elemente legen, in Bezie-
hung bringst. Gibt es noch andere westliche
Künstler, die einen starken Einfluss auf dich
gehabt haben?

MXC Ich mag die Arbeiten von Jeff Wall und
Andreas Gursky sehr, aber sie haben mich
nicht beeinflusst.

WH Welchen Aspekt ihrer Arbeit schätzt du
am meisten?

MXC Jeff Wall beeindruckt mich mit der
Tiefe und dem Umfang seiner sozialen Dar-
stellungen. Obwohl er seine Themen vor
allem in dem begrenzten Umfeld rund um
Vancouver findet, geben seine Fotos den
Geist einer ganzen Ära wieder. Gurskys
Sensibilität, eine Komposition (kang chang-
mian) zu sehen, ist sehr außergewöhnlich.
Während ein Maler seinen Stil durch seinen
Pinselstrich und andere Mittel ausdrücken
kann, ist es für einen Fotografen schwierig,
einen individuellen Stil zu entwickeln. Mei-
ner Ansicht nach können nur große Foto-
grafen diese Idee von Kunst umsetzen, und
Gursky ist einer von ihnen.

WH Stil kann nicht von Entwicklung ge-
trennt werden – beide beinhalteten konti-
nuierliche künstlerische Experimente.

MXC Es bedeutet aber auch, eine einzigar-
tige Art und Weise zu entwickeln, die Welt zu
sehen. Ich fühle, dass die Fotografie mehr
mit Sehen als mit Machen zu tun hat. Ich
fotografiere nur, was ich sehe.

BIOGRAFIE
BIOGRAPHY

MIAO XIAOCHUN

1964	Born in Wuxi, Jiangsu, China
1982–86	Studied at Nanjing University, China
1986–89	Studied at The Central Academy of Fine Arts, Beijing, China
1989–95	Lived as artist in Beijing, China
1995–99	Studied at Kunsthochschule Kassel, Germany
From 2000	Teaches at the Central Academy of Fine Arts, Beijing, China

SELECTED SOLO EXHIBITIONS | AUSGEWÄHLTE EINZELAUSSTELLUNGEN

2010	MACROMANIA, Ludwig Museum, Koblenz, Germany	
	BEIJING INDEX, ALEXANDER OCHS GALLERIES BERLIN	BEIJING, Berlin, Germany
2009	INDEX, WHITE SPACE BEIJING and ALEXANDER OCHS GALLERIES BEIJING, Beijing, China	
	MICROCOSM, Walsh Gallery, Chicago, USA	
2008	MICROCOSM, ALEXANDER OCHS GALLERIES BERLIN	BEIJING, Berlin, Germany
	MICROCOSM, Osage Gallery, Singapore and Hong Kong	
	Heaven and Earth: Miao Xiaochun's Virtual World, Lin & Keng Gallery, Taipei, Taiwan	
2007	H2O, WHITE SPACE BEIJING, Beijing, China	
	H2O, ALEXANDER OCHS GALLERIES BERLIN	BEIJING, Berlin, Germany
	H2O – A Study of Art History, Walsh Gallery, Chicago, USA	
	The Last Judgment in Cyberspace, Contemporary Visual Art Projects, South Australia, Contemporary Art Centre of South Australia, Parkside, Australia	
2006	A Birdview, Zhu Qizhan Art Museum, Shanghai, China	
	Image + Imagination, Osage contemporary art space, HK, China	
	Viewpoint, WHITE SPACE BEIJING, Beijing, China	
	The Last Judgment in Cyberspace, Walsh Gallery, Chicago, USA	
	The Last Judgment in Cyberspace, ALEXANDER OCHS GALLERIES BERLIN	BEIJING, Berlin, Germany
	Urban Landscape, John Hope Franklin Centre of Duke University, Durham, USA	
2004	Phantasmagoria, Walsh Gallery, Chicago, USA	
	A Visitor from the Past, Epson Photogallery Shanghai–Beijing, China	
2002	Linger, Galerie Urs Meile, Lucerne, Switzerland	
2001	From East to West and Back to East, Museum of the Central Academy of Fine Arts, Beijing, China	
1999	Kulturbegegnungen, Galerie Stellwerk, Kassel, Germany	
1994	Beijing Art Museum and Shanghai Art Museum, China	
1992	National Museum of Chinese History, Beijing, China	
1991	Beijing Art Museum, China	
1988	Gallery of the Central Academy of Fine Arts, Beijing, China	

SELECTED GROUP EXHIBITIONS | AUSGEWÄHLTE GRUPPENAUSSTELUNGEN

2010	Chinesische Landschaften neu betrachtet (Chinese Landscapes Reconsidered), Galerie Moderne Chinesische Malerei des Museums für Asiatische Kunst, Berlin, Germany	
	BEIJING TIME	URBANO DEMASIADO URBANO, Casa Asia, Madrid, Spain
	Reshaping History – Chinart from 2000–2009, National Conference Center, Beijing, China	
	China Design Now, Portland Museum of Art, Oregon, USA	
	Speed and Chaos: Into the Future of Asian Art, Bryce Wolkowitz Gallery, New York, USA	
	State of the Dao – Chinese Contemporary Art, Lehman College Art Gallery, New York, USA	

2009 Guangzhou Photo Biennial 2009, Guangdong Museum of Art, Guangzhou, China

Ein Bild ist ein Bild | The WUNDERkammer (higgledy-piggledy),
ALEXANDER OCHS GALLERIES BERLIN | BEIJING, Berlin, Germany

CHINA – Ein anderer Blick (Another View), Kunstverein Augsburg, Germany

Open Vision, National Gallery in Prague, Czech Republic

China Design Now, Cincinnati Art Museum, Ohio, USA

Photography in China, Willem Kerseboom Gallery, Amsterdam, Netherlands

FotoRio – Vídeo Short List/Dream Machine,
Museu de Arte Contemporânea de Niterói, Niterói, RJ, Brazil

Next Nature, National Gallery of Indonesia, Jakarta, Indonesia

XUN DAO: Seeking the Way, Spiritual Themes in Contemporary China,
Frederieke Taylor Gallery, New York, USA

5a Bienal VentoSul – o mundo todo aqui (Água Grande: the altered maps), vai mexer com voce,
Museu de Arte Contemporânea do Paraná, Curitiba, Brazil

Vistas | Vision of U-City, Incheon International Digital Art Festival, Incheon, Korea

Nature | Nation, Museum on the Seam,
Socio Political Contemporary Art Museum, Jerusalem, Israel

The Tales of Angels, Red Mansion Foundation, London, UK

Re-Imagining Asia, The New Art Gallery Walsall, UK

Crossway: Liu Liyun & Miao Xiaochun, Osage Gallery Soho, Hong Kong, China

Mahjong – Contemporary Chinese Art from the Sigg Collection,
Peabody Essex Museum, Salem, Massachusetts, USA

Spectacle: To Each His Own, Museum of Contemporary Art Taipei, Taiwan

Metropolis Now! – A Selection of Chinese Contemporary Art,
Meridian International Center, Washington, DC, USA

Keep Watching – Conceptual Photography Exhibition, Chongqing International Art Festival,
Chongqing 501 Contemporary Art Museum, Chongqing, China

Masks, Foto Museum of Youngwol, Youngwol; Sungkok Art Museum, Seoul, Korea

2008 China: Construction/Deconstruction – Contemporary Chinese Art,
MASP – Museu de Arte de São Paulo, São Paulo, Brazil

Mahjong – Contemporary Chinese Art from the Sigg Collection, The University of California,
Berkeley Art Museum, Pacific Film Archive, Berkeley, USA

Expenditure, Busan Biennale 2008, Busan MoMA, South Korea

Images in the Night, Le Grand Palais, Paris, France

Up: Chinese Contemporary Art, Singapore Art Museum, Singapore

The Revolution Continues: New Chinese Art, The Saatchi Gallery, London, UK

Mediations, Poznan Biennial, Poznan, Poland

Go China – New World Order, Present-day Installation Art and Photography,
Groninger Museum, Groningen, Netherlands

Re-Imagining Asia, Haus der Kulturen der Welt, Berlin, Germany

China Design Now, Victoria & Albert Museum, London, UK

The 6th Shenzhen International Ink Painting Biennial,
Shenzhen Fine Art Institute, Shenzhen, China

China Gold, Musée Maillol, Paris, France

55 Days in Valencia, Chinese Art Meeting, IVAM Centre Julio González, Valencia, Spain

Synthetic Times – Media Art China 2008, NAMOC – National Art Museum of China, Beijing, China

Water·Wood·Environmental Sky – Beijing Film Academy New Media Art Triennial,
Beijing Film Academy, Beijing, China

2D/3D: Negotiating Visual Languages, PKM Gallery, Beijing, China

Himmlischer Frieden (1919–2008), Collegium Hungaricum Berlin, Germany

The Evolution of Concept – 10 Years' Retrospective and prospective of
Chinese conceptual Photography, 798 Space, Beijing, China

Fabricating Images from History, Chinablue Gallery, Beijing, China

Facing Reality, NAMOC – National Art Museum of China, Beijing, China

Zhù Yì! China actual photography, Palau de La Virreina, Barcelona, Spain

Asia in Harmony – The 23rd Asian International Art Exhibition·Special Exhibition,
Wall Art Museum, Beijing, The University City Art Museum of Guangzhou Academy of Fine Arts,
Guangzhou, China

Recent Trend of Contemporary Arts: Re-Viewing, Gyeongnam Art Museum, Chang Won, Korea

2007 China: Facing Reality, MUMOK, Vienna, Austria

CHINA NOW, Kunst in Zeiten des Umbruchs / Art at a time of transformation,
Cobra Museum, Amstelveen, Netherlands

Floating – New Generation of Art in China, National Museum of Contemporary Art, Seoul, Korea

RED HOT – Asian Art Today from the Chaney Family Collection,
Museum of Fine Arts, Houston, Texas, USA

Thermocline of Art – New Asian Waves, ZKM Karlsruhe, Germany

Dragon's Evolution, Chinese Contemporary Photography,
China Square Art Centre, New York, USA

New Directions from China, [plug.in], Basel, Switzerland

The Constructed image: Photographic culture,
Museum of Contemporary Canadian Art (MOCCA), Toronto, Canada

Chinese Contemporary Photography and Video, Gana Art Center, Seoul, Korea

La primavera del drago – Zoom on China, Palazzo Loggia, Wave Photogallery, Brescia, Italy

Passion For Art, Kunst der Gegenwart Sammlung Essl, Klosterneuburg, Austria

Zhù Yi! Chinese Contemporary Photography,
Artium – Centro Museo Vasco de Arte Contemporáneo, Vitoria-Gasteiz, Spain

MADE IN CHINA, Louisiana Museum of Modern Art, Louisiana, Humlebaek, Denmark;
Israel Museum, Jerusalem, Israel

Whispering Wind: Recent Chinese Photography,
Frist Centre for the Visual Arts, Nashville, Tennessee, USA

Mahjong – Contemporary Chinese Art from the Sigg Collection,
Museum der Moderne Mönchsberg, Salzburg, Austria

Martell Artists of the Year 2007, National Art Museum of China, Beijing;
Shanghai Art Museum; Guangdong Art Museum, China

Contemporary Artists from China, Gow Langsford Gallery, Auckland, New Zealand

Collective Identity, Chinese Arts Centre, Manchester, UK;
Hong Kong University Museum and Art Gallery, Hong Kong

2006 Media City Seoul 2006, The 4nd International Media Art Biennial, Seoul, Korea

Susi: Opening up to China Art Today, Metropolitan Museum, Manila, Philippines

Between Past and Future – New Photography and Video from China,
Haus der Kulturen der Welt, Berlin, Germany; Santa Barbara Museum of Art, California;
Nasher Museum of Art at Duke University, Durham, North Carolina, USA

New Urban Reality: Chinese Contemporary Art,
Museum Boijmans Van Beuningen, Rotterdam, Netherlands

CHINA NOW – Kunst in Zeiten des Umbruchs / Art at a time of transformation,
The Essl Collection of Contemporary Art, Klosterneuburg, Austria

Totalstadt. Beijing case, ZKM Karlsruhe, Germany

Mahjong – Contemporary Chinese Art from the Sigg Collection,
Hamburger Kunsthalle, Germany

Another world – Photography from China, Gallery Lukas Feichtner, Vienna, Austria

Beyond Foreordination, Art Seasons, Singapore

Process & Expression, Star 85 Gallery, Taiwan

Ultra-Sense, Seoul International Photo Festival, Seoul, Korea

Entry Gate: Chinese Aesthetics of Heterogeneity, MOCA Shanghai, China

China Beyond Experience: The New China, Arario Beijing, Beijing, China

FotoFreo, International Photography Festival, Australia

Transformations: New Chinese Photography, Fremantle Arts Centre, Fremantle, Australia

Seduced and Abandoned, Zero field in 798, Beijing, China

Walking about in the Garden, Confucius Gallery, Beijing, China

Poetic Reality: A Reinterpretation of Jiangnan, RCM Art Museum, Nanjing, China

Asia: the place to Be? ALEXANDER OCHS GALLERIES BERLIN | BEIJING, Berlin, Germany

Placed in China, Walsh Gallery, Chicago, USA

Guangzhou International Photo Biennial, Guangdong Art Museum, Guangzhou, China

A Utopia of the Visible, Beijing New Art Projects at 798, Beijing, China

Unclear and Clearness, 2006 Heyri Asia Project | Chinese Contemporary Art Festival,
Heyri, Seoul, Korea

Signes d'existence, Museum of the Central Academy of Fine Arts, Beijing, China

The First Almanac Exhibition of Chinese Contemporary Art,
China Millennium Monument, Beijing, China

2005 Scapes: The Century and Paradise, 2nd Chengdu Biennial, Chengdu,China

Between Past and Future – New Photography and Video from China,
Museum of Contemporary Art Seattle, USA

Re-Viewing the City, Guangzhou Photo Biennial 2005,
Guangdong Museum of Art, Guangzhou, China

The City in 360 degrees, Beijing New Art Projects at 798, Beijing, China

Mahjong – Chinese Contemporary Art from the Sigg Collection, Art Museum Bern, Switzerland

Confluents II, international artists in Ludwig Museum Koblenz, Germany

Between Past and Future – New Photography and Video from China,

Victoria and Albert Museum, London, UK

City of Dreams, The Red Mansion Foundation, London, UK

Grounding Reality – Chinese Contemporary Art, Seoul Art Center, Korea

Making a New Relationship – The Art Ethics, Dimensions Art Center, 798, Beijing, China

Urban Legend, 798 Space, Beijing, China

City Skin – Research of Possibilities of Contemporary Urban Images,
Macao Tap Seac Gallery; Shenzhen Art Museum, Macao and Shenzhen, China

The Second Reality – Chinese Contemporary Photography,
Piazza of the Berlaymont European Commission Building, Brussels, Belgium

2004 Performing the Body – Photography and Performance from China,
ALEXANDER OCHS GALLERIES BERLIN | BEIJING, Berlin, Germany

Performance of the body, Contemporary Chinese Photography,
Visual Gallery, Photokina, Cologne, Germany

Between Past and Future – New Photography and Video from China,
ICP and Asia Society, New York, USA; The David and Alfred Smart Museum of Art
and Museum of Contemporary Art, Chicago, USA

Beyond Boundaries, Shanghai Gallery of Art, Shanghai, China

Pinyao in Paris, National Library François Mitterrand, Paris, France

Spellbound Aura – The New Vision of Chinese Photography,
Museum of Contemporary Art, Taipei, Taiwan

Rivka Rinn and Miao Xiaochun, WHITE SPACE BEIJING, Beijing, China

Le Printemps de Chine, Musée CRAC Alsace – Centre rhénan d´art contemporain,
Altkirch, France

Sightseeing Beijing, SCA Gallery, Sydney College of the Arts, Sydney, Australia

Un-normal Perspective, 798 Space, Beijing, China

2003 Me & More, Art Museum Lucerne, Switzerland

Left Hand, Right Hand, A Sino German Exhibition of Contemporary Art,
798 Space, Beijing, China

Concept in situ, The Villa Museum, Beijing, China

Modernization & Urbanization – Asian Art Now, Marronnier Art Center, Seoul, Korea

Encounter, Museum of the Central Academy of Fine Arts, Beijing;
Liu Haisu Museum, Shanghai, China

2002 Urban Creation, Shanghai Biennial 2002, Shanghai Art Museum, China

Media City Seoul 2002, The 2nd International Media Art Biennial, Seoul, Korea

China – Tradition and Modernity, Ludwig Museum, Oberhausen, Germany

Under Construction, Tokyo Opera City Art Gallery, The Japan Foundation, Tokyo, Japan

Golden Harvest – Chinese Contemporary Art, Museum of Contemporary Art, Zagreb, Croatia

Fantasia, East Modern Art Center, Beijing, China

PUBLIC COLLECTIONS | ÖFFENTLICHE SAMMLUNGEN

Art Gallery of Ontario, Toronto, Canada

ChinArt Collection, Monaco/Switzerland

Essl Art Museum / Essl Collection, Klosterneuburg, Austria

FNAC, Paris, France

Goetz Collection, Munich, Germany

Guangdong Museum of Art, Guangzhou, China

Museum moderner Kunst Stiftung Ludwig, Vienna, Austria

LEISTER Collection, Switzerland

The Museum of Fine Arts, Boston, USA

The Museum of Modern Art, New York, USA

The National Museum of Contemporary Art, Seoul, Korea

The New Art Gallery, Walsall, UK

The Red Mansion Foundation, London, UK

Shanghai Art Museum, Shanghai, China

Shenzhen Museum of Art, Shenzhen, China

SIGG Collection, Switzerland

The Smart Museum of Art, Chicago, USA

White Rabbit Contemporary Chinese Collection, Sydney, Australia

The Yuz Art Museum, Jakarta, Indonesia

Zabludowicz Collection, London, UK

BIBLIOGRAFIE
BIBLIOGRAPHY

MONOGRAPHIC PUBLICATIONS | MONOGRAPHIEN

Miao Xiaochun: Microcosm, Osage Singapore, Singapore 2008

Miao Xiaochun: H2O – A Study of Art History, Walsh Gallery, Chicago 2007

Miao Xiaochun: H2O – A Study of Art History, Osage, Hong Kong 2007

Miao Xiaochun, The Last Judgment in Cyberspace,
White Space Beijing and ALEXANDER OCHS GALLERIES BERLIN | BEIJING, Beijing 2006

Miao Xiaochun: The Last Judgment in Cyberspace, Walsh Gallery, Chicago 2006

Miao Xiaochun: image + imagination, Osage Contemporary Art Space, Hong Kong 2006

Phantasmagoria, Walsh Gallery, Chicago 2004

Miao Xiaochun – A Visitor from the Past, EPSITE Shanghai and Beijing 2004

Miao Xiaochun – Verweilen, Galerie Urs Meile, Lucerne 2002

Kulturbegegnungen / Cultural Shock, Deutsche Botschaft Peking;
Museum of the Central Academy of Fine Arts, Beijing 2001

Miao Xiaochun, Beijing Art Museum, Beijing; Shanghai Art Museum, Shanghai 1994

Miao Xiaochun, National Museum of China, Beijing 1992

Miao Xiaochun: Recent Works, Beijing Art Museum, Beijing 1991

Miao Xiaochun's Paintings, Gallery of the Central Academy of Fines Arts, Beijing 1988

SELECTED PUBLICATIONS | AUSGEWÄHLTE PUBLIKATIONEN

Nature | Nation, Museum on the Seam, Socio-political Contemporary Art Museum, Jerusalem 2009

Jiang Jiehong, *The Tale of Angels*, exhibition catalogue, The Red Mansion Foundation, London 2009

Wu Hung, *Making History: Wu Hung on Contemporary Art*, Beijing 2009

Fan Di'an, Zhang Ga (eds.), *Synthetic Times: Media Art China 2008*,
National Art Museum of China, Beijing 2008

Jiang Jiehong, *The Revolution Continues: New Chinese Art*, The Saatchi Gallery, London 2008

Shaheen Merali (ed.), *Re-Imagining Asia*, Haus der Kulturen der Welt, Berlin 2008

Alona Kagan (ed.), *CHINA GOLD*, Musée Maillol, Paris 2008

Richard Vine (ed.), *New China New Art*, Munich/Berlin/London/New York 2008

Zhang Hongxing, Lauren Parker (eds.), *China Design Now*, Victoria & Albert Museum, London 2008

Biljana Ciric (ed.), *Rejected Collection*, Milan 2008

Jiang Jiehong / Joshua Jiang (ed.), *Burden or Legacy: from the Chinese Cultural Revolution
to Contemporary Art*, Hong Kong 2007

Uta Grosenick, Caspar H. Schübbe (eds.), *CHINA ART BOOK*, Cologne 2007

China – Facing Reality, Vol. 2, Museum Moderner Kunst Stiftung Ludwig, Vienna 2007

ARROGANCE & ROMANCE, Ordos Art Museum, Ordos 2007

Passion for Art, Exhibition on the occasion of the 35th anniversary of the Essl Collection,
Edition Essl Collection, Klosterneuburg 2007

Gregor Jansen (ed.), *Totalstadt. Beijing Case – High Speed Urbanisierung in China*,
Zentrum für Kunst und Medien, Karlsruhe 2006

CHINA NOW, Kunst in Zeiten des Umbruchs / Art at a Time of Transformation,
Edition Essl Collection, Klosterneuburg 2006

Bernhard Fibicher, Matthias Frehner (eds.), *Mahjong – Contemporary Chinese Art from the Sigg Collection*,
Ostfildern-Ruit 2005

Wu Hung. Christopher Phillips (eds.), *Between Past and Future, New Photography and Video from China*,
International Center of Photography, New York, Göttingen 2004

Mami, Kataoka, (ed.), *Under Construction: New Dimensions of Asian Art*,
The Japan Foundation Asia Center, Tokyo 2002

Peter Fischer, Susanne Neubauer (eds.), *Me and More*, Art Museum Lucerne, Lucerne 2002

Wonil Rhee (ed.), *Luna's flow*, The 2nd Seoul International Media Art Biennale Media_City Seoul,
Seoul Museum of Art, Seoul 2002

ABOUT THE AUTHORS
ÜBER DIE AUTOREN

GREGOR JANSEN

is art historian and the director of the Kunsthalle Düsseldorf since 2010. From 2005 until 2009 he was the director of the ZKM | Museum for Contemporary Art in Karlsruhe and curated exhibitions about themes such as the history of light art, about the urbanization and art in Beijing, *totalstadt. Beijing case,* Cologne 2006, about the extended painterly concept within the Collection Goetz, about Paul Thek and the German Question *Vertrautes Terrain* Heidelberg 2009.

Kunstwissenschaftler und seit 2010 Künstlerischer Leiter der Kunsthalle Düsseldorf. Er war von 2005 bis 2009 Leiter des ZKM | Museums für Neue Kunst in Karlsruhe und kuratierte Ausstellungen u.a. zur Geschichte der Lichtkunst, zu Pekings Urbanisierung und Kunst unter dem Titel *totalstadt. Beijing case,* Köln 2006, zum erweiterten Malereibegriff mit der Sammlung Goetz, zu Paul Thek und zur Deutschlandfrage *Vertrautes Terrain* Heidelberg 2009.

WU HUNG

a Harrie A. Vanderstappen Distinguished Service Professor of Art History, East Asian Languages & Civilizations; Director, Center for the Art of East Asia at the University of Chicago; Consulting Curator, Smart Museum of Art. Wu Hung is the author of *Transience: Chinese Experimental Art at the End of the Twentieth Century,* Chicago 1999, *Monumentality in Early Chinese Art,* Stanford University 1995, *Three Thousand Years of Chinese Painting,* New Haven 1997, and the forthcoming *Remaking Beijing: Tiananmen Square and the Creation of a Political Space.* (In Berlin, he curated the large-scale project "About Beauty" at the House of World Cultures in 2005.)

hält an der University of Chicago als Harrie A. Vanderstappen Distinguished Service Professor einen Lehrstuhl der Chinesischen Kunstgeschichte, für Ostasiatische Sprachen und Kulturen; er ist Direktor des Instituts für Ostasiatische Kunst und beratender Kurator des Smart Museum of Art. Wu Hung ist Autor zahlreicher Publikationen, wie zum Beispiel *Transience: Chinese Experimental Art at the End of the Twentieth Century,* Chicago 1999, *Monumentality in Early Chinese Art,* Stanford 1995, *Three Thousand Years of Chinese Painting,* New Haven 1997, and the forthcoming *Remaking Beijing: Tiananmen Square and the Creation of a Political Space.* (In Berlin kuratierte er 2005 im Haus der Kulturen der Welt, das große Projekt „Über Schönheit").

SIEGFRIED ZIELINSKI

Professor for Media theory with emphasis on Archaeology and Variantology of art and media at the Hochschule der Künste Berlin. Michel Foucault expert, Professor for media archaeology and techno-culture at the European Graduate School in Saas Fee. Director of the Vilém-Flusser archive at the Universität der Künste,

Berlin. Founding headmaster of the Kunsthochschule für Medien in Cologne (1994–2000). Member of the Academy of Art in Berlin and the European Film Academy. Writer of amongst others *Deep Time of the Media*, Cambridge 2006 and editor of the series *VARIANTOLOGY – On Deep Time Relations Between Arts, Sciences, Technologies*, 5 Volumes, Cologne 2005–2010.

Professor für Medientheorie mit dem Schwerpunkt Archäologie und Variantologie der Künste und der Medien an der Hochschule der Künste Berlin; Michel-Foucault-Experte; Professor für Medienarchäologie & Techno-Kultur an der European Graduate School in Saas Fee; Direktor des Vilém-Flusser-Archivs an der Universität der Künste, Berlin; Gründungsrektor der Kunsthochschule für Medien Köln (1994–2000). Mitglied der Akademie der Künste Berlin und der Europäischen Filmakademie. Verfasser u.a. von *Deep Time of the Media*, Cambridge 2006 und Herausgeber u.a. der Reihe *VARIANTOLOGY – On Deep Time Relations Between Arts, Sciences, Technologies*, 5 Bände, Köln 2005–2010.

UTA GROSENICK

has worked as exihibition manager at the Deichtorhallen Hamburg and the Bundeskunsthalle in Bonn, and was curator at the Kunstmuseum Wolfsburg. She has edited *Art at the Turn of the Millennium* (1999), *Women Artists* (2001), *ART NOW* (2002), *ART NOW Vol 2* (2005). From 2006 until 2009 she worked as editorial director at DuMont publishers in Cologne, for whom she co-authored *International Art Galleries: Post-War to Post-Millennium* (2005), edited the *CHINA ART BOOK, PHOTO ART, Tobias Rehberger 1993–2008* and *Yang Shaobin* (2009, with Alexander Ochs).

hat als Ausstellungsorganisatorin an den Hamburger Deichtorhallen und der Bundeskunsthalle in Bonn gearbeitet und war Kuratorin am Kunstmuseum Wolfsburg. Sie hat *Art at the Turn of the Millennium* (1999), *Women Artists* (2001), *ART NOW* (2002), *ART NOW Vol 2* (2005) herausgegeben. Von 2006–2009 war sie Programmleiterin beim DuMont Verlag in Köln, für den sie *INSIGHT INSIDE – Galerien 1945 bis heute* (2005) mitverfasst hat, es folgten *CHINA ART BOOK, PHOTO ART – Fotokunst im 21. Jahrhundert, Tobias Rehberger 1993–2008* und *Yang Shaobin* (2009, mit Alexander Ochs).

ALEXANDER OCHS

has worked as a freelance curator for Neue Musik. Since 1992 first exhibition projects with Chinese artists, since 1997 he leads galleries in Berlin and Beijing/China. He was curator of several exhibitions in China and Inner Mongolia, and he held lectures at the CAFA, Central Academy for Fine Arts Beijing and the Deutsche Guggenheim, Berlin. He edited *Michael Bach, Fingerbords and Overtones*, Berlin 1991, *Arrogance & Romance*, Ordos Art Museum, China 2007, *Yang Shaobin* (with Uta Grosenick), Cologne 2009, and *Von einer Wand zur anderen – Festschrift für Micha Ullman* (with Matthias Flügge), Nuremberg 2009 amongst others.

arbeitete als freier Kurator für Neue Musik; 1992 erste Ausstellungen mit chinesischen Künstlern, seit 1997 Galerist in Berlin und Beijing/China; kuratierte zahlreiche Ausstellungen in China und der Inneren Mongolei; umfangreiche Vortragstätigkeit u.a. an der CAFA, Central Academy for Fine Arts Beijing und Deutsche Guggenheim, Berlin, Publikationen u.a. *Michael Bach, Fingerbords and Overtones* (Hrsg.), Berlin 1991, *Arrogance & Romance* (Hrsg.), Ordos Art Museum, China 2007, *Yang Shaobin* (Hrsg. mit Uta Grosenick), Köln 2009 und *Von Einer Wand zur anderen – Festschrift für Micha Ullman* (Hrsg. mit Matthias Flügge), Nürnberg 2009.

IMPRINT
IMPRESSUM

THANKS TO | DANKSAGUNG

Uta Grosenick, Alexander Ochs and DuMont Publishers would like to thank Miao Xiaochun and all authors for their extraordinary engagement. The publishers would like to thank as well the following people, without their effort and contribution this book would not have been realized: Tian Yuan, Zhang Di, Andrew Gong / WHITE SPACE BEIJING, Iris Scheffler, Nora Roho, Kathrin Barwinek and Dorka Krasznahorkai.

Uta Grosenick, Alexander Ochs und der DuMont Buchverlag danken Miao Xiaochun und allen Autoren für ihr großes Engagement. Die Herausgeber danken weiterhin folgenden Personen sehr herzlich, ohne deren Unterstützung dieses Buch nicht zustande gekommen wäre: Tian Yuan, Zhang Di, Andrew Gong / WHITE SPACE BEIJING, Iris Scheffler, Nora Roho, Kathrin Barwinek und Dorka Krasznahorkai.

Our special thanks to | Unserer besonderer Dank gilt
Chen Wei, Huang Du, Julie Walsh / Walsh Gallery, Chicago

IMPRINT | IMPRESSUM

Editors | Herausgeber
Uta Grosenick & Alexander Ochs

Idea and Concept | Idee und Konzept
Miao Xiaochun & Alexander Ochs

Authors | Autoren
Gregor Jansen, Wu Hung, Siegfried Zielinski,
Uta Grosenick, Alexander Ochs

Editiorial Office | Lektorat
Uta Grosenick, Iris Scheffler

Translations | Übersetzungen
Kathrin Barwinek, Mark Belcher,
Brian Currid, Wilhelm von Werthern

Graphic Design | Graphische Gestaltung
Dorka Krasznahorkai

Photo Credit | Bildnachweis
The copyright of the images is held by the artist and ALEXANDER OCHS GALLERIES BERLIN | BEIJING, unless stated different.

Die Copyrights der abgebildeten Arbeiten liegen, soweit nicht anders angegeben, beim Künstler und ALEXANDER OCHS GALLERIES BERLIN | BEIJING.

The copyright of the Conversation between Wu Hung and Miao Xiaochun is held by Walsh Gallery, Chicago.

Die Abdruckrechte für das Gespräch zwischen Wu Hung und Miao Xiaochun liegen bei der Walsh Gallery, Chicago.

© 2010 DuMont Buchverlag GmbH & Co. KG, Köln
www.dumont-buchverlag.de

ALEXANDER OCHS GALLERIES BERLIN | BEIJING
www.alexanderochs-galleries.com

All rights reserverd | Alle Rechte vorbehalten

ISBN 978-3-8321-9285-3
Printed in China